THE GIFT OF THE OTHER

SUNY series in Gender Theory
———————————

Tina Chanter, *editor*

THE GIFT OF THE OTHER

Levinas and the Politics of Reproduction

Lisa Guenther

STATE UNIVERSITY OF NEW YORK PRESS

Published by
STATE UNIVERSITY OF NEW YORK PRESS
ALBANY

© 2006 State University of New York

All rights reserved

Printed in the United States of America

No part of this book may be used or reproduced in any manner whatsoever without written permission. No part of this book may be stored in a retrieval system or transmitted in any form or by any means including electronic, electrostatic, magnetic tape, mechanical, photocopying, recording, or otherwise without the prior permission in writing of the publisher.

For information, address
State University of New York Press
194 Washington Avenue, Suite 305, Albany, NY 12210-2384

Production by Kelli Williams
Marketing by Anne M. Valentine

Library of Congress Cataloging-in-Publication Data

Guenther, Lisa, 1971–
 The gift of the other : Levinas and the politics of reproduction / Lisa Guenther.
 p. cm. — (SUNY series in gender theory)
 Includes bibliographical references (p.) and index.
 ISBN-13: 978-0-7914-6847-0 (hardcover : alk. paper)
 ISBN-10: 0-7914-6847-X (hardcover : alk. paper)
 ISBN-13: 978-0-7914-6848-7 (pbk. : alk. paper)
 ISBN-10: 0-7914-6848-8 (pbk. : alk. paper)
 1. Women—Philosophy. 2. Reproduction—Philosophy. 3. Motherhood—Philosophy.
 4. Levinas, Emmanuel. I. Title. II. Series.
 HQ1206.G838 2006
 306.874'301—dc22 2005033880

Contents

Acknowledgments	vii
Introduction The Gift of the Other	1
A Feminist Approach to Levinas	5
A Levinasian Approach to Feminism	8
Birth, Time, Ethics	10
Chapter One The "Facts" of Life: Beauvoir's Account of Reproduction	15
Take 1: Birth as a Project	19
Take 2: Birth as an Ambiguous Situation	24
Chapter Two The Body Politic: Arendt on Time, Natality, and Reproduction	29
Vita Activa: Labor, Work, Action	32
The Temporality of Action: Promise and Forgiveness	36
Thinking Through Natality	41
Reproducing Natality: Cavarero's Reading of Arendt	44
Chapter Three Welcome the Stranger: Birth as the Gift of the Feminine Other	49
Derrida and the Gift of the Impossible	50
Cixous and the Gift of the Feminine	53
Levinas and the Gift of Hospitality	57
I am welcomed: From *ethos* to *oikos*	58
You are welcome: From *oikos* to *ethos*	64

CHAPTER FOUR FATHERS AND DAUGHTERS: LEVINAS,
 IRIGARAY, AND THE TRANSFORMATION OF PATERNITY 75

 Paternity as Infinite Discontinuity 77
 Otherwise than Paternity: Irigaray Reading Levinas 84
 From Paternity to the Maternal Body: Isaiah 49 89

CHAPTER FIVE ETHICS AND THE MATERNAL BODY:
 LEVINAS AND KRISTEVA BETWEEN THE GENERATIONS 95

 Time and the Maternal Body 97
 Ethics and *Herethics* 108
 Moses and His Mothers: Numbers 11:12 129

CHAPTER SIX MATERNAL ETHICS, FEMINIST POLITICS:
 THE QUESTION OF REPRODUCTIVE CHOICE 141

 Defending the Imaginary Domain: Drucilla Cornell 143
 Levinas Between Ethics and Politics 147
 Ethics, Politics, and the Prospect of "Unborn Mothers" 155
 Altered Maternities 161

NOTES 165

BIBLIOGRAPHY 179

INDEX 187

Acknowledgments

On a hot, humid day in the Kootenays, my dear friend Candace gave birth to a baby boy. I went to spend time with her and to meet Toshi for the first time. When I arrived, he had just fallen asleep, and Candace was curled up on the bed beside him. I remember touching his tiny hands carefully, afraid to wake him. His body was so small and red, and the faces he made in his sleep looked like tiny grimaces. What could he be feeling? Who was he, and who might he become?

For the next few days I tip-toed around, scared to be left alone with the baby—astonished at his power to change everything and everyone around him, but also astonished at his frailty. He was so small to begin with, and he just kept losing weight. Candace tried hard to get him to "latch on properly," as the books said. I boiled up a thick, disgusting slurry of barley tea for her to drink, looking through endless baby manuals for some kind of solution. But he was like an alien in our midst, howling with—what? Sometimes it seemed like rage, sometimes pain, and sometimes it seemed he was screaming just to remind us that he was there. The less he slept, the less Candace could sleep; I worried for both of them. It wasn't fair; she had been through hours of labor and needed to recover in peace and quiet. But the baby filled the house with his screams, and Candace seemed to be the only one who could soothe him. I remember watching the two of them on the couch. He would latch on like a textbook baby, but then suddenly tear his head away and cry for no apparent reason. Candace would cradle his head in her hand, whisper a few words, tickle his lower lip, and try again. Again and again, she tried to get him to swallow some milk and keep it down—until finally he started gaining weight, and we cheered for every ounce of his flesh.

At night I slept outside in my tent, reading Levinas by flashlight. It was a sort of escape, I admit; out there, I could find the peace and quiet of a life alone, with no one to take care of but myself. But the escape was not complete; night after night, I dreamed of tiny little babies tumbling from a plastic egg carton into the grass. I'd rip open the tent in the middle of the night to

search for them—only to find myself cold and disoriented in the garden, the goats staring at me curiously from their pen. I'm not sure when it happened, but at some point in my stay I made a connection between our two lives, between my books and Candace's family. There in the house, on a mattress on the floor in the spare bedroom of her sister's house, Candace was already doing what I had been trying to understand in my book: she was responding to the Other, substituting for Toshi like a maternal body, welcoming him into the world and into her life. This welcome was beautiful and moving, but it was also so very difficult and frightening and messy and full of tears. The book you now hold in your hands found its beginning there in a house where a woman brought a child into the world, and where she gathered the patience and the strength to bear his weight. Thank you to Candace and Toshi for teaching me something about responsibility and love, and for providing the inspiration for this book.

Thank you also to the many people who contributed to the writing of this book, whether through conversation, correspondence, or simply by being there. My mother and father, Dianne and George Guenther, my partner Rohan Quinby, and my sister Julie Guenther have all given me the support I needed to pull this book together. Bob Gibbs, Rebecca Comay, Graeme Nicholson, Jamie Crooks, and Daniel Fischlin have all been wonderful teachers; Bob's influence in particular runs throughout this book, probably in ways that I myself don't recognize yet (though I've tried to indicate wherever it's clear to me!). Thank you to my colleagues and friends who have read various drafts or helped to develop these ideas along the way: Ros Diprose, Michael Jackson, Susanna Trnka, Lucy Holmes, Mia Yardley, Agnieszka Zabicka, Matthias Michl, Andres van Toledo, Victoria Wynne-Jones, Robert Wicks, Murray Johnston, Ryan Wiens, Kevin Krein, Abbie Levin, and Daniel Goldman. Thank you in particular to Tina Chanter for encouraging me to develop my PhD thesis into a book, and to do it sooner rather than later. Finally, thank you to Joanna Forsberg for the cover photo, and to Murray Edmond for lending a hand.

These acknowledgments would not be complete without a word of thanks to my friends in the Yukon, for the wonderful mixture of community and solitude that I found in their midst. I miss that crazy rhythm of dark winters full of potluck dinners, and endless summer days spent on rivers or mountains. Looking over these pages, I remember where many of them were first written: on the banks of the Yukon River with my laptop plugged into a car battery, or at the table in the cabin surrounded by candles and kerosene lamps, or in the mosquito tent I rigged up for the summer, or in Zola's café, or the computer room of the Whitehorse Public Library. Thanks to Yukon College for giving me my first real job and for the interlibrary loans that must have cost taxpayers a fortune. Thank you to the taxpayers of the Yukon for their unwitting support of feminist scholarship on Levinas—may it continue in the present and future! And finally, thank you to my colleagues and

students at the University of Auckland philosophy department, and to the wonderful bunch of philosophers in Sydney and Melbourne who have helped to make me feel at home in the Antipodes: Ros Diprose, Ann Murphy, Catherine Mills, Moira Gatens, Paul Patton, Linnell Secombe, and Matt Sharpe, just to name a few.

Finally, revised versions of the following articles appeared originally in these journals, and grateful acknowledgment is made to them here: "Unborn Mothers: The Old Rhetoric of New Reproductive Technologies," in *Radical Philosophy* 130 (March/April 2005); "The 'Facts' of Life: Beauvoir and the Ethics of Maternal Embodiment," in *Symposium* 9:2 (Fall 2005); and "Like a Maternal Body: Levinas and the Motherhood of Moses," in *Hypatia* 21:1 (Winter 2006); "Giving Birth," taken from *Dancing Girls and Other Stories* by Margaret Atwood, is used by permission of McClelland and Stewart Ltd.

INTRODUCTION

The Gift of the Other

> We, living now, are always to ourselves young men and women. When we, living always in such feeling, think back to them who make for us a beginning, it is always as grown and old men and women or as little children that we feel them, these whose lives we have just been thinking. We sometimes talk it long, but really, it is only very little time we feel ourselves ever to have being as old men and woman or as children. . . .
>
> We say then, yes we are children, but we know then, way inside us, we are not to ourselves real as children, we are grown to ourselves, as young and grown men and women. Nay we never know ourselves as other than young and grown men and women. When we know we are no longer to ourselves as children.
>
> —Gertrude Stein

To be born is, in a sense, to forget one's birth. Perhaps we cannot help but forget—the moment of birth hovers ambiguously on the edge between time and anarchy, selfhood and anonymity, existence and nothingness. But often we conspire in the forgetting of birth, preferring to imagine ourselves as "young and grown men and women," not children but rather self-made and self-sufficient adults, always already standing on our own two feet. To forget one's birth would be to avoid the apparent humiliation of being born "between feces and urine," as St. Augustine famously put it (cited in Beauvoir 1952, 156). But this forgetting of birth would also erase the very condition of my existence: namely, a woman who *gave* birth to me. Neither a virgin queen nor a sordid birth canal, this woman first let me exist in a world, and continues to remind me of the birth I seem only too willing to forget.

To remember birth properly is difficult, if not impossible. But to remember oneself as born *to an Other*—not only in passivity, but in passivity before an Other who gave birth to me—this is perhaps the most difficult thought. Not only do I fail to choose my own existence, but I also begin this existence

as an infant (*in-fans*, without speech) naked and vulnerable, utterly dependent on Others who take care of me. Gertrude Stein remarks upon the difficulty of understanding oneself as the child of parents who "make for us a beginning." From the moment we emerge into self-consciousness, we tend to feel ourselves as "young and grown men and women": strong, sure-footed, and capable. The three year old, as much as the fifty-three year old, wants to see herself in this way, and tends to see her parents as either "old men and women" or small, gradually shrinking children. What would it mean to "know ourselves as other than young and grown men and women"? Stein answers: "When we know we are no longer to ourselves as children."

To know oneself as a child—and as the child of parents who also feel themselves as "young and grown"—would be already to pass beyond childhood, toward a different understanding of birth, time, and ethics. If to forget birth is to feel oneself as the "young and grown" origin of one's own existence, then to remember the givenness of birth would be both to feel oneself as the child of another and also to feel oneself as *other than a child*: as a self who, more than "young and grown," is both dependent on Others and responsible for them. To be born is to be given to Others, such that I do not choose my own origin; further, it is to be given in responsibility, such that I do not merely "choose" to be good. I wish to recognize in the gift of birth an imperative—and not merely the choice of an autonomous subject—to pass on this gift of time and responsibility. Perhaps it is only by giving to Others that we may recall the givenness of our own birth, precisely in its immemoriality.

This book considers the ethical and temporal significance of birth as the gift of the Other. This gift is unique in that it gives rise to its own recipient; the child who receives the gift of birth exists only thanks to this gift. In this sense, birth is not only given *to* me; it also *gives* me, bringing me forth into a world in which I have always already responded to Others. Birth marks the beginning of my own existence in time; but the givenness of birth suggests that my existence is not quite my own, that my time is already bound up with the time of the Other. How might one respond ethically to the maternal gift of time and existence? I approach this question from two directions at once: through a reading of Levinas on time and ethics, and through a feminist critique of birth and reproduction. Levinas's account of responsibility gives me a language to articulate the ethical and temporal dimensions of birth as the gift of the Other; but Levinas's own ambivalent discourse on maternity and the feminine demands a feminist response. The material, embodied, and gendered significance of birth has been carefully explored by many feminist philosophers, but something important can be learned about the ethics and temporality of birth from Levinas's account of responsibility. By reading Levinas alongside the work of Beauvoir, Arendt, Irigaray, Kristeva, and Cornell, I hope to generate new approaches to the theory—and practice—of motherhood as the gift of the Other.

In what sense is birth given, and by whom? Throughout this book, I argue for a twofold understanding of birth as a gift. In one sense, birth is a gift *from* the Other, a gift that makes my own existence possible. I receive myself from the Other who gives birth to me; even egoism presupposes an Other whom I have forgotten or denied, but who has made my existence possible. At the same time, the child is also an Other given to those who receive it into the world and make room for it in their home. Giving and being given intermingle here, to the point where it is difficult to say who is more profoundly receptive, the parent or the child. The child makes the woman a mother, even as the mother "makes" the child within her own body. The emergence of this child demands a responsibility that it also makes possible, simply by showing its face. This imbrication of giving and receiving suggests a second sense pertaining to the gift of the Other: the sense in which I receive from the Other *even my own capacity to give*. As Alphonso Lingis suggests, "What gifts give is the ability to give gifts" (Lingis 2000, 181). The gift of the Other thus remains *of* the Other, never quite becoming my own possession; even when I receive it from an Other, this gift does not belong to me but rather commands me to give to Others. To give birth, then, is not to possess something tangible that I could just as well keep for myself; the gift of birth materializes only in the giving-away. Birth contests any absolute possession of one's own existence; I become "young and grown," sure and self-possessed, or even generous and responsible, only thanks to an Other who initiated my existence. In this sense, even my gift *for* the Other is a gift *from* an Other; my generosity does not belong to me, but arises only as a response to Others who make my generosity possible.

These awkward grammatical constructions—a gift that "gives gifts," or that arises from the Other for whom it is given—point toward the strange temporality of birth. From the perspective of the one who is born, birth is an event that must have always already happened in the past, but is never quite present as a moment in one's life. My birth slips away from me at the same time that it makes me. Is there anything stranger than this newly-born self whom I must have been but never "was"? I may remember my mother's face hovering over the baby carriage; I may even experience the lingering effects of the "birth trauma" that Otto Rank famously describes.[1] But in what sense can I be said to experience or remember my own birth? If birth is the emergence of the self into existence, then who might be "there" (except the Other who gives birth, and the Others who attend her) to witness my emergence? Birth points to a time of existence that is already *me* but never quite *mine*: a time on the cusp of selfhood, prior to my identity as a self-conscious ego. As a moment that has always already slipped into the past, my birth exists neither in the present nor in the future; it is never quite a possibility *for me*. If anything, it is a possibility that precedes my own existence: an anarchic possibility that can only exist "for" me by coming before me.

For Levinas, anarchy refers to a time before the origin [*an-archē*], in which I find myself already responsible for the Other before having willingly undertaken to commit myself to such a responsibility. This anarchic response to the Other antecedes and interrupts the projects through which I define myself; it contests my "place in the sun."[2] In what follows, I suggest that the time of birth, understood as the gift of the Other, is anarchic in a similar sense.[3] Birth refers to a past that antecedes and interrupts the remembered or represented past in which I constitute myself as an autonomous, self-possessed subject. It points to the anarchy of givenness without which no other projects or initiatives would be possible. The anarchic event of my birth suggests that, however sovereign and masterful I may be, there is an aspect of my existence that does not quite belong to me but remains as the trace of this generous gift of the Other. In the chapters that follow, I argue that this gift already implicates me in a radical responsibility for Others. My responsibility is not like a debt that demands reciprocation, as if I could somehow return the favor of birth with a pledge of loyalty or love for the one who gave birth to me. Rather, the gift of birth—this anarchic "ground" of my existence—demands of me a certain hospitality for the stranger who has given me nothing to speak of: a generosity without expectation of return, a responsibility without measure.

Drawing on the work of Arendt, Levinas, and Kristeva, I have imagined the ethical temporality of birth as a time of promise and forgiveness, both of which alter our relation to the future and the past. As Arendt observes, "No one can forgive himself and no one can feel bound by a promise made only to himself" (Arendt 1958, 237). Promise and forgiveness suggest a relation to Others, even as much as they suggest a relation to time. Birth is like a promise for both the parent and the child; it implies a new hope for the future, as well as a future responsibility. The newly born child brings the promise of a renewed time that would be different from the past, a future that does not already belong to the terms and conditions of the present. At the same time, the newly emerging parent is promised to the child with a responsibility that goes beyond what the parent can expect or control. Levinas accounts for parenthood (or, as he puts it, "paternity") as a response to the future of the child: a future that is not my own, and does not necessarily include me, but for which I am nevertheless bound to respond.[4] While promise opens a future for both parent and child, forgiveness addresses their relation to the past. The word "forgiveness" usually implies a particular fault or transgression that is then pardoned; but I have sought to interpret forgiveness more generally in terms of a relation to the past and to Others, beyond the significance of particular faults. Just as I am responsible for the Other beyond what I have undertaken or initiated, I may also forgive the Other beyond what she has done or failed to do. The forgiveness of Others allows us to take up a new relation to the otherwise fixed and intransigent past without claiming to erase or undo what has been done. Perhaps only this gesture of forgiveness allows me to "face" the past of my own birth as neither a burden nor a possession, but rather as the gift of

the Other. Forgiveness and promise suggest a time whose very significance is intersubjective and ethically charged. Here, time is given by the Other in such a way that it does not remain mine to keep but only to pass on to another Other, by forgiving her less-than-perfect past and promising her a future of responsibility. As a gesture of promise and forgiveness, birth is the gift of time, a gift that engenders in me a responsibility to give generously to *other* Others, or to pass the gift of time along.

A FEMINIST APPROACH TO LEVINAS

Throughout this book, I draw on the account of ethical responsibility given by Emmanuel Levinas. For Levinas, "Morality is not a branch of philosophy, but first philosophy" (TaI 304; TeI 340).[5] Moral theory itself is already a secondary concern, since my immediate face-to-face encounter with a singular Other exceeds what can be theorized in philosophical discourse. Prior to maxims and morals and normative claims, I am commanded to respond by an Other who faces me. This does not mean that systems of morality are unnecessary, that they should or even *could* be tossed aside. Rather, it means that the possibility of any moral system already follows on this anarchic response to the Other. Moral philosophy is important; but it is important for the sake of an Other who makes a claim on me prior to the constitution of any philosophical system. For Levinas, responsibility does not refer merely to what I have done or chosen, nor does it obligate me only to those whom I already know and love. Rather, I am responsible for the stranger who faces me, despite what she has done or failed to do. My obligation to the Other is not caused by an action or disposition, nor is it dictated by a universal moral law; rather, it is commanded of me by the vulnerability and exposure of the Other's face. Levinas calls this "a responsibility for the freedom of Others," a responsibility that calls my own freedom into question (OB 109; AE 173). This radical responsibility makes room for the Other to be there or not be there, to confront me but also to slip away beyond my reach. For Levinas, this responsibility for the Other exceeds the bounds of what is reasonable, practical, or even possible. The more I give to the Other, the more I find myself required to give; my obligation increases the more I attempt to satisfy it. Responsibility is not only infinite; it is anarchic, in the sense that it both *disrupts* my sovereignty as an ego, and also commits me to a responsibility that is *prior to the origin* of this sovereignty. I have always already been called to responsibility because there is always already an Other who is there before me, demanding a response. As Alphonso Lingis explains in his introduction to *Otherwise than Being*: "To be responsible is always to have to answer for a situation that was in place before I came on the scene" (OB xx).

What does Levinas's account of ethical responsibility offer for the reflections on birth undertaken in this book? I approach this question through a reading of two central figures for responsibility in his work: hospitality in

Totality and Infinity, and maternity in *Otherwise than Being*. In giving hospitality, I make room for the stranger in my home, without first asking why he deserves it or what I will get in return. But I am only given this capacity to welcome Others in hospitality thanks to a feminine Other who has always already opened up the space of welcome within the home. In chapter 3, I elaborate the relations between hospitality and birth, welcome and welcoming, the feminine Other and the stranger. In short, I argue that the parent who gives birth to a child welcomes him as a stranger into her home, already commanding him to pass this welcome on to another stranger.[6] The command to welcome the Other is also, I argue, a command to be feminized by the Other: to be put in question as a virile, autonomous, and sovereign individual. This feminization of the self in response to an Other suggests a nonbiological, but nevertheless embodied interpretation of femininity that I will elaborate at length through the course of this book. The gift of birth from a feminine (but not necessarily female) Other implicates me in responsibility for a stranger whom I have not yet met, but to whom I am already bound to give welcome.

In *Otherwise than Being*, Levinas suggests that responsibility for the Other obligates me to bear her "like a maternal body" (OB 67; AE 109), even though she is a stranger whom I have "neither conceived nor given birth" (Num. 11:12, cited in OB 91; AE 145). To be responsible is not only to welcome the stranger into one's home, but to bear her in the flesh, despite the pain that this bearing might bring. The maternal body is not only a host but already a hostage for the Other, unable to extricate herself from a responsibility that she did not undertake but to which she was already assigned by the Other. This radical responsibility disrupts the identity of the self for the sake of an Other who remains as a stranger, the "other-in-the-same," neither alienated and rejected nor integrated into the identity of the maternal self (OB 78; AE 126). For Levinas, to be responsible is to "substitute" oneself for the Other in the sense of bearing responsibility for the Other's own responsibility, and even for the persecution with which she afflicts me. This account of a maternal, embodied, and perhaps even "feminine" ethics has interesting implications for a feminist philosophy of birth, yet it seems clear that Levinas himself was not a feminist in any recognizable sense of the word.[7] By invoking maternity as a figure for infinite and unchosen responsibility, Levinas risks lapsing into a painful and damaging cliché against which women have struggled for decades, if not centuries. Women have long been expected to give selflessly to Others without expectation of return; there is nothing particularly feminist about the theme of maternal responsibility or self-sacrifice. While Levinas does not exclude men from the ethical imperative to bear Others,[8] his use of maternity as a metaphor for ethics in general threatens to appropriate the generous gift of maternity without acknowledging women's very particular, historical, and embodied experience as mothers. How might a feminist reader of Levinas respond to these dangers, without overlooking the feminist potential of his work?

There is already a wide range of feminist responses to the work of Levinas.[9] For some, the recognition of sexual difference in his work is significant, and rare in the history of philosophy; but this recognition alone is not enough to make Levinas a feminist, or even sympathetic to feminism. In Levinas's oeuvre, the feminine Other appears differently at different moments: as a figure for alterity par excellence (*Time and the Other*), as an infantile and even animal presence (*Totality and Infinity*), as a figure for responsibility (*Otherwise than Being*), and as a secondary or even subordinate creature ("Judaism and the Feminine," "And God Created Woman"). In my own interpretation of the feminine Other, I seek neither to justify this figure for Levinas nor to defend her against his account, but rather to problematize any stable, unambiguous interpretation of femininity in his work. Between the discourses of philosophy, feminist politics, and—at certain key moments—biblical scripture, the stability of the feminine begins to waver: sons turn into daughters, fathers turn into mothers, and mothers turn into men.[10]

A touchstone for my inquiry has been Levinas's phrase, "like a maternal body" (OB 67; AE 109).[11] By putting emphasis on the word "like" in this phrase, I wish to destabilize any strict correlation between women and mothers, or between motherhood and responsibility. As I interpret it, the phrase may or may not refer to the biological birth of a child; I can become "like" a maternal body whether or not I physically give birth to a child. To become *like* a maternal body for someone is to become responsible for her *as if* she were my child, as if I bore this responsibility in my flesh. In responding to the Other like a maternal body, I do not insert myself as her cause or origin, but rather give to her a past of forgiveness and a future of promise. To give birth is thus to *give time* to the Other; it is to make a gift of time that circumvents possession and asks to be passed on. Here, time itself may be understood in ethical terms, as a gift *for* the Other and *from* the Other. The distance implied by the word *like* in this phrase, "like a maternal body," opens up a gap between maternity as a biological fact and as an ethical response. I interpret the figure of maternity in resistance to the gender ideology that would make women single-handedly responsible for every child conceived. If to be born is to be given the imperative to bear even the stranger whom I "have neither conceived nor given birth to" (Num. 11:12), as Levinas suggests, then both men and women are commanded to become like a maternal body for the Other, whether or not they give birth in a biological sense. I interpret this ethical imperative as a command for even the virile, autonomous self to be feminized and maternalized in his encounter with the Other. In this sense, maternity would not refer to a biological or social imperative for women to reproduce, but rather an ethical imperative for each of us to bear the stranger *as if* she were already under my skin, gestating in my own flesh.

Without a doubt, this interpretation raises questions for a feminist philosophy of birth. To what extent can maternity be interpreted as a figure for ethics without thereby abstracting from the lived experience of a woman giving birth

to children? Maternity is not just a metaphor; nor does it refer in any simple way to the literal moment of giving birth. Rather, maternity constitutes an ongoing ethical and political practice that includes a long history and even prehistory in which women have often been compelled to "give" birth against their will, without a choice in the matter. What is the relation between this history of forced reproduction and the ethical interpretation of birth as the gift of the Other? We may insist that the imperative to become "like a maternal body" is addressed to both men and women. But how does this imperative resound differently for a woman who is capable of giving birth in a biological as well as an ethical sense?

A LEVINASIAN APPROACH TO FEMINISM

Motherhood has been a contested subject for feminists and nonfeminists alike. The capacity to gestate and give birth to a child marks a difference between women's and men's bodies that needs to be taken into account in some way. Recent developments in reproductive technology have exacerbated the need for reflection on what it means to be a mother, even as they have multiplied and displaced the traditional meanings of motherhood. Is maternity located in the contribution of an egg, or in the gestation of a fetus, or in the social and economic support of a child? Can a child have two mothers, or a male mother, given the possibilities of artificial insemination, surrogacy, adoption, and other forms of technological intervention and/or social arrangement? And in what sense can birth be understood as the gift of the Other, if this gift is capable of being sold on the open market, or coerced from women as a social or biological duty?

The most emphatic condition for an ethical interpretation of birth as a gift is, I shall argue, a feminist discourse on motherhood and the politics of reproduction. Without a situation of reproductive justice—in which women have access to a meaningful range of reproductive choices that take into account differences in race, income, mobility, and sexuality—the ethics of birth that I have outlined here could have profoundly unethical and unjust consequences for women. The generosity of giving birth requires a situation in which it is not already demanded of women as their biological duty, and women's bodies are not reduced to mere vessels for reproduction or incubators for social property. The systemic political asymmetry between women and men means that the "gift" of the Other can be taken from women: coerced, exacted, exchanged. Where power is shared unequally across gender, race, and class lines, it seems naïve and even dangerous to claim that birth is a gift for which no adequate reciprocation is possible. Surely a woman who has no access to decent birth control, little participation in the public realm, and a marginalized political voice, benefits little from a poetic celebration of the unchosen contingency of birth. What, then, is the relation between an ethical interpretation of birth as a gift beyond choice and the political imperative for women's reproductive choice?

It seems to me that we must think on both levels at once, articulating both the ethics of birth as a gift and the politics of birth as a site where the gift can often be spoiled in the reception. Levinas makes a helpful distinction between ethics and politics in his work. Ethics involves the anarchic and nonreciprocal response to an Other who comes from above and beyond me, and whose command radically puts in question my own interests and abilities. But there is never just one Other who faces me; there is also third, and a fourth, and countless Others who "deserve" my attention just as much or as little as the Other who immediately faces me. Because there is more than one Other, we need justice: a rational discourse through which rights and responsibilities may be balanced and negotiated. Without the imperative of ethics, justice would become little more than a calculation of interests, but, without justice, ethics would become an unbearable weight, an enslavement to the Other that crushes the self to the point where she is incapable of any further response. Justice is necessary: not primarily for one's own sake, but for the sake of the other Others, the third party who would be left without a response if the self should disappear. In chapter 6, I argue that the maternal ethics proposed by Levinas in *Otherwise than Being* requires a feminist politics of maternity if it is to avoid turning the gift of birth into a point of coercion.

What would this feminist politics of maternity look like? I wish to position myself in resistance to two myths that seem at first glance to be mutually opposed: first, the antifeminist myth that women are biologically "programmed" for maternity and therefore naturally bound to become mothers; and second, the liberal (and sometimes radical) feminist myth that, since women have been socially bound to motherhood throughout patriarchal history, we must be liberated *from maternity* if we are to exist as free and equal persons in the public realm.[12] While the first myth reduces mothers to vessels for reproduction, the second reduces mothers—perhaps unintentionally—to vessels for the patriarchal order, as if it were impossible for a woman to be both a feminist *and* a mother. My aim in addressing this second myth is not to downplay the sense in which mothers really have been constrained by patriarchal demands, but rather to open the door for other, nonpatriarchal meanings of motherhood.

Neither of these myths can account for birth as it is *given*, in a strong sense, by a mother. The first fails to grant women a strong enough sense of individual subjectivity to be generous; if women are programmed for maternity, then birth cannot be an ethical gesture, but only an instinct, a biological fate. The second myth contests this denial of women's subjectivity, and rightly so; however, by arguing for the position that women "own" their bodies and therefore have a right to determine how this property is used, it comes no closer to interpreting birth as an ethical gift. Rather, if the self is understood as an autonomous, self-possessed individual, then any gift turns out to be a loss, a theft, a diminishment of what is properly one's own. This image of a fully self-sufficient individual conceals a gender ideology that works

against a feminist politics of reproduction, even if it is sometimes invoked in its name. Think, for example, of Locke's formulation: "Every Man has a Property in his own Person" (cited in Petchesky 1995, 393). If I own myself, then I should have the right to dispose of myself as I please. Even if I enter into agreements with Others to enhance or protect my property, I remain an autonomous individual despite these agreements. But the idea of an entirely self-possessed individual is at odds with the understanding of oneself as born to an Other. In her critique of the liberal individual, Seyla Benhabib refers to Hobbes's vision of men "as if [they had] but even now sprung out of the earth, and suddenly, like mushrooms, come to full maturity, without all kind of engagement to each other" (cited in Benhabib 1992, 156). Benhabib comments: "This vision of men as mushrooms is an ultimate picture of autonomy. The female, the mother of whom every individual is born, is now replaced by the earth. The denial of being born of woman frees the male ego from the most natural and basic bond of dependence" (156). The autonomous individual—like Gertrude Stein's "young and grown men and women"—maintains the fiction of self-possession by imagining his birth as an autochthonous miracle, in which he springs from the earth fully grown and ready to take on the world. In this sense, the dream of perfect autonomy would deny the fact of birth to a mother; it would also deny any responsibility to Others beyond that which it willingly and consciously undertook for itself.

In light of this potential impasse, I suggest that the feminist politics of reproduction might be better served by a vision of the self as embodied and engendered, but neither biologically determined as a mother nor socially committed to the pursuit of individual autonomy. This other politics of reproduction would seek to recuperate the sense in which mothers offer a profoundly ethical gift of time, in resistance to both the history that interprets this gift as a natural debt to the species, and the philosophy that seeks to shield the autonomous individual from all forms of indebtedness. By invoking a Levinasian sense of justice as both a requirement for ethics and already the afterthought of a more radical ethical response, I argue for a feminist vision of reproductive equality that is both the condition for an ethics of birth and already a consequence of thinking through this ethics as carefully as possible.

BIRTH, TIME, ETHICS

To be born is to be given to an Other in a time of irrecuperable pastness that is not my own, but rather time *from* the Other and ultimately *for* the Other. The irretrievable pastness of birth—the sense in which I can never quite recall or reconstruct the event of birth as it "really" was—is not merely an intellectual curiosity but rather a point of great philosophical and ethical significance. For the lapse of time between myself and my birth disrupts in advance the possibility of a completely masterful, unified selfhood. If I do not posit my own existence—and if even my fantasies of repeating or reclaiming birth already

require this birth as their most basic condition—then my selfhood remains radically exposed to Others even when I try most to deny this exposure. Thanks to the given time of birth, the mastery of the self remains forever incomplete, depending on the gift of an Other even to deny this givenness. But if the past is never completely my own, then my possession of present and future time is also put in question. As I shall argue, the irrecuperable past of my given birth opens a future of giving-forth or responsibility for the Other.

To be given in birth is already to receive the imperative to bear or support an Other who may or may not be my child. I bear the Other "like a maternal body" not because I am the cause of the Other's existence, but precisely insofar as I am *not* her cause. Levinas's phrase disengages responsibility from causation and releases the gift of birth from the self-interest to which it might otherwise revert. To become like a maternal body for the Other is to bear responsibility for her *as if* she were my child, as if her cries wounded me the way a mother might be wounded by her child's suffering. The word "like" puts pressure on our understanding of both responsibility and maternity. For if responsibility for an Other means bearing the stranger like a maternal body, then maternity must signify more than a genetic, biological relation to "my own" flesh and blood. Already, maternity points to an encounter with an Other who is both intimate and strange, both utterly close and inexorably distant. The child, like the mother, is a self born to an Other and exposed to her in what I describe as the anarchy of gestation. But the mother, unlike the child, is a self with the capacity to give and to welcome, to represent the world and to have these representations challenged by an Other. How does the helpless and vulnerable child become "like" a mother for the stranger whom it has not yet met? In what time does the dependence of givenness turn into the generosity of giving? And how does the sexual specificity of pregnancy bear upon its significance for ethics? These questions will emerge time and again in this book, as I explore the significance of birth as the gift of the Other.

The book begins by examining two accounts of birth that question the biological myth that women are "programmed" for reproduction, but also return to this myth in some way. Chapter 1 looks at Simone de Beauvoir's ambivalent account of birth in the *The Second Sex*. On the one hand, Beauvoir makes a convincing argument that women should not, and cannot, be reduced to their reproductive function; on the other hand, Beauvoir herself describes the pregnant woman as "the victim of the species," as if pregnancy doomed women to a more difficult struggle against nature and immanence than men must endure (Beauvoir 1952, 18). This image of mothers as the victims of both biology and patriarchy makes a strong case for women's reproductive freedom, but it does not yet exhaust the significance of birth for feminism. I argue that Beauvoir both grants biology too much independent weight and also provides some of the philosophical resources needed to rethink birth beyond its apparently "natural" and patriarchal significance. Chapter 2 picks up the themes of nature and

culture through a response to Arendt's concept of natality, which she identifies as an important, but often overlooked category for political theory. Thanks to birth, there is always a plurality of new and unanticipated political actors coming into the world whose response I can neither control nor predict, but who—precisely for that reason—make political life possible. Arendt's concept of natality provides feminist thought with a powerful language to challenge the image of the virile, autonomous self, and to articulate the ethical and political significance of birth. But I argue that Arendt's opposition between "natality" (largely understood as the figurative birth and rebirth of the nongendered citizen) and "reproduction" (as the embodied, biological birth of a child to a mother) compromises the radicality of her concept of natality, and calls for a feminist response.

Chapter 3 elaborates the suggestion, first raised by Arendt, of a discontinuous, nonrepetitive, and ethical temporality of birth. In particular, it offers a reading of hospitality in *Totality and Infinity* which suggests an account of birth as welcome, or as the gift of the Other. I relate this account of hospitality to Derrida's and Cixous's different approaches to the gift, in light of which the welcome of the feminine Other appears to command me in advance—and perhaps in writing—to be "feminized" in response to the stranger, becoming for him "the welcoming one par excellence" (TaI 157; TeI 169). Chapters 4 and 5 expand this reading of Levinas by interpreting his work on paternity (in *Totality and Infinity*) and maternity (in *Otherwise than Being*) alongside an important feminist critic (Irigaray and Kristeva, respectively). In both chapters, I locate a rupture or opening in the text of Levinas, in which the citation of a biblical verse (Isaiah 49 and Numbers 11:12, respectively) suggests a significant reinterpretation of paternity and maternity in his work. In chapter 4, I argue that the discontinuous temporality that Levinas describes as "paternity" cannot be confined to fathers and sons, but must be extended to mothers and daughters to remain both just and ethical. In chapter 5, I explore the anarchic temporality of pregnancy and gestation, and suggest an "herethical" approach to the question of ethical persecution and expiation for the Other.

In chapter 6, I address the relation between ethics and politics, and take up the particular concerns facing a feminist politics of reproductive choice. On the one hand, an ethics of maternity along the lines I have discussed promises to account for the dimensions of birth—as a welcome, a gift, a renewal of time—that Beauvoir's account of reproduction does not fully articulate. And yet, without a more explicit political analysis of reproduction, this maternal ethics risks falling into a situation that expects women in particular to bear responsibility for the Other in their bodies, whether or not they have chosen to undertake this responsibility. I resist both of these possible implications by elaborating the difference and proximity between a maternal ethics and a feminist politics. Drawing on Drucilla Cornell's defense of the "imaginary domain" held open by the legal guarantee of women's access to safe abortion, I interpret current media representations of fetuses as (so-called) unborn mothers. While

these representations threaten to restrict the imaginary domain and foreclose the possibility of an ethical response between women and fetuses, I argue that Levinas's distinction between ethics and politics helps us to work through this impasse, even if Levinas himself might not have supported a feminist approach to reproductive choice. In this final chapter, as throughout the book, I seek to recuperate an ethical and political space where the mother's gift of birth may be remembered, but also carried forth to Others—across the generations.

CHAPTER ONE

The "Facts" of Life: Beauvoir's Account of Reproduction

Giving birth has long been interpreted as a merely natural or biological process that, for this very reason, has only a negligible ethical and philosophical significance. A wolf makes another wolf; a human being makes (or remakes himself as) another human being. What does the *re-* signify in the word *reproduction*, if not this endless process of repeating the individual in the species, ceaselessly producing more of the same? In the *Symposium*, for example, Plato contrasts the carnal reproduction of children with the spiritual production of ideas and works of art, the latter of which are "lovelier and less mortal than human seed" (Symposium 209c). In this view, procreation is a less noble and more transient form of artistic or intellectual creation; the lover of wisdom secures for himself a greater fame than those who "turn to woman as the object of their love, and raise a family, in the blessed hope that by doing so they will keep their memory green, 'through time and through eternity'" (208e). If the difference between giving birth and creating a work of art or philosophy is simply a matter of leaving behind more or less enduring monuments to oneself, then Diotima's question is apt: "[W]ho would not prefer such [spiritual] fatherhood to merely human propagation" (209c)?

My guiding question in this chapter concerns the hierarchy between cultural production and natural reproduction, articulated in this passage from Plato but prevalent in the history of Western philosophy. Must we understand reproduction starting from the model of production? And if we concede that reproduction is a natural process in which one might be unintentionally involved, without prior choice and even without an immediate awareness of another existence taking shape in one's body, then in what sense can birth be understood as an event with ethical significance? Why should we expect reproduction to be any more philosophically interesting than digestion or respiration? Furthermore, if reproduction "happens" to men and women differently, then

does it condemn women in particular—as the sex who bears the fetus in her body, sometimes at the expense of her own health or comfort—to an existence overtaken by nature, condemned to repeat itself for the sake of the species?

Beauvoir takes up these and other questions in *The Second Sex*, with an ambivalence that has led some of her critics to conclude that Beauvoir herself viewed reproduction as a stumbling block for feminism.[1] In the section called "The Data of Biology," Beauvoir describes the female as "the victim of the species" (Beauvoir 1952, 18). Women's capacity to gestate a fetus seems to condemn her to an existence not quite her own: "First violated, the female is then alienated—she becomes, in part, another than herself" (19). This sense of alienation seems to make woman in particular the instrument of a larger force, to which her individuality is forced to submit: "The species takes residence in the female and absorbs most of her individual life; the male on the contrary integrates the specific vital forces into his individual life" (21). Worst of all, the woman may become an instrument for the social reproduction of values and institutions that contribute to her own maternal servitude; pleased with the attention and respect she gains as a mother, she may support the very practices that confine her value to motherhood.[2] It would seem, then, that for Beauvoir the only way to women's freedom is the way *beyond* maternity; reproduction is incompatible with the vision of an independent, self-transcending, and free individual.

While there is no shortage of textual support for this reading of maternity in *The Second Sex*, it nevertheless overlooks the wider context in which these remarks arise. Throughout *The Second Sex*, Beauvoir emphasizes the contingency of biological "facts" and their dependence on social sanction for their power and authority:

> But in truth a society is not a species . . . for the individuals that compose the society are never abandoned to the dictates of their nature; they are subject rather to that second nature which is custom and in which are reflected the desires and the fears that express their essential nature. It is not merely as a body, but rather as a body subject to taboos, to laws, that the subject is conscious of himself and attains fulfilment. (Beauvoir 1952, 33)

In this sense, there can be no *purely* biological account of the reproductive body; the "victim of the species" is also—if not primarily—subject to the social conventions that construct her as a victim, and present this construction as women's biological destiny.

One of Beauvoir's central tasks in *The Second Sex* is to distinguish between woman's biology—especially her reproductive capacity—and her social or psychological identity. While I may be born female, this category does not already define the woman I will become: "No biological, psychological, or economic fate determines the figure that the human female presents in society" (Beauvoir 1952, 249). And yet the fact remains that only female bodies (and not all female bodies) can become pregnant. To the extent that my embodied

situation shapes my existence in significant ways, the possibility of pregnancy will play a role in the social and personal experience of being a *woman*, and not only in the biological life of the female. Much depends on the way the "facts" of life are interpreted.[3] How do we distinguish between the female who is born and the woman she becomes without neglecting the sense in which women are also female? Furthermore, how do we account for the sexual specificity of pregnancy without implying that women can be known by their reproductive capacity alone?

My response to these questions turns on Beauvoir's interpretation of the body as a *situation* with both biological and cultural aspects. My body is not simply a discrete organism moving indifferently through the world, driven by its natural instincts or biological "programming." Whatever else it may be, my body is also the starting point for a world; it forms the material basis for my experience of things and my interaction with Others. From this perspective, sexual difference matters not because it determines my natural destiny, but because my embodied, sexed, and gendered perspective on the world informs my understanding: "For, the body being the instrument of our grasp on the world, the world is bound to seem a very different thing when apprehended in one manner or another" (Beauvoir 1952, 29). The body is my starting point for a meaningful world; but the meaning of my own body is not fixed in advance, nor is it completely up to me to decide. The natural and the cultural are not opposed in the experience of the body, but rather interwoven: "In the human species nature and artifice are never wholly separated" (476). From the moment I am born, my body is interpreted by Others who draw upon their own experience of the world, which in turn draws upon "that second nature which is custom" (33). In this sense, my starting point is never an absolute beginning; it enters a world that is already under way by the time I arrive.

As a situation, the body is always open to interpretation by oneself and others. This is both its danger (since my own preferred interpretation can be contested by others) and its promise (since no interpretation, however bleak, is absolutely incontestable). Where the body is understood as a situation to be interpreted, it remains open to a future of possibility; the task of interpretation is never completed, so "we can never close the books" on the meaning of sexual difference (Beauvoir 1952, 30). The ambiguity of this embodied situation informs Beauvoir's account of maternity:

> The bearing of maternity upon the individual life, regulated naturally in animals by the oestrus cycle and the seasons, is not definitely prescribed in woman—society alone is the arbiter. The bondage of woman to the species is more or less rigorous according to the number of births demanded by society and the degree of hygienic care provided for pregnancy and childbirth. Thus, while it is true that in the higher animals the individual existence is asserted more imperiously by the male than by the female, in the human species individual "possibilities" depend upon the economic and social situation. (Beauvoir 1952, 31)

On the one hand, "society alone" decides the value and significance of maternity; but, on the other, "it is true" that the female experiences reproduction differently from the male, and that her individual existence is more threatened by subordination to "the species." To say that the body is always interpreted in light of its a particular historical and existential situation is not to imply that the body is interpretation "all the way down." Moira Gatens argues for the importance of the material, factual aspect of bodies in *The Second Sex*: "To maintain, as Beauvoir does, that the capacities of the body— understood in naturalistic or biological terms—always require interpretation, is not equivalent to maintaining that the body is itself an interpretation or pure social construction" (Gatens 2003, 273). Rather, Beauvoir's analysis suggests "an interactive loop between bodies and values" (Gatens 2003, 274), which I now seek to elaborate in the particular context of maternity. Given the intertwining of bodies and values in maternity, how do we account for women's experience of maternity as a biological burden or an ethically significant gift—or both?

In what follows I will explore two possible interpretations of the ethical significance of maternity in Beauvoir's work. The first approaches reproduction from the perspective of existential ethics, focusing on the possibility of experiencing birth as a project and a choice. For the most part in *The Second Sex*, Beauvoir argues that this possibility is more open to men than to women, such that maternity appears mainly as a failed project, an unchosen submission of one's individuality. The second approach rereads *The Second Sex* in light of *The Ethics of Ambiguity*; it reconsiders the existential emphasis on individual transcendence and develops the ethical richness of ambiguity between self and Other, transcendence and immanence, activity and passivity, in the experience of maternity. In *The Second Sex*, it might seem that pregnancy threatens the freedom of the individual by burdening her with an Other who interferes with her projects and even alters her experience of her own body; but a different view of freedom emerges in *The Ethics of Ambiguity*. As Beauvoir explains, "An ethics of ambiguity will be one which will refuse to deny *a priori* that separate existants can, at the same time, be bound to one another" (Beauvoir 1964, 18). Here, the freedom of the self is not opposed to the Other, but rather *requires* the freedom of Others to whom it is nevertheless ambiguously bound. From either perspective, Beauvoir's text does not claim to tell the meaning of reproduction *as such*, but rather to describe the predominant experience of pregnancy in different situations. As I will argue, the experience of maternity as a failed project or an unchosen submission is not a biological fact, but rather a "truth" produced by the particular situation of sexist oppression. This reading is substantially informed by the social and temporal structure of oppression as described in *The Ethics of Ambiguity*. On the basis of this reading, I argue that the way beyond women's oppression involves a reinterpretation—and not a repudiation—of maternity as an ethical situation.

TAKE 1: BIRTH AS A PROJECT

Beauvoir announces her perspective of existentialist ethics in the introduction to *The Second Sex*:

> Every subject plays his part as such specifically through exploits or projects that serve as a mode of transcendence; he achieves liberty only through a continual reaching out toward other liberties. There is no justification for present existence other than its expansion into an indefinitely open future. . . . Every individual concerned to justify his existence feels that his existence involves an undefined need to transcend himself, to engage in freely chosen projects. (Beauvoir 1952, xxviii)

While the past confronts me with its burden of given conditions and factical constraints, the future opens up a field of possibilities in relation to which even my past may be transformed. Through my projects, I transcend the present moment and orient myself toward an open future in which I *am* nothing other than what I *choose to become*. The project of femininity is contradictory because the woman—"a free and autonomous being like all human creatures—nevertheless finds herself living in a world where men compel her to assume the status of the Other" (Beauvoir 1952, xxviii). As the Other of man, woman's individual existence is defined in advance as the negation or lack of masculinity; even her potentially transcendent activities are directed toward the goal of passivity and immanence.[4] The feminine woman is a subject forced to masquerade as an object to be valued by men, and even by other women. But while the framework of existentialist ethics allows Beauvoir to challenge any notion of a fixed feminine essence, it poses problems for a feminist interpretation of birth; reproduction resists conforming to the structure of a freely chosen project. Beauvoir claims that "in any case giving birth and suckling are not *activities*, they are natural functions; no project is involved; and that is why woman found in them no lofty affirmation of her existence—she submitted passively to her biologic fate" (57). While we may contest Beauvoir's verdict on parturition and breast-feeding [recalling that even Freud sees the latter as an activity (Freud 1965, 143)] we may still take Beauvoir's point that birth involves an irreducible element of passivity. In giving birth, my body and even my own future are bound to an Other in ways that are not for me alone to decide. Even when I am explicitly trying to become pregnant, I cannot *make* myself so, nor can I choose the particular child who grows inside me.[5] Does this resistance to choice cast a shadow over women's reproductive capacity, setting a limit to women's transcendence? Or does it open a different, less virile, and more thoroughly intersubjective approach to existential ethics?

Beauvoir claims that, in most animals, the female of the species bears a greater reproductive burden than the male. The pregnant body is like a hostage to the fetus, taken over by someone other than herself whom she did not consciously choose, but with whom she is in the closest proximity. Unlike the

male, she is forced—at least in the absence of decent reproductive choices—to nourish this child with her own body before and after birth, sometimes at great expense to her own health. By contrast, the male body seems to transcend itself in coition, losing nothing essential with its ejaculation of sperm. With this brief gesture, the male creates something outside of himself, something "other" that will outlive his own mortal body without making an immediate claim on his autonomy. This bodily detachment from the gestating child would seem to make possible a more abstract and "free" relation to parenthood as a project freely undertaken rather than a process undergone in passivity. The child whom the male helps to create—and whom, thanks to the laws and conventions of paternity, he can then call "his own"—does not nest inside his own body. It does not change his shape, disturb his sleep, or kick against his skin. Indeed, the male of the species need not even claim this offspring as his own; he has the freedom to "choose" or deny parenthood, while the biological mother of the child is obvious for all to see.

Beauvoir considers the possibility that differences in male and female sexuality might produce different relationships to the process of reproduction and even different configurations of individuality and community:

> Immediate, direct in the female, sexuality is indirect, it is experienced through intermediate circumstances, in the male. There is a distance between desire and satisfaction which he actively surmounts; he pushes, seeks out, touches the female, caresses and quiets her before he penetrates her. . . . This vital superabundance, the activities directed toward mating, and the dominating affirmation of his power over the female in coitus itself—all this contributes to the assertion of the male individual as such in the moment of living transcendence. (Beauvoir 1952, 20)

While this preference for transcendence in the male may be cultural as much as it is natural, nevertheless the implication here is that men have a better chance than women of experiencing reproduction as an active project that enhances their individuality—and, moreover, that this experience is clearly preferable to the passivity of bearing a fetus in one's body. As in Plato's *Symposium*, reproduction would be a more carnal and ultimately less reliable form of transcendence—but only for the man. For the woman, even this carnal transcendence would remain difficult. As Beauvoir describes it, birth can leave a woman exhausted, misshapen, malnourished, emotionally unstable, and possibly even dead (Beauvoir 1952, 24). Pregnancy does not always accommodate itself to the women's own projects; it does not admit a bodily distance between self and other, or between the maker and the made, by virtue of which the reproducing woman could rise above her "product." It would seem that, while production conforms to the will of the producer, reproduction happens depite the one whom it nevertheless requires.

Temporally, the pregnant body "assumes transcendence, a stirring toward the future, the while it remains a gross and present reality" (Beauvoir 1952, 467).

To produce is to make something new; to reproduce is to make more of the same, binding the future to the present and past. Beauvoir describes this temporal difference in sexual terms; while the man injects creativity into time with his contribution to reproduction, the woman merely maintains its continuity:

> To maintain is to deny the scattering of instants, it is to establish continuity in their flow; to create is to strike out from temporal unity in general an irreducible, separate present. And it is true that in the female it is the continuity of life that seeks accomplishment in spite of separation; while separation into new and individualized forces is incited by male initiative. The male is thus permitted to express himself freely; the energy of the species is well integrated into his own living activity. On the contrary, the individuality of the female is opposed by the interest of the species; it is as if she were possessed by foreign forces—alienated. (Beauvoir 1952, 22)

Excluded from warfare and confined to the inglorious task of raising children, women become the instruments of continuity while men grasp hold of the future on the strength of their own actions. Here, the father would seem to introduce separation and individuality into an otherwise continuous relation between mother and child; he interrupts the flux of "life" to make novelty and initiative possible.[6] While this alteration offers freedom and transcendence for the male, it traps the female of the species in immanence, offering her no way out of embodied, factical existence. With each successive pregnancy, the mother is "plunged anew into the mainstream of life, reunited with the wholeness of things, a link in the endless chain of generations, flesh that exists by and for another fleshly being" (Beauvoir 1952, 467). Precisely because the male body is not directly implicated in the process of reproduction—because he exists in and for himself, rather than by and for another—he seems to have a greater chance of viewing birth as a form of creative self-expression. To Beauvoir, the implication of female flesh in the very process of reproduction suggests a lack of autonomy on the part of the pregnant woman; even if a woman looks forward to childbirth and finds a kind of dignity or power in her capacity to give birth, "this is only an illusion. For she does not really make the baby, it makes itself within her; her flesh engenders flesh only, and she is quite incapable of establishing an existence that will have to establish itself" (468). Where authenticity is tied to my free engagement in projects, it would seem impossible for women to have an authentic experience of giving birth, except perhaps with the help of reproductive technology that lets her achieve a more distanced, disembodied relation to birth. But would the female experience of reproduction become authentic only to the extent that it approximates the male? Here we reach a stumbling block: not with reproduction as such, but with the existential interpretation of birth as a project of transcendence.

The interpretation of pregnancy as a failed existential project does not allow the pregnant woman to appear as anything more than the pawn of impersonal, natural forces. By implication, any relation with the mother becomes a

nonhuman, amoral relation with a natural force that is trapped in immanence, but for this very reason also threatens to overwhelm the child's own transcendent individuality. For even the producer of intellectual genius has been reproduced; even the solitary existentialist has been gestated in the body of a woman. Not only does maternity itself resist interpretation as a project, but where existence is defined in terms of active, transcendent projects, then even my relation to the mother would seem to thwart my independence. Proximity to her body reminds me that I am not the origin of myself, that the freedom promised to me by the open possibilities of the future is also threatened by the facticity of the past. In this sense, the gift of birth is also the curse of death; from the moment I am born, I begin dying. The mother comes to symbolize both the source of all goodness and the source of all possible deprivation: "Now ally, now enemy, she appears as the dark chaos from which life wells up, as this life itself, and as the over-yonder toward which life tends" (Beauvoir 1952, 134). Where the mother is identified with the unending cycle of repetition that human projects seek to master, there remains little hope for an ethical relation between man and woman, or even between mother and child. Beauvoir explains: "Man seeks in woman the Other as Nature and as his fellow being. But we know what ambivalent feelings Nature inspires in man. He exploits her, but she crushes him, he is born of her and dies in her; she is the source of his being and the realm that he subjugates to his will" (Beauvoir 1952, 134). In the mythic figure of Woman as Mother, birth and death are joined together in an endless circle from which the child must escape if he is to survive.[7]

If the child is understood to begin in this seductive but disabling unity with the mother, then we should not be surprised to hear that the fundamental project of existence is to transcend birth, to *produce* reproduction on my own terms, as if I had created myself from the ground up, as if I had given birth to myself. Only by repeating or reclaiming birth does the subject lay claim to an existence of *his own*, in which he is no longer trapped in the body of the mother. Of the child, Beauvoir writes:

> He would like to have sprung into the world, like Athena fully grown, fully armed, invulnerable. To have been conceived and then born an infant is the curse that hangs over his destiny, the impurity that contaminates his being. And, too, it is the announcement of his death. . . . The Earth Mother engulfs the bones of her children. (Beauvoir 1952, 136)

To be born to an Other is—at least in this context—to be doomed to passivity, contingency, and death.[8]

In *Being and Nothingness*, Sartre takes this idea to its limit, arguing that even my own birth is a kind of retrospective choice, in the sense that I alone decide the significance that birth will hold for me:

> Someone will say, "I did not ask to be born." This is a naïve way of throwing greater emphasis on our facticity. I am responsible for everything, in

fact, except for my very responsibility, for I am not the foundation of my being. . . . Yet I find an absolute responsibility for the fact that my facticity (here the fact of my birth) is directly inapprehensible and even inconceivable, for this fact of my birth never appears as a brute fact but always across a projective reconstruction of my for-itself. I am ashamed of being born or I am astonished at it or I rejoice over it, or in attempting to get rid of my life I affirm that I live and assume this life as bad. Thus in a certain sense I *choose* being born. (Sartre 1956, 556)

While Sartre acknowledges that "I am not the foundation of my being," he argues that this very fact compels me to *assume* my own foundation, as if I had chosen it for myself. The opacity of my birth calls not for a recognition of its strangeness but for a "projective reconstruction" in which I decide the meaning that this undecidable, potentially meaningless fact will have for me. For Sartre, birth is tantamount to abandonment; "I find myself suddenly alone and without help, engaged in a world for which I bear the whole responsibility without being able, whatever I do, to tear myself away from this responsibility for an instant" (Sartre 1956, 556). This responsibility is inescapable, since whether I find my existence joyful or hateful, my subjective response remains the final arbiter of its meaning. Sartre explains: "We are taking the word 'responsibility' in its ordinary sense as 'consciousness (of) being the incontestable author of an event or object.'" (530). Precisely because I am author of my own existence, "everything that happens to me is mine" (530). I make the facts of life my own by "making myself," by "stamping" any given situation "with my seal" (531). Responsibility for my existence derives precisely from this *ownness*, from this act of self-production; I made myself by choosing my relation to birth, and *therefore* I am responsible for my own existence.

But precisely here, in this proud assertion of self-authorship, the significance of my birth to a mother is reduced to the status of raw material waiting to bear my stamp. If my birth is a project undertaken in retrospect, then reproduction in the body of a woman is at best a condition for my own self-production and at worst a factical hindrance to my own existential freedom. From this perspective, an ethical relation to maternity would seem impossible. Either the child authors its own existence, in which case the mother hardly matters as an Other who *gives* birth; or else the mother authors the child, in which case (presuming she is able to achieve the transcendence necessary for such a project) the child could not be any more responsible or free than a product or a work of art. But is there not something important to be learned from the sense in which birth is *not* chosen, but rather given by an Other? This gift need not appear to the child as a humiliating insult to its freedom, a passivity to be overcome; nor must it appear to the mother as a failed project, tainted by biological processes that alter her body and resist conforming to her will. As Beauvoir herself writes, "The close bond between mother and child will be for her a source of dignity or indignity according to the value placed upon the child" (Beauvoir 1952, 33). The same could be said for the

value placed on the mother, and for the interpretation of birth itself. In the next section, I will take a different approach to the relation between mother and child, reinterpreting the value of embodied ambiguity not as a threat to freedom and responsibility, but as their very condition.

TAKE 2: BIRTH AS AN AMBIGUOUS SITUATION

While the existentialist perspective is by no means absent from *The Ethics of Ambiguity*, it is significantly modified by an insistence on the intersubjectivity of freedom.[9] For Beauvoir, "it is other men [and women] who open the future to me," sketching out possibilities which I alone could not have imagined for myself (Beauvoir 1964, 82). Freedom requires a sense of the future as open and indeterminate, a time whose significance is decided neither by facticity nor by my own subjective projects and choices. Rather, freedom requires a plurality of Others in relation to whom the future becomes meaningful as a horizon of incalculable possibilities; precisely because I am not the only one in the world, I do not know what the future will bring. Others may respond to my projects in unforeseen ways, or their own projects may implicate me in dramas I could have never anticipated. In this sense the solitary, isolated individual of existentialist literature may be unrestricted by Others, but he is not for this reason free: "No man can save himself alone" (62). Freedom becomes significant only in a social and ethical situation that sustains ambiguity rather than resolving it through a final arbiter or author of meaning. This ambiguity of intersubjective life suggests a horizon beyond my own narrowly subjective view; it keeps the temporality of my existence open beyond the future sketched out by my own projects. Beauvoir argues that, because my freedom arises through a collaboration with Others, I cannot be truly free if there are Others who remain oppressed; "[t]o will oneself free is also to will others free" (73). This is not to say that my freedom is therefore guaranteed by the existence of Others, nor even by my desire for the Other's freedom. For other people can also exclude me from full participation in the world, cutting me off from an open future and reducing my singular existence to a static function of my race, my class, my sex. The ambiguity of existence is also a risk; it suggests that the meaning of one's life "is never fixed, that it must be constantly won" (129). The Other is indispensable for my freedom, but the Other can also become my oppressor.

On this reading of Beauvoir, transcendence is not clearly preferable to immanence; the ambiguity of existence involves "both perpetuating itself and . . . surpassing itself" (Beauvoir 1964, 82). My freedom is grounded in facticity, and transcendence necessarily refers to the immanence of a situation that can be transformed but never completely overcome. Oppression attempts to deny this ambiguity, splitting transcendence from its conditions and reserving the privilege of freedom for a select few. "Oppression divides the world into two clans: those who enlighten mankind by thrusting it ahead of itself and those who are condemned to mark time hopelessly in order merely to support

the collectivity; their life is a pure repetition of mechanical gestures" (83). This temporality of oppression vividly recalls Beauvoir's account of reproduction, in which the world is divided into two sexes: the men who transcend and the women who are doomed to immanence, defined in advance by their natural capacity to reproduce the species and maintain its continuity. It also recalls her description of women's work in the home as a series of endless tasks whose effect is simply "marking time: [the housewife] makes nothing, simply perpetuates the present" (Beauvoir 1952, 425). The analysis of oppression in *The Ethics of Ambiguity* allows us to read these descriptions of women's reproductive labor in a different light; rather than illuminating a natural or ontological truth about women, they point to a situation of sexist oppression, in which the ambiguity of women's existence is denied and even cited as a source of their "natural" subordination to men. Of course, "one of the ruses of oppression is to camouflage itself behind a natural situation since, after all, one cannot revolt against nature" (Beauvoir 1964, 83). Women's enslavement to the species, then, might be already an effect of social and political oppression rather than one of its root causes. Where the future of women *as women* is blocked in this way, it would be no surprise if her most sexually specific experiences appeared as an endless repetition of the same. The point is not only that women's bodies appear immanent, repetitive, and unfree under patriarchy; it is that they appear inevitably and *unambiguously* so, with no possibility of a different or indeterminate future. Given Beauvoir's analysis of oppression, the most compelling path of resistance would not be to claim transcendence for oneself, thus gaining access to the realm of those who "enlighten mankind by thrusting it ahead of itself," but rather to enhance and empower the sense of ambiguity between transcendence and immanence, freedom and facticity, surpassing and perpetuating.

This empowerment implies a temporal and ethical existence whose significance remains open and indefinite, whose meaning "must be constantly won." For Beauvoir, the oppressor

> defends a past which has assumed the icy dignity of being against an uncertain future whose values have not yet been won; this is what is well expressed by the label 'conservative.' As some people are curators of a museum or a collection of medals, others make themselves the curators of the given world; stressing the sacrifices that are necessarily involved in all change, they side with what has been over against what has not yet been. (Beauvoir 1964, 91)

A woman who is reduced to her reproductive capacity is oppressed in this sense: not because reproduction itself makes her unfree, but because the meaning of her life has been defined in advance by one of its many aspects. In *The Second Sex*, Beauvoir writes: "Woman is not a completed reality, but rather a becoming. . . . What gives rise to much of the debate is the tendency to *reduce her to what she has been, to what she is today*, in raising the question of her capabilities" (Beauvoir 1952, 30; my emphasis). In reducing the becoming of

woman to a static form of being, sexist oppression denies women the possibility and the risk of an open-ended future; it restricts her existence to the "reality" of past and present, in relation to which birth may appear as a failed project of transcendence. Ironically, the very ambiguity of pregnant embodiment that posed problems for its interpretation as an existential project also suggests a possibility for *resisting* oppression and holding open a future of becoming for women, whether or not they decide to reproduce. In what follows, I explore the possibility of understanding pregnancy as "the strange ambiguity of existence made body" (Beauvoir 1952, 685) in order to shed a different light on the ethical significance of birth.

In *The Second Sex*, the pregnant woman feels "the immanence of her body at just the time when it is in transcendence" (Beauvoir 1952, 467).[10] It is difficult to say where the pregnant woman ends and the gestating child begins, yet the very possibility of alienation in pregnancy suggests that there is always already a difference between mother and child even in the midst of ambiguity. Beauvoir writes:

> Tenanted by another, who battens upon her substance throughout the period of pregnancy, the female is at once herself and other than herself; and after the birth she feeds the newborn upon the milk of her breasts. Thus it is not too clear when the new individual is to be regarded as autonomous: at the moment of fertilization, of birth, or of weaning? (Beauvoir 1952, 19)

The woman who gives birth is both herself and an Other, both altered by pregnancy and still maintaining a sense of difference from the fetus. Beauvoir draws attention to the strangeness of this situation, where an Other whom I have never met and about whom I know almost nothing, is nevertheless formed within my body, in closest proximity to me. While the child is mine to bear and perhaps to raise, he still remains unknown to me: "Everything he experiences is shut up inside him; he is opaque, impenetrable, apart; [the mother] does not even recognize him because she does not know him. She has experienced her pregnancy without him: she has no past in common with this little stranger" (Beauvoir 1952, 478). This strangeness need not signify alienation; as I will argue in my reading of Levinas, the otherness of the child opens a future that is not my own, and for this very reason makes an ethical response to birth possible.

On my first reading of *The Second Sex*, pregnancy seemed to disclose a future in which the pregnant woman herself did not figure, and in which she could only participate by dissolving herself into the "whole," the "species," the swelling rhythm of "life." Beauvoir concludes: "Woman, like man, *is* her body; but her body is something other than herself" (Beauvoir 1952, 26). A woman's body may or may not be for her a reliable tool for mastering the world or attaining transcendence. And yet this ambiguity—in which woman *is* her body, but her body is *other* than herself—suggests a more complex sense of the embodied self than one might draw from the subject who uses his body as an instrument. Perhaps Beauvoir's sense of a woman *being*, but not possessing or

controlling, her body—and her sense of pregnancy opening up a future that is not quite *her own*—can be understood not merely as a sign of alienation or absorption into the species, but rather as the possibility of incarnate Being-for-the-Other, of a feminist ethics *in the flesh*. This possibility requires a commitment to the freedom of Others, where freedom is understood not as the right to choose one's own birth but rather as the openness of an indeterminate, ambiguous, and intersubjective future.

At first glance it would seem that Beauvoir finds little, if any, promise in becoming "flesh that exists by and for another fleshly being" (Beauvoir 1952, 467). But could we not reconsider the significance of this flesh, and even the significance of prepositions such as "by" and "for"? Rather than understanding the maternal body as "plunged into the mainstream of life" (467), immersed in the continuity of the species, could we not find in this body that exists *by* and *for* another body the figure of a self who is born and gives birth, a body whose flesh signifies not the continuity of the species but rather the abrupt discontinuity of responsibility for an Other?[11] It is not clear that autonomy and projection are the best categories for feminist change, or for understanding what it means to give birth to an Other. The ambiguity of the pregnant body need not force the alienation of the self; it may suggest a different sort of transcendence, not *of* the self but *toward* the Other. It is not necessarily a bad thing to "deny the proud singularity of the subject" (151); such a denial need not amount to merely an assertion of our enslavement to the species.

It is certainly possible to interpret *The Second Sex* as a lament for the failed project of reproduction. But this interpretation would underestimate the ethical significance of ambiguity in Beauvoir's work, and even in her account of maternity. I have argued that reproduction is not best understood as a mode of production whose aim is to repeat the self or extend its existence beyond death, "through time and through eternity" (Symposium 208e). Rather, to give birth is to bring an Other into the world: a distinct self with her own future, her own embodied existence, and even her own capacity to reproduce. In this sense, birth introduces something—or someone—utterly and unrepeatably new into the realm of the familiar. The daughter has her mother's eyes, her father's smile, yet she is more than the sum of her parents and different from anything they might have made for themselves. Reproduction takes place in this ambiguous nexus between present and future, nature and culture, passive reception and active engagement. As Colette Audry writes of her son:

> His life had germinated within me, and, whatever might happen, I had to bring this development to term, without being able to hurry things even if it meant my death. Then he was there, born of me; thus he was like a piece of work that I might have done in life . . . but after all he was nothing of the kind. (cited in Beauvoir 1952, 468)

The gestation of a child takes its own time; except in fantasy and mythology, there is no sudden moment of inspiration in which the child springs fully

formed from the head of its creator. But this duration of time, this slow germination, also takes on a life of its own, an otherness of which I am the facilitator but not the cause. There is nothing of which this new child is "the kind"; yet he or she nevertheless comes from me, emerging in time from my own body. This surprise, this upsurge of the strange in the midst of the familiar, marks an ontological but, more important, an *ethical* ambiguity that I will now explore in the work of Hannah Arendt.

CHAPTER TWO

The Body Politic:
Arendt on Time, Natality, and Reproduction

A new self emerges from the body of an Other; a new future begins, already leaving the past in its wake. At the moment of birth, someone utterly new comes into the world, and a unique life story begins to unfold. The narration of this story does not rely exclusively on the direct experience and memory of the one who is born; for the beginning of my own life is like a blank that can only be filled in—and then only partially—by stories that other people tell and repeat. Paradoxically, my own autobiography does not begin for me at the moment of birth, but only filters down to me later as a story told by an Other. My mother says, *It was the coldest night of the year, everyone had red noses.* My father says, *The doctors wouldn't let me into the delivery room! Things were different back then.* Listening to these stories, I learn about my beginning in birth only after this moment has receded into the past, and only through the mediation of others who have cared to pass on the story. This preliminary fact of a birth that does not quite belong to me, and behind which my existence is somehow delayed, suggests a complication in the time of existence. Time does not unravel like a ball of yarn, from beginning to end; nor does it spring ecstatically from the end to the beginning, recapturing the moment of birth with an existential gesture that would claim it as "my own." For even if I represent my birth as chosen or made—as if I had authored my own existence—I am nevertheless confronted by the sense in which this version of the story is only possible after the fact, once the moment of birth has already slipped away and countless other versions have already been told. The more I hear these stories about my birth, the more familiar I become with my own autobiography. I may feel like I remember these early events that "make for me a beginning," but what I remember are the stories; new memories have grown up around photographs, old toys, and bits of clothing to the point where I, too, can recite the story or correct it when the details don't match up.

In her book, *The Human Condition*, Hannah Arendt develops the concept of natality to explain this birth of a self who is both new and familiar, and whose identity is constituted through a web of interwoven narratives.[1] For Arendt, we are all "newcomers who are born into the world as strangers" (Arendt 1958, 9). The birth of any given child has never happened before and will never happen again; as such, it resists both expectation and exact repetition. With the concept of natality, Arendt catches sight of the extraordinary renewal of time in birth: a renewal that is made possible by the fact that we are not born to ourselves but to a mother and into a community of Others. Birth marks both the *initiative* or new beginning of someone new, and the *initiation* of the self into a world where Others are already there in a particular place, at a particular point in history, awaiting the arrival of someone new. In this sense my birth is both found and claimed, both accidental and open to a range of different intentions. To put this somewhat differently, I am both given existence at birth and also given the chance to take up this existence in a new or even revolutionary way. While Arendt develops the innovative or revolutionary aspect of this tension within natality, I argue that she underestimates the sense in which birth is passively given to me in a way I do not initially choose or control. Despite her insightful interpretation of birth's temporality in terms of forgiveness and promise, Arendt stops short of thinking through natality in its most radical, embodied passivity before a woman who *gives* birth to me. This imbalance is connected to Arendt's general neglect of sexual difference and, more specifically, to her negative account of the politics of reproduction in the private realm of women, in distinction from the politics of "natality" in the public realm of sexually neutral "citizens." In the end, Arendt's own concept of natality requires a feminist critique of the opposition that Arendt herself upholds between nature and politics, private and public, labor and action, reproduction and natality. Writing almost half a century later than Arendt, Adrianna Cavarero addresses this threefold neglect of passivity, sexual difference, and reproduction in her books, *In Spite of Plato* and *Relating Narratives*. Toward the end of this chapter I draw on Cavarero's work to suggest a feminist approach to natality that is both embodied and political, both reproductive and nonrepetitive.

Arendt's analysis of natality finds both its strength and its limitation in the concept of *action*, which is conditioned by birth and also endows it with political significance. While work produces things or artifacts that endure over time, and labor processes the matter for biological existence, action cuts across work and labor, giving rise to the political realm in which action itself takes place. As the condition for action, natality implies a plurality of Others who, as natal creatures, come into the world as newcomers and strangers. This plurality "is the condition of human action because we are all the same, that is, human, in such a way that nobody is ever the same as anyone else who ever lives, lived or will live" (Arendt 1958, 8). Each of us is born into the world as this one, this indivisible and irreplaceable person. Despite the categories to

which I belong even before the moment of birth—nationality, language, race, sex, and so forth—I remain irreducible to these categories thanks to my singular emergence into the world at this particular moment in time. As a stranger and newcomer, I am given the capacity to begin or initiate action with other natals. This capacity to act or to begin something new, to start another chapter in my life story, introduces a dimension of contingency and surprise into finite existence. Arendt writes:

> The life span of man running toward death would inevitably carry everything human to ruin and destruction if it were not for the faculty of interrupting it and beginning something new, a faculty which is inherent in action like an ever-present reminder that men, although they must die, are not born in order to die but in order to begin. (Arendt 1958, 246)

With these words, Arendt turns the existentialist account of finitude on its head. Birth is not merely a factical burden whose significance is disclosed in relation to one's ownmost death; rather, birth itself interrupts the fatality of death by beginning something new. Arendt argues that "since action is the political activity par excellence, natality, and not mortality, may be the central category of political, as distinguished from metaphysical, thought" (Arendt 1958, 9). By shifting her attention from existence to action, and from metaphysics/ontology to politics, Arendt brings natality to the fore as a serious philosophical and practical concept.[2]

Action undertaken by natals coexisting in a pluralistic political world interrupts the ruin of mortal time; it puts pressure on the notion of a national(istic) political "destiny" and introduces into history the possibility of renewal and regeneration. Here, action does not refer merely to the actualization of given possibilities or to the projection, anticipation, or repetition of these possibilities. Instead, to act is both to *initiate* something new and to *be initiated* into a world that is already given, and in which I cannot help but inter-act with Others. As Arendt writes in her later work, *The Life of the Mind*, "To be alive means to live in a world that preceded one's own arrival and will survive one's own departure" (Arendt 1978, I:20). Action implies a world that does not belong to me so much as I belong to it; for "we are of the world and not merely in it" (I:22). In this shared world, every initiative is already a response to someone, every action already an interaction with Others who precede or follow me. Precisely because "the actor always moves among and in relation to other actor beings, he is never merely a 'doer' but always and at the same time a sufferer" (Arendt 1958, 190). Thus, action is not merely the activation of my own spontaneous will, but rather a fragile negotiation between activity and passivity, spontaneity and affectation.

This negotiation implicates the natal self in a situation with a plurality of human actors, each of whom has different interests, possibilities, and limitations. In this sense, action "corresponds to the human condition of plurality, to the fact that men [and women], not Man, live on the earth and inhabit

the world" (Arendt 1958, 7).[3] No one is born alone, and no one acts alone—despite what the autonomous individual may intend or desire. As soon as I initiate an action, I find myself initiated into a complex interaction with Others whose response I cannot control or anticipate. "Since action acts upon beings who are capable of their own actions, reaction, apart from being a response, is always a new action that strikes out on its own and affects others. Thus action and reaction among men never move in a closed circle and can never be reliably confined to two partners" (190). Even the smallest action exceeds its own limits, overflows its established boundaries. Action is distinguished from existential choice by the sense in which it demands (and does not merely tolerate) the participation of other actors over whom I have no control, and from whom I cannot extricate myself without abdicating a human existence. I can never take full possession of my "own" actions; I can only perform them, and in this performance my actions are received by an audience of other performers who interpret them in different ways. Natality is a condition for action not only because it allows me to begin something new, but also because it prevents me from either finishing or escaping whatever I begin. There is always a residue or excess of action that accompanies the one who acts and prevents the actor from grasping himself or herself as a whole. This residue is not something inherent in the ontology of the self; rather, it emerges thanks to the plurality of Others who respond and interact with me, redirecting my own action along unexpected paths. Thus, the human world—the public, political, and historical world—is a world of incompletion; for that very reason, it is granted the possibility of a difference that emerges in the midst of the same, a new and inconclusive future that arises from our shared relation to the past. Each action remains bound to the past that helped to form its particular circumstances; but, as a new initiative, action also departs from the past in ways that are not strictly or univocally determined by it. I can never take back or erase my own actions; "men have never been and will never be able to undo or even to control reliably any of the processes they start through action" (Arendt 1958, 233). But this is precisely what distinguishes action from labor and work within the *vita activa*.

VITA ACTIVA: LABOR, WORK, ACTION

The *vita activa* is a life of active engagement with other people and the world.[4] Arendt distinguishes between three different activities within the active life: labor, work, and action. In what follows, I consider the different aspects of birth from the perspective of each category—as reproduction, production, and natality, respectively—by focusing in particular on their temporal structure.

The most immediate aspect of the *vita activa* is labor. For Arendt, labor refers to the basic activities that sustain the biological life of the human body: processes such as growing food, tending sheep, baking bread, and reproducing the species. The need for labor renews itself constantly, and so its tasks must

be repeated endlessly; they cannot be accomplished once and for all.[5] As such, labor remains caught in a circular temporality; every day we eat, every fall we take in the harvest, every generation we give birth to a new generation. By virtue of this cyclical temporality, the laborer or *animal laborans* remains closely tied to its own body and to the bodies of others. The labor of the maternal body in particular appears within a time of endless natural repetition lacking in direct political significance for Arendt. A footnote points out that all European words for "labor" carry the double significance of pain and exertion on one hand, and childbirth on the other.[6] In ancient Greece, where the public realm flourished, laboring women and slaves were hidden away in the private sphere: "not only because they were somebody else's property but because their life was 'laborious,' devoted to bodily functions" (Arendt 1958, 72). Both the manual labor of slaves and the reproductive labor of women partake of the same cyclical temporality; as such, neither has a place in the public sphere of the *polis*, though they may indeed support this sphere invisibly. Arendt distinguishes sharply between the essentially private, natural, or "animal" labor that deposits me onto the earth, and the action (conditioned by natality) that initiates me into a public, political—and therefore *human*—world. For these reasons, it would seem that while the biological birth of a child reproduces the species, it does not yet unfold the full dimensions of natality.

Viewed from this perspective, reproduction appears as an endless, monotonous repetition, not unlike the cyclical temporality of birth in *The Second Sex*. A woman's reproductive labor gives birth to new laborers, who will grow and reproduce more laborers, who will continue to do the same. This circularity blurs the distinction between birth, death, and rebirth; it unravels the edges or limits that give meaning to the human condition, threatening a lapse into ahistorical, animal existence.

> Cyclical, too, is the movement of the living organism, the human body not excluded, as long as it can withstand the process that everywhere uses up durability, wears it down, makes it disappear, until eventually dead matter, the result of small, single, cyclical, life processes, returns into the over-all gigantic circle of nature herself, where no beginning and no end exist and where all natural things swing in changeless, deathless repetition. (Arendt 1958, 96)

To the extent that we regard birth as a form of labor and reproduction, there is no individuality, no meaningful distinction between self and Other; one face blurs into the other. This anonymity traps the *animal laborans* in its own private world; without a distinction between you and me, there can be no "we," no public dialogue between equals, no *polis* and no politics. All that binds us to one another is our common attachment to the life force that repeats itself through us, mindlessly issuing endless copies of the same without beginning or end. Arendt associates the apparent indistinction of biological life with a female reproductive body and a feminine (if also impersonal) nature. She writes:

Nature and the cyclical movement into which she forces all living things know neither birth nor death as we understand them. The birth and death of human beings are not simple natural occurrences, but are related to a world into which single individuals, unique, unexchangeable, and unrepeatable entities, appear and from which they depart. (Arendt 1958, 96–97)

Human—that is, public, political, and nonreproductive—birth tells a story that is different from the eternal repetition of nature. More important for Arendt, it *tells a story*, distinguishing the *bios* or biography of a human being from the *zoë* of its natural, physiological processes. The relentless drive of reproductive labor threatens the human significance of natality and action, even while it forms their most basic condition. For Arendt, reproduction acquires a human, biographical significance—and indeed, its significance as *natality*—only insofar as it is lifted from the context of natural, feminine labor and woven into the narrative, historical fabric of a public world that is constituted by action and supported by durable works. For Arendt, "Birth and death presuppose a world which is not in constant movement, but whose durability and relative permanence makes appearance and disappearance possible, which existed before any one individual appeared into it and will survive his eventual departure" (Arendt 1958, 96–97). This stable, human world arises not through the circular time of labor but through the linear time of work.

Work produces a well-defined product that endures over time, an artifact that is not meant to be consumed in the process of life but rather to transcend its instability and impermanence. A chair, a painting, a skyscraper: each of these is a product of work, cutting across the circularity of labor to establish the world as the home of distinctly human beings. In this sense, work helps to constitute a public realm, a world in common. This chair is not only there to sustain my life like an apple or a loaf of bread; rather, it is there for all of us to use and is meant to outlast any given individual. Unlike the feminine *animal laborans* who remains trapped in the cycle of labor, *homo faber* rises above his own activity, gaining mastery over his circumstances through work. *Homo faber* does not merely accommodate himself to the circumstances of life but works to shape and remake the found world, bending it to his own use through an instrumental logic of means and ends. Without work there can be no stability, no "reliable home for men" upon the earth (Arendt 1958, 167), no objective world against which the subject might stand *as* a subject. Arendt writes that human beings, "their ever-changing nature notwithstanding, can retrieve their sameness, that is their identity, by being related to the same chair and the same table" (137). The identity of the same, and the coherence of one's life story, rely on this fabricated world constructed on the earth through work.

Work not only builds on the materiality of labor; it also violently opposes it. For Arendt, work inevitably requires an "element of violation and violence" such that *homo faber* "has always been a destroyer of nature. The *animal laborans*, which with its body and the help of tame creatures nourishes life, may be lord and master of all living creatures, but he still remains the servant of nature

and the earth; only *homo faber* conducts himself as lord and master of the whole earth" (Arendt 1958, 139). This violence is justified so long as it is exerted for the sake of maintaining a world: "The end justifies the violence done to nature to win the material, as the wood justifies the killing of the tree and the table justifies destroying the wood" (153). However, this justification of means by their ends can easily slip into a self-justification of violence and a reduction of all things—including the world itself, which work is meant to support—to means for an ever-receding end.[7] Indeed, Arendt detects in the instrumental logic of work a "rebellion against human existence as it has been given, a free gift from nowhere (secularly speaking), which he wishes to exchange, as it were, for something he has made himself" (Arendt 1958, 2–3). She warns of the temptation to overcome the contingency of existence by making or refashioning what has already been given, thus claiming mastery over the world of human affairs and destroying the contingency of action. In work, "one man, isolated from all others, remains master of his doings from beginning to end" (220). If I can conceive of myself as something made or self-made rather than someone born, then I might be able to control the terms of my existence from beginning to end, as if I were both the project and the engineer of my own existence. Where birth is understood in terms of work, as a task of production or self-production, the distinction between justified and unjustified violence can become blurred. Evelyn Fox Keller notes the perversity with which even instruments of death and destruction can be viewed as "children" to whom their producers have "given birth." She draws attention to the way scientists and politicians referred to the atom bomb as Oppenheimer's "baby":

> As early as December 1942, physicists at Chicago received acknowledgment for their work on plutonium with a telegram from Ernest Lawrence that read, "Congratulations to the parents. Can hardly wait to see the new arrival."
> . . . Two days after the Alamogordo test, Secretary of War Henry Stimpson received a cable in Potsdam which read:
>> Doctor has just returned most enthusiastic and confident that the little boy is as husky as his big brother. The light in his eyes discernable from here to Highhold and I could have heard his screams from here to my farm.
>
> And, as the world was to learn just three weeks later, the "little boy" was indeed as husky as his brother.
> In this inversion of the traditional metaphor, this veritable backfiring, more monstrous in its reality than any fantasies of anal birth explored by psychoanalysts, nature's veil is rent, maternal procreativity is effectively coopted, but the secret of life has become the secret of death. (Keller 2000, 489)

Work may be required to support the world we hold in common, but when it becomes the guiding principle of the world, it can destroy what it ought to maintain. The drive to imagine politics as a kind of making also, perhaps unwittingly, threatens "the very substance of human relationships" (Arendt

1958, 195); these relationships are founded not on production or authorship, but on the plurality and open-endedness of action and natality.

Only action—understood as *inter*action with Others—is rich enough to sustain a public realm of free and equal human beings. Action moves in neither the circular time of labor nor the linear time of work; rather, it introduces the possibility of a time of renewal and hope, a political—and, I would argue, also an *ethical*—time of forgiveness and promise. Time has a history, and history can change, thanks to the birth of new and unprecedented Others, each of whom initiates a narrative or life story that falls into the web of existing stories told and retold by Others. History is nothing other than this continually shifting and expanding web of stories that, thanks to natality, remain inconclusive and open-ended. For Arendt, a story is never merely made or conceived by its author; it is listened to, interpreted, retold, and enacted by Others who did not initiate the story, but nevertheless alter it with their response. While I may be the protagonist or "subject" (in both senses, as actor and sufferer) of my life's story, I am never its solitary author. I do not create my own existence the way a sculptor creates a statue or a novelist creates her characters. For while I may initiate my own autobiography, the human condition of plurality ensures that I can never complete it without exposing this story to Others, who respond to Others, and so on. Arendt suggests that true courage—the courage to initiate action—does not demonstrate an attraction to danger and glory, but rather a willingness to expose oneself in vulnerability, to begin a story over which I do not have absolute control or authority. Anyone who acts must accept the possibility that his actions might go uncelebrated, and, further, that:

> he is "guilty" of consequences he never intended or foresaw, that no matter how disastrous and unexpected the consequences of his deed he can never undo it, that the process he starts is never consummated unequivocally in one single deed or event, and that its very meaning never discloses itself to the actor but only to the backward glance of the historian who himself does not act. (Arendt 1958, 233–34)

The historian gathers the stories of the past into a history. This narration of history introduces a temporality that weaves together the open-ended, unpredictable time of action and the linear, controlled time of work. The absence of a single author or listener keeps history open-ended and contingent, unpredictable and undecidable. For Arendt, this partiality or incompletion of the self in history suggests an interpretation of time not as repetition and anticipation, but as the forgiveness and promise of Others.

THE TEMPORALITY OF ACTION: PROMISE AND FORGIVENESS

How do promise and forgiveness disclose the temporality of action, and what relation do they bear to natality? Arendt begins her discussion of this question

by citing a verse from Ecclesiastes that despairs at the absence of anything new: "Vanity of vanities; all is vanity. . . . There is no new thing under the sun . . . there is no remembrance of former things; neither shall there be any remembrance of things that are to come with those that shall come after" (cited in Arendt 1958, 204). Ecclesiastes gives voice to the fear that, if we are only born in order to die, then nothing matters. If time is just a circle joining birth to death and death to birth, then there can be no hope for change, no disjunctive narrative cutting across the circle of time and disrupting its inevitable flow. Without the emergence of something new in the world, there is no hope for the future and no remembrance of the past; without the initiative and initiation of Others in natality, there is no history, but only the endless repetition of the same. This repetition would erase the distinction between past and future time, making both remembrance and hope futile. As Ecclesiastes expresses it: "What has been is what will be, and what has been done is what will be done" (Eccl. 1:9). One response to this futility of mortal time is to grasp hold of the repetition itself, remaking oneself as a project or artifact, becoming the author of one's own existence. But as I have previously argued in chapter 1, this response creates further problems, erasing the mother's gift of birth and reducing the ethical ambiguity of one's own existence. Ecclesiastes expresses the futility of any project that seeks to transcend reproduction through production: "As he came from his mother's womb, he shall go again, naked as he came, and shall take nothing for his toil, which he may carry away in his hand" (Eccl. 5:15). The artifacts produced by work and "toil" dissolve in the face of death, even if they might seem to hold out the promise of eternal fame. If it is true that time circulates endlessly in repeated patterns, then perhaps the mother's gift of birth is indeed a curse, and "the day of death [is better] than the day of birth" (Eccl. 7:1); for at least death releases me from the vanity of living.[8]

But if birth is not merely the beginning of the end, and if time unfolds historically through action and interaction as Arendt claims, then the possibility emerges of a new and hopeful future, as well as a remembrance of the past that is not confined to remorse or despair. For Arendt, the fact of natality gives us hope for something utterly "new under the sun." Every birth of a child brings into the world an unexpected and unrepeatable stranger. Thus, the birth of Others—an event both ordinary and miraculous—gives us hope for a future that unfolds otherwise than the past. It releases us from both the circular logic of labor and the linear logic of work, suggesting a political temporality in which change is possible but not constant or inevitable. This political time does not belong to any given individual but rather emerges in the interaction between people in a shared world. Without forgiveness from the Other, we would never be released from the endless repetition of past deeds; without making promises to Others, we would not find any assurance, however circumscribed, for the unpredictable and contingent future. Forgiveness and promise provide a measure of continuity within time that is neither cyclical nor linear, precisely because they rely on the *discontinuity* between

self and Other. Both forgiveness and promise "depend on plurality, on the presence and acting of others, for no one can forgive himself and no one can feel bound by a promise made only to himself; forgiving and promising enacted in solitude or isolation remain without reality and can signify no more than a role played before one's self" (Arendt 1958, 237). Natality may not secure the future once and for all against the threat of vanity and despair, but by orienting my time toward a stranger and newcomer, it nevertheless prevents me from ever "closing the book" on history altogether.

How do forgiveness and promise articulate a time that is both *for* Others and *from* Others? I begin my response to this question with a discussion of promise and forgiveness in *The Human Condition*, but I will elaborate this ethical account of time in the work of Levinas in further chapters.[9] Arendt calls morality "the good will to counter the enormous risks of action by readiness to forgive and to be forgiven, to make promises and to keep them" (Arendt 1958, 245). For Arendt, a promise is the opposite of a determined fate; it is an assurance given to the Other in a world without absolute assurances. The word "promise" comes from the Latin *pro-mittere,* meaning "to send forth"; promises send my word forth toward other people and into the future. In sending forth a promise, I expose myself to the double contingency of time and the Other. However well intentioned, my promise can never become an absolute guarantee; it both resists and requires the unpredictability of the future, without which it would be either meaningless or unnecessary. The promise is conditioned by natality; it could arise only in a world of action and plurality, where I do not know with certainty what the next day will bring. Rather than attempting to overcome this unpredictable future through production or self-authorship, Arendt interprets this uncertainty as the very condition for political life. A promise cannot determine the future, but it nevertheless alters the significance of the future for both the promiser and the one who is promised. Between us, there can be no final arbiter of the future's significance; but this lack of finality is itself a source of hope, a reminder that the future does not end with me. Promising "corresponds exactly to the existence of a freedom which was given under the condition of non-sovereignty" (Arendt 1958, 244). It is precisely as one who is *not* masterful that I may freely bind myself to the words I speak, even if I cannot single-handedly enforce their meaning.

While promises alter the future of the Other, forgiveness alters her past, releasing the actor from deeds that cannot be undone or erased, but whose significance can nevertheless be transformed. To forgive is not to repeat the past, but to *let it go*, letting the past remain as past rather than continuing to dominate the present or future. To forgive someone is to pardon, *par-donner*: literally, to "give-for" or "give-toward." In this sense, forgiveness is the gift of the Other, a gift of time that one cannot make for oneself, but only give or receive or pass along to others. Forgiveness confirms the life of the Other as a contingent human life, subject to error and insufficiency, but also open to the

response of other imperfect actors. I forgive the Other for not being perfect and complete, for not existing as a masterful work of art. In so doing, I confirm the fact of her natality and grant her the open-endedness that natality implies. Forgiveness does not exclude memory; we do not need to forget to forgive. Rather, forgiveness requires a certain kind of remembrance, understood here as an interaction with Others regarding the past. We forgive what the person did for the sake of who they are. In this sense, we do not necessarily forgive radical evil; rather, we forgive mistakes, and in so doing we release the Other from the perpetual repetition of these mistakes. To forgive is to give the past of the Other back to her, but to give it back differently, transformed by the act of forgiveness. The future of the Other relies on this forgiveness; it is needed "in order to make it possible for life to go on by constantly releasing men from what they have done unknowingly. Only through this constant mutual release from what they do can men remain free agents, only by constant willingness to change their minds and start again can they be trusted with so great a power as that to begin something new" (Arendt 1958, 240).

Arendt's account of forgiveness and promise suggests an intersubjective sense of time in which my temporal existence is concretely transformed by the response of the Other. What concerns me in promising and forgiveness is not the possession of my own time but rather the *gift* of time from and for the Other. This ethical and/or political sense of time implies a shift in Arendt's understanding of birth, from despair over the endless repetition of the same, to the desire to remake one's own existence as an artifact, toward a sense of birth as an occasion for promise and forgiveness. Perhaps this hope for "something new under the sun" allows us to recall the significance of our own birth, not only as the initiative to begin but as the profoundly passive initiation into a world opened up by the Other. Forgiveness gives us hope for a past that is more than a repetition of itself; promise gives us the different, but related hope for a future that exceeds any individual horizon. Together, they suggest an ethical temporality of the political sphere, a time that emerges only thanks to the gift of natality.

And yet, as I have already noted in passing, this account of natality still implies a forgetting of the embodied and specifically female gift of reproduction. For Arendt, the hope of natality emerges not through the embodied reproduction of children, but rather through the "second birth" of adult citizens who initiate their own political life. Arendt writes:

> With word and deed we insert ourselves into the human world, and this insertion is *like a second birth*, in which we confirm and take upon ourselves the naked fact of our original physical appearance. This insertion is not forced upon us by necessity, like labour, and it is not prompted by utility, like work. It may be stimulated by the presence of others whose company we may wish to join, *but it is never conditioned by them*; its impulse springs from the beginning which came into the world when we were born and

to which we respond by beginning something new *on our own initiative*. (Arendt 1958, 176–77, my emphasis)

Having been first initiated into the natural world through the body of a labouring woman, Arendt's political actor initiates *himself* into the fully human world, as if to "confirm and take upon" himself the "naked fact" of his prior birth to a mother by giving himself a "second birth." Like the existential self who authors his own existence, this actor would insert himself into the world on the strength of his own words and deeds. This claim for a rebirth of the self on its own initiative puts pressure on the sense in which action is always also a passive suffering among Others, such that no one is the sole author of his own life story. The emphasis in this passage on the *initiative* of birth as an impulse to begin and "take" action compromises the sense in which initiative also relies upon a prior *initiation* into the world with Others who condition my existence and make it possible.

In this sense, Arendt's underestimation of the contribution that women's reproductive labor makes to political life threatens to compromise the radicality and richness of action itself, understood as an interaction with Others who are not self-made or even self-inserted but rather brought into the world by a woman. From this perspective, the exclusion of laboring women from political life does not support the sphere of equality and freedom, as Arendt suggests in her analysis of labor, but rather threatens to collapse it. To paraphrase Beauvoir, my freedom cannot rest on the oppression of Others who take care of the "dirty work" of everyday life so that I can dedicate myself to words and deeds; rather, my freedom requires *the freedom of Others* without whom a political life would be utterly impossible. Where the laboring mother is reduced to a condition for my own freedom, the existence of other political actors (whom Arendt elsewhere insists are crucial to the very practice of politics) are reduced to the status of a background "whose company we may wish to join" but by whom we are "never conditioned." This suggestion of a human "condition" that is not conditioned by Others would foreclose the ethical possibility of a future that Arendt eloquently describes as a time of hope and promise.

The opposition between a laborious, private, and feminine labor of reproduction and an active, public, political, and apparently sexually undifferentiated "second birth" conspires to reduce the maternal body to a biological or animal condition for a human existence from which she herself is excluded. Arendt acknowledges that the ancient Greek *polis* that she admires could not have existed without the hidden and private labor of countless women and slaves, but she seems unwilling to condemn the injustice of this political system for which the freedom and equality of a few is founded on the enslavement and inequality of many.[10] Arendt's subordination of the private, feminine meaning of birth to the more public, apparently asexual significance of natality is clearly troublesome from a feminist perspective. But I will argue that the concept of natality still holds the promise of a different, more positive significance for

feminism. Natality resists any strict dichotomy between public and private, masculine and feminine, active and passive; the intersubjective time of natality suggests the possibility of promise and forgiveness for the mother, and not only for one's fellow "man."

THINKING THROUGH NATALITY

Feminists have argued, with good reason, that the opposition between private and public realms works to silence and diminish the concerns of those who have traditionally given birth, raised children, and kept a household running. Unpaid labor in the home forms the invisible foundation on which the paid, public economy operates and depends. Along with feminist critics of the public/private split, Arendt recognizes that the public sphere is only sustained thanks to women's reproductive labor in the home; but she parts company with most feminists in affirming this situation as the necessary condition for a just and vibrant political life, and in opposing any revaluation of the private as something more than support for a separate public realm.[11] Arendt's insistence on a mutual separation between private and public has drawn criticism from many feminists and rightly so; it implies that women's labor *ought* to remain invisible so that "equality" and "freedom" may appear elsewhere, in a public realm that women can presumably enter, but only if they manage to keep the frenzy of their reproductive bodies under control.

However, the simple removal of a distinction between private and public spheres would not in itself address the root concerns of feminists who hope that a reconfiguration of spheres would produce equality and freedom for all women. bell hooks has argued that the distinction between private and public does not mean the same thing to middle-class white women and to black and/or poor women, for whom "working outside the home" might not be a right and a privilege, but a painful necessity.[12] Luce Irigaray has observed that an uncritical removal of the private/public distinction without an interrogation of its logic merely forces women to become "like men" for their concerns to be publicly recognized. Furthermore, feminists like Barbara Duden (1991), Emily Martin (1987), and Alice Adams (1994) have demonstrated that the displacement of reproduction from the private to the public sphere does not automatically "liberate" birthing women, but can actually subject them to increased medical and social surveillance and decreased authority over the legal and political significance of their own pregnant bodies. As Seyla Benhabib puts it, "In a society where 'reproduction' is going public, practical discourse will have to be 'feminized'" (Benhabib 1992, 113).

While feminist response to Arendt has been ambivalent[13]—and while Arendt's own relation to feminism was probably hostile[14]—I will argue that Arendt's own discourse on natality demands a critique of sexist domination and a reevaluation of family life in the home, neither of which Arendt herself attempted. Throughout *The Human Condition*, Arendt upholds the Aristotelian

distinction between one's private life with family in the household or *oikos*, and one's public life with fellow citizens in the *polis*. While privacy designates a relation to that which is "one's own" (*idion*, root of our word "idiotic"), the public realm refers to a world that is shared or held in common (*koinon*) (HC 24). The public is the realm of freedom, equality, and justice, whereas the private realm remains bound by the necessity of labor and the unjustified dominance of the paterfamilias. In the ancient Greek *polis* as well as in the modern state, public and private realms are already gendered masculine and feminine, and this designation is correlated to the sexual difference between men's and women's reproductive labor. Arendt writes:

> That individual maintenance should be the task of the man and species survival the task of the woman was obvious [to the Greeks], and both of these natural functions, the labour of man to provide nourishment and the labour of the woman in giving birth, were subject to the same urgency of life. Natural community in the household therefore was born of necessity, and necessity ruled over all activities performed in it. (Arendt 1958, 30)

The necessity of labor makes freedom impossible within the home; a delimitation of the private sphere is required before free and equal beings can emerge. "Without mastering the necessities of life in the household, neither life nor the 'good life' is possible, but politics is never for the sake of life" (Arendt 1958, 37). Private life may never disappear altogether, but unless it is hidden from view the truly human, political actor would never appear on the scene. For Arendt, the body is paradigmatic of private space since the household is largely organized around bodily needs.[15] The body is mute and, in a political sense at least, invisible; its needs and sensations "cannot be voiced, much less represented" (112, 147). In *The Life of the Mind*, Arendt confirms this view that the biological body is insignificant until it "shows itself" in the public sphere as a distinct—and distinctly human—actor. Without publicity, the body remains anonymous and meaningless, bereft of individuality or uniqueness: "[N]o matter how different and individualized we appear and how deliberately we have chosen this individuality—it always remains true that 'inside we are all alike,' unchangeable except at the cost of the very functioning of our inner psychic and bodily organs" (Arendt 1978, I:37). This unchangeable "inside" of the body is at the same time the site of constant change: "It is obvious that a mindless creature cannot possess anything like the experience of personal identity; it is at the complete mercy of its inner life process, its moods and emotions, whose continual change is in no way different from the continual change of our bodily organs" (Arendt 1978, I:32).

For Arendt, the life of the body is both changing and unchangeable; the constant flux of its inner processes makes meaningful distinctions impossible, such that without the life of the mind, the human animal would be condemned to a private life of mute biological processes that look the same for everyone. This notion—that the body does not signify without the mind, or that

it does not exist for Others until it shows *itself*—confirms Arendt's view that the human self does not emerge as a political actor until it inserts itself into a public world, distancing itself from reproduction and initiating its own second birth. At the same time, it condemns the reproducing woman—the woman whose body "goes into labor" without following orders from her mind—to a life of indistinction and private anonymity. While the laboring man may set aside his labor without abandoning his body altogether, a woman's reproductive labor is an integrated aspect of her embodied life that persists even when she leaves the home and enters the public sphere—*if* she enters the public sphere. For by opposing labor to action and correlating labor to the indistinct processes of the body, Arendt makes it difficult to imagine a political actor who is *also* at the same time a laboring animal, or a free and equal citizen who is *also* an embodied, reproducing woman.

Why does Arendt object so strongly to the private realm, and why does she associate it with biological, reproductive, and female or feminine life? She writes:

> The privation of privacy lies in the absence of others; as far as they are concerned, private man does not appear, and therefore it is as though he did not exist. Whatever he does remains without significance and consequence to others, and what matters to him is without interest to other people. (Arendt 1958, 58)

Private life is a deprivation to the extent that the private man, alone and at home with himself, *does not matter to Others* and derives the significance of his existence from himself alone. The private individual only emerges as a unique and political self through its interaction with Others who are "the same" as him only "in such a way that nobody is ever the same as anyone else who ever lives, lived or will live" (Arendt 1958, 8). Arendt explains:

> The polis was distinguished from the household in that it knew only "equals," whereas the household was the center of the strictest inequality. To be free meant not to be subject to the necessity of life or to the command of another and not to be in command of oneself. It meant neither to rule nor to be ruled. Thus within the realms of the household, freedom did not exist, for the household head, its ruler, was considered to be free only insofar as he had the power to leave the household and enter the political realm, where all were equals. (Arendt 1958, 32)

The head of the household is not free *as such*, for two main reasons: because life at home keeps him bound to the necessities of labor and reproduction, and because—as the uncontested ruler of the family—he remains a man without equals or peers. In order to be free, he must be in a position of neither ruling Others nor being ruled by them; in this sense, his absolute power in the home actually *deprives* him and others of the equality required for either of them to be free. I have already cast doubt on the fateful "necessity" of cyclical

reproduction, and will continue to do so throughout this book. My main concern here is the latter point: that the ruler of the household is unfree precisely insofar as he remains a ruler without tolerating an equal within the home.

Arendt's conviction that family life is private in the sense of deprivation, and that it therefore does not allow the unique political actor to appear as such, rests on her uncritical acceptance of the patriarchal model of the family as the site of domination by a single ruler, the paterfamilias. Within such a family structure, women's individual lives—including their labor, their work, their words, and their deeds—literally do not appear. They remain "without significance and consequence to others," and "without interest to other people" (Arendt 1958, 58). Few would disagree that this patriarchal model of the family fails to achieve the rich political life of action and interaction that Arendt describes; but this failure indicates a problem with the model, not with family life in all its potential forms. Rather than excluding women and mothers from the political realm on account of their invisibility as free and equal citizens, Arendt's analysis of privacy as deprivation ought to suggest a *critique* of the degree to which women's work in the home remains invisible and insignificant to Others. This critique demands a reinterpretation of family life not as the endless cycling of anonymous generations but as the interaction of people who remain different in the midst of their familiarity. It also demands a different account of reproduction, not merely as the preliminary condition for my "second birth" into the *polis* but as a process that already manifests the plurality and surprise of natality. Finally, it demands a certain promise and forgiveness—a renewed significance of the past and the future—for the women whose labor, work, and action have gone largely unnoticed for too many generations. I find hope for this threefold task in Cavarero's work on natality and reproduction.

REPRODUCING NATALITY: CAVARERO'S READING OF ARENDT

While Arendt addresses the lack of philosophical attention to birth in the Western tradition, she nevertheless overlooks the sexed and embodied aspects of natality without which it could never speak to birth as a lived experience as well as a philosophical concept. As Cavarero puts it, "Arendt does not highlight the concept of birth as a coming from the mother's womb, but accepts the concept of birth as a coming from nothing" (Cavarero 1995, 6). Supporting and extending Arendt's argument, she argues that "universal 'Man' is never born and never lives. Instead, individual persons are born and live their lives gendered in difference as either man or woman. But every human born, male or female, is always born of a woman, who was born of a woman, who, in turn, was born of another woman, and so on, in an endless backward movement toward our origins. This maternal continuum delineates the feminine root of every human being" (60). Working both with and against Arendt's account of natality, Cavarero criticizes the opposition between public

and private realms, and locates the unique appearance of women and men within a maternal continuum of reproduction rather than a disembodied form of political natality.

From Arendt's perspective it hardly matters that at the moment of birth, I make my first appearance (and my *only* first appearance) to a mother because this appearance does not yet distinguish me as a unique and distinct human being. At the moment of birth, my mother is not my peer; we do not meet for the first time as free and equal actors, but rather in a radical asymmetry within which I am completely dependent on her immediate care. I do not yet have the capacity to express myself in words and deeds; from the perspective of public life I am still just another squalling baby, more or less indistinguishable from any other newborn, and interesting only from the statistical, demographic point of view that Arendt associates with "society," in which the category of labor occupies the political stage.[16] What Arendt misses and Cavarero emphasizes is that for at least one person this baby is *not* like any other. Already in the mother's first glimpse of her newborn child, this boy or girl appears as unique and irreplaceable. The asymmetry between mother and child is not a barrier to this recognition of uniqueness, but rather a condition of our natality, a sign that we are not made but born.

> [I]n birth one is not alone but in a duo: the mother and the one who is born. Birth is therefore inevitably a relationship between unequals. The one who is born, the living human, is here already, is already to be found. Certainly, the newborn is unrepeatably "new," it is a re-present-ation (a making eternally present) of the "beginning" that inscribes its own being in every living creature that came into the world to begin and not to die (Arendt 1959: 154ff). However, in its singularity the newborn is a "beginning" found already "started" inside the mother: it is generated by the female who has already been generated by a m/other, and so on ad infinitum in a sequence (*theoria*) of past mothers. (Cavarero 1995, 82)

Not only do I first emerge as unique in the eyes of the woman who gives birth to me, but this relationship between mother and child is itself unique. I will never dwell in the body of any other person but my mother; I will never again share this sort of intimacy with someone, this dense intertwining of "accident, innocence and indebtedness" (Cavarero 1995, 83). Where nature is interpreted not merely as a mute and impersonal flux but as the animal root of human existence, and where the home is seen not merely as an economic site for the processing of basic needs but as a place of hospitality and ethical life, there is no need to posit an oppositional hierarchy between private and public, nature and culture, reproduction and natality.[17]

In fact, where Arendt finds her saving grace—in the public realm that treats all men as peers—Cavarero locates an obfuscation of the unique, embodied *and* sexually differentiated natality of reproduction. While Arendt opposes the *polis* that recognizes uniqueness to the economically based "society" that

reduces individuals to examples of a type or blips on a graph, Cavarero locates uniqueness in the realm of *physis* and seeks to protect this generative uniqueness from the neutral juridical discourse that would ignore sexual difference and reduce men and women to the neutral "Man" or "citizen." For Cavarero, experiences such as birth, love, and death "are rooted precisely in the singularity of a lived personal life that the public sphere has always wanted to absorb into codes and regulations. But turning the gaze toward the mother, one can acknowledge that these are separate from the site of negotiable common living, and not subject to societal regulation. They are *physis* rather than *polis*" (Cavarero 1995, 82). This is clearly a point of disagreement with Arendt, but it is a disagreement that takes seriously (with one crucial amendment) her central insight that "men [and women], not Man, live on the earth and inhabit the world" (Arendt 1958, 7). This turn from *polis* to *physis* does not indicate that the politics as such are any less important to Cavarero, but only that the *polis* as a historically specific political form excludes the sexual specificity of reproduction and thereby risks losing the character of mutually recognized uniqueness for which Arendt prizes it. Cavarero calls for "a disinvestment in the polis" (Cavarero 1995, 84), arguing that "nothing prevents the imagining of another polis, a space where the rules of common living are found through the concrete matter that concerns it" rather than through a reductive public discourse that depends on a separate but occluded private sphere (85). Women ought to disinvest or withdraw from the patriarchal *polis* rather than simply try to negotiate a better place within it, since even a victory through the latter strategy would still remain a victory on patriarchal terms and within its political boundaries.

What would this disinvestment involve? If reproduction grants the lives of the women and men called "citizens" of the *polis*, then it also occupies a strange liminal space on the political map. Both excluded from the *polis* as a private, deprived process and already incorporated within it as the material condition for its supply of citizens, reproduction stands on the border of the *polis*: both inside and outside, before and "meanwhile." The cyclical temporality of reproduction that, for Arendt, puts physical birth below the level of politics also sets the stage for Cavarero's own disinvestment from the patriarchal *polis*. Physical birth initiates the political life of citizens who could not exist without having first been born; but the moment of birth also remains an exception to the *polis*, just as difficult to integrate into a single political narrative as it is to tell the story of my own birth. In both cases, the narrative significance of birth begins most immediately with the woman who gives birth, since she is the only person who absolutely must be in attendance at the moment when life begins. The time of reproductive natality—both cyclical and new, both regenerating biological life and initiating the distinct life stories of unique individuals—introduces a persistent knot that refuses to be fully integrated into any given political narrative. This knot provides women with a few loose threads, a chance to unravel the web of patriarchal stories that have managed to entangle

even such thinkers as Arendt. To disinvest from the *polis* is to invent new ways of thinking and doing politics that do not require the erasure of women's reproductive bodies but rather their guidance. "Certainly, the one who is born also belongs to the *polis*, and will have to live with others (both female and male) according to common rules, probably negotiated, contingent and revisable. But these rules will not aim at defining what belongs to the secret of the natal relationship, a secret that takes the form of a mother's decision bequeathed by nature to the origin of every living human before social integration" (84).

If it were not for the plurality of Others brought into the world through reproduction, there would be no one to promise or forgive, no natality, no action. Could we not tell a different story of the relation between labor and action, one that does not seek the mediation of work but rather finds already in reproduction a collaboration with Others, a difference emerging in the midst of the same, a discontinuity that interrupts both the circle and the line? What if birth involved neither the witless repetition of Nature nor the willed repetition of a second birth, but rather the discontinuous time of welcome and receptivity from one generation to the other? What if the most intimate "inside" of our bodies already spoke, already signified to an Other in the flesh before showing itself publicly? What if the unique and irreplaceable political actor were also, at the same time, a reproducing animal? We can imagine this possibility of another story, but we must not *only* imagine.

CHAPTER THREE

Welcome the Stranger:
Birth as the Gift of the Feminine Other

We speak lightly of "giving" birth.

> But who gives it? And to whom is it given? . . . No one ever says *giving death*, although they are in some ways the same, events, not things. And *delivering*, that act the doctor is generally believed to perform: who delivers what? Is it the mother who is delivered, like a prisoner being released? Surely not; nor is the child delivered to the mother like a letter through a slot. How can you be both the sender and the receiver at once? Was someone in bondage, is someone set free? Thus language, muttering in its archaic tongues of something, yet one more thing, that needs to be renamed. (Atwood 1977, 239)

Margaret Atwood raises questions about an expression so mundane that its subtlety is often overlooked. If birth is a gift, then who gives what to whom? A woman gives birth to a child, but only by receiving this child into the world. The child makes the woman a mother through the gift of its own appearance; but this gift is also a demand—for warmth, for love, for a full belly and a clean diaper. Atwood asks: "How can you be both the sender and the receiver at once?" And how does the meaning of sending or receiving change when viewed from the different perspectives of mother or child?[1] The question of birth has us running in circles; but the ambiguity between giving and receiving as a mother or a child suggests that the circle is not closed, that the end does not always return to the beginning.

For both Arendt and Beauvoir, reproduction implies a circular temporality from which the individual must somehow wrest itself in order to be free. Arendt locates this freedom in the active initiative to insert oneself into the world through a kind of "second birth"; Beauvoir finds it in the possibility of repeating birth as an existential choice, or even (as for Sartre) in a project of self-authorship. Nevertheless, both emphasize the sense in which my

individual freedom requires a plurality of Others in the midst of whom I emerge as uniquely myself; the politics of natality and the ethics of ambiguity raise the possibility of a time that is neither circular nor linear, but rather the discontinuous time of responding to Others. And yet, both Arendt and Beauvoir seem reluctant to question the circularity of reproduction as such; this assumption of circularity makes it difficult to imagine birth as a gift that is not already caught up in the economy of the same. A gift that automatically circles back to me—whether by extending my existence "through time and through eternity" as in Plato's *Symposium*, or by returning in the form of filial devotion, social prestige, or even unpaid household chores—would not be a gift in the true sense of the word. To understand the significance of giving birth, we must attempt to think reproduction otherwise: not as the circulation of individuals through the species, nor as a debt of familial obligation incurred by the credit of birth, but as an open circuit of generosity that gives more than it could possibly possess.

What breaks the circle of donation and restitution in the gift of reproduction? Is it indeed a circle? A number of different responses are possible here, none of which is entirely incompatible with the others. In what follows, I will briefly explore two possibilities raised by the work of Derrida and Cixous, respectively; I will focus my attention on a third possibility raised by Levinas's account of hospitality, which brings together both a concern for the intangible gift of time or space, and the question of sexual difference.

DERRIDA AND THE GIFT OF THE IMPOSSIBLE

In *Given Time*, Derrida considers the difficulty of accounting for a gift that, in order to exist as such, ought to be exempt from any form of reciprocity or exchange. As soon as the gift is recognized by either the giver or receiver, an economic circle of debt and repayment already gets under way. A gives B to C, as if giving extended in a line from one to the Other; but as soon as C receives the gift that is intended for her—as soon as A *intends* this gift, and anticipates the gratitude or self-satisfaction that she will receive in return—the line bends into a circle, and the distinction between "gift" and "exchange" becomes blurred. Derrida writes:

> A gift could be possible, there could be a gift only at the instant an effraction in the circle will have taken place, at the instant all circulation will have been interrupted and *on the condition* of this instant. What is more, this instant of effraction (of the temporal circle) must no longer be part of time. (Derrida 1992, 9).

The gift—if indeed there is a gift—interrupts the economic circle of possession, dispossession, and equivalent compensation that is already inscribed in the phrase, "A gives B to C." This interruption may arise when someone "gives what [she] does not have" (Derrida 1992, 2), passes on what was never fully

in her possession, by *giving time* to the Other. This given time is not visible on a clock or a calendar, nor does it find a place in philosophical representations of time as a circle or a line. Rather, the gift of time registers as the "rest" or remainder of a time that defies representation but nevertheless presences itself as a trace.[2]

To elucidate this gift of (the remainder of) time, Derrida offers a reading of Madame de Maintenon's phrase: "The King takes all my time; the rest I give to Saint-Cyr, to whom I would like to give all" (cited in Derrida 1992, 1). The king "takes" all her time; yet, despite this taking there is something left over, a remainder that slips through the grasp of the king, and which Madame de Maintenon gives to Saint-Cyr (a school which she started for impoverished young noblewomen). While she can only give the rest or remainder of her time to Saint-Cyr, she would like to "give all." What would it mean to "give all" when, as we already know, the king has "taken all her time"? To give all in this case would mean wanting to give more than she has, and more than the king has taken. The lack and insufficiency of "the rest of time" that remains give rise to a desire for surplus expenditure, for a gift that exceeds the alternatives of possession or dispossession. Derrida calls the rest of time "a remainder that is not nothing since it is beyond everything, a remainder that is nothing but that *there is* since she *gives it*" (3). The pure gift might be impossible, since it depends on a remainder that cannot be intended, represented, perceived, recognized, or exchanged. But perhaps this impossibility is the secret of giving insofar as it breaks or effracts the circle of economic exchange; in a very mundane sense, I can only give what I do not "have" in the sense of claiming exclusive ownership of it, and also what is not simply "taken" from me by force or coercion. As Derrida notes, Lacan makes a similar point about love: "It gives what it does not have" (cited in Derrida, 1992, 2). But, if this is the case, then the gift is impossible not in the sense that we are simply incapable of giving to others, but rather in the sense that each gift, however mundane, brings about an apparently impossible transformation of lack into excess, such that I am never satisfied with having given *enough*. Derrida writes of Madame de Maintenon:

> She lacks this leftover time that is left to her and that she cannot give—that she doesn't know what to do with. But this rest of the rest of time, of a time that moreover is nothing and that belongs properly to no one, this rest of the rest of time, that is the whole of her desire. Desire and the desire to give would be the same thing, a sort of tautology. But maybe as well the tautological designation of the impossible. Maybe the impossible. (Derrida 1992, 4–5)

Perhaps all desire is the desire to give more and more, a desire to turn lack into an excess that is not mine to keep, but only arises as such through the expenditure of giving to another. This would be the first tautology of desire: the desire to give, rather than to take or to have. But Derrida points out a

second tautology, related to the first. As the desire to give more and more, desire would amount to a desire for the impossible, a desire that runs into contradictions such as, "she gives what she does not have." As an impossible desire to give more than "all," my desire could never be fulfilled: not because it is defined by lack, but because it insists on excess.

Derrida articulates this impossible gift (or this gift *of* the impossible) in terms of given time. The gift of time resists formulation in terms of a subject "A" who gives an object "B" to another subject "C." What is time, such that I could give it away without ever having it? Time is not a thing; it seems to be the medium in which things are given. And yet I cannot help spending my time in one way or another. I may spend time with my child, but I do not thereby *lose* the time I give to her; if anything, my own time is enriched when I give it to Others. Even if we depict time as a circle and imagine this circle as a constant give-and-take in which every lost object receives its compensation, it is difficult—if not impossible—to locate the gift of time on this circle, precisely because it gives what it does not have, loses nothing by giving, and yet constantly spends itself or slips away without return. "The difference between a gift and every other operation of pure and simple exchange is that the gift gives time. *There where there is gift, there is time*" (Derrida 1992, 41).

This formulation of the gift sheds light on the sense in which the process of reproduction exceeds circularity to emerge as the gift of the Other. Quite literally, birth "gives" what no one—neither the mother nor the child—"has" in the sense of possessing something; it brings forth the time of the Other. This gift of birth is not a simple transfer of existence from one subject to another; rather, it gives rise to the Other to whom it will have given birth. The newborn child is not already present in such a way that she could "take" birth in the instant when it is given; rather, she comes to presence in and through the gift of birth.[3] In a sense, birth gives no thing to no one; this is precisely what distinguishes reproduction from the endless circulation of the same. The emergence of a new existent in a newly beginning time makes possible every other moment of giving or exchanging *within* existence. Derrida remarks:

> It is thus, for example, that 'to give time' is not to give a given present but the *condition* of presence of any present in general; 'donner le jour' (literally to give the day, but used in the sense of the English expression 'to give birth') gives nothing (not even the life that it is supposed to give 'metaphorically,' let us say for convenience) but the *condition* of any given in general. To give time, the day, or life is to give nothing, nothing determinate, even if it is to give the giving of any possible giving, even if it gives the condition of giving.[4] (Derrida 1992, 54)

The gift of birth gives time to an Other who emerges *as* Other through the very gesture of giving; it both ruptures the economy of circular exchange and also provides the condition for giving (in) the future. This understanding of birth disrupts the image of a closed circle from which one must escape in order

to start something new. But, without an account of how this gift is embodied in the process of reproduction, we may find ourselves returning, ineluctably, toward Arendt's distinction between the rupture of natality and the apparent continuity of reproduction in female bodies. While Derrida analyzes examples of feminine generosity in *Given Time*,[5] it is not his concern in this book to explore the particular relation between sexual difference and the gift of birth.[6] For this, I turn to the writing of Hélène Cixous.[7]

CIXOUS AND THE GIFT OF THE FEMININE

Cixous contrasts the closed circle, or restricted economy, of masculine desire with the open-ended or general economy of feminine desire.[8] In her essay, *Sorties*, Cixous writes:

> All the difference determining history's movement as property's movement is articulated between different economies that are defined in relation to the problematic of the gift.
>
> The (political) economy of the masculine and the feminine is organized by different demands and constraints, which, as they become socialized and metaphorized, produce signs, relations of power, relationships of production and reproduction, a whole huge system of cultural inscription that is legible as masculine or feminine. (Cixous 1975, 80–81)

For Cixous, the terms "masculine" and "feminine" refer neither to social roles nor to biological facts, but rather to different libidinal economies, different ways of giving and responding to the gift.[9] The difference between masculine and feminine is not essential, but rather economic: it refers to different patterns in the circulation of pleasure, power, and meaning. And yet these different libidinal economies are inscribed and enacted in material bodies; they refer to patterns and movements of the flesh instead of abstract relations "added on" to previously constituted bodies. Masculine and feminine economies account for different ways of living the body, different modalities of fleshly existence—and different relations to the gift.

For Cixous, a restricted or masculine economy recuperates its losses in a closed circle of debt and repayment. In such an economy, nothing is absolutely lost or gained; there is no remainder or excess that resists integration into the whole. Cixous calls this economy "The Empire of the Selfsame" (Cixous 1975, 78); there is no Other here that is not already the other *of* the same, where opposites like light/dark, black/white, and male/female remain locked in mortal combat. Cixous notes the predominance of this masculine economy in the history of the West: "All history is inseparable from economy in the limited sense of the word, that of a certain kind of savings. Man's return—the relationship linking him profitably to man-being, conserving it. This economy, as a law of appropriation, is a phallocentric production" (80). Within this masculine economy, women's capacity to give birth is fed seamlessly into the process of

production; following the "law of appropriation," the child whom she brings into the world becomes the property of its father, incorporated into his ever-widening household. This masculine economy destroys the gift as such "Loss and exchange are stuck in the commercial deal that always turns the gift into a gift-that-takes. The gift brings in a return. Loss, at the end of a curved line, is turned into its opposite and comes back to him as profit" (87).

But the feminine economy of open-ended expenditure disrupts this circle of give-and-take through its embodied performance of excessive generosity. In contrast to Derrida's analysis, which identifies economy with a closed circularity within which the gift would always be impossible, Cixous proposes an *economy of giving* that is noncircular, discontinuous, and (if it may be put this way) self-effracting. This feminine economy generates something out of nothing; it bears the other *in* the same, without reducing the difference in between.[10] Differences circulating within such an economy multiply without lining up along the axis of binary opposition. The feminine economy does not operate on the principle of exchange, but rather with a nonreciprocal generosity given "without calculating, without hesitating, but believing, taking everything as far as it goes, giving everything, renouncing all security—spending without a return—the anti-Ulysses" (Cixous 1975, 75).[11] Rather than locating the feminine gift in an impossible exception to the circular give and take of the masculine economy, Cixous argues that the masculine circle already presupposes a *restriction* of the feminine generosity that exceeds and disrupts it. Both within and without the circularity of exchange, feminine desire cannot be confined to any point or segment *on* the circle. Rather, she escapes—stealing or flying [*voler*]—elsewhere.[12]

> Still, having a present does not prevent woman's beginning the story of life elsewhere. Elsewhere, she gives. She doesn't measure what she is giving, but she gives neither false leads nor what she doesn't have. She gives cause to live, to think, to transform. That 'economy' can no longer be expressed as an economic term. Wherever she loves, all the ideas of the old management are surpassed. (Cixous 1975, 100)

Of course, the question remains: *Are* the ideas of old management surpassed? Does the excessive generosity of feminine desire really contest or subvert the appropriation of women's bodies in a patriarchal economy, or does it silently and invisibly support this appropriation? Cixous's point is not that feminism's political goals are already accomplished in the moment of feminine jouissance, nor that it is enough for women to give themselves unreservedly to make the revolution happen. Rather, she suggests that the general economy of jouissance might help to transform phallocentric logic from within and without rather than simply establishing another binary opposition (say, between feminism and patriarchy) that can be all too easily recuperated into the Empire of the Selfsame. Masculine and feminine economies do not necessarily exclude one another; an excess arises in the midst of circular return *and* as an exception to

it. Cixous compares this logic of non-exclusion to the embodied experience of pregnancy, which gives rise to an Other *in the midst of the same*, generating a surplus that grows from the pregnant woman and within her but also flows away from her, never to return. In pregnancy, the woman becomes more than what she "is"; her body brings forth a future that is irreducible to the present or the past, and which is even incommensurate with her own future, narrowly conceived as the future of a discrete individual. The notion of an open-ended feminine economy demands a renewed approach to the theory and the practise of maternity:

> *The relation borne to the child* must also be rethought. One trend of current feminist thought tends to denounce a trap in maternity that would consist of making the mother–woman an agent who is more or less the accomplice of reproduction: capitalist, familialist, phallocentrist reproduction. An accusation and a caution that should not be turned into prohibition, into a new form of repression. (Cixous 1975, 89)

Cixous calls for a different approach to family relations, no longer restricted to the triad of mother, father, and child: "let's de-mater-paternalize" (Cixous 1975, 90). She imagines the child not as an extension or product of the parent, but as a familiar stranger: "The child is the other but the other without violence. The other rhythm, the pure freshness, the possibles' body. Complete fragility. But vastness itself" (90). Echoing Simone de Beauvoir, she acknowledges the sense in which women's reproductive bodies have been put to use in the service of patriarchal production; at the same time, she insists that this appropriation does not exhaust the significance of pregnancy for women:

> It is because they have always suspected that the pregnant woman not only doubles her market value but, especially, valorizes herself as a woman in her own eyes, and undeniably takes on weight and sex. There are a thousand ways of living a pregnancy, of having or not having a relationship of another intensity with this still invisible other. (Cixous 1975, 90).

Invisible but tangible, the Other-in-the-same of pregnancy disrupts the economy in which maternal bodies are put to good use under the law of appropriation, for the sake of phallocentric production.

Cixous looks to the practice of writing as a way of flying/stealing from the masculine economy without reproducing its logic. In writing, the self touches on the Other who resists incorporation into the same:

> Writing is the passageway, the entrance, the exit, the dwelling place of the other in me—the other that I am and am not, that I don't know how to be, but that I feel passing, that makes me live—that tears me apart, disturbs me, changes me, who?—a feminine one, a masculine one, some?—several, some unknown, which is indeed what gives me the desire to know and from which all life soars. (Cixous 1975, 85–86).

In writing, the self gives rise to an Other who emerges from within itself and yet exceeds its grasp, interrupting its potential circularity. The text makes a space through which the Other may pass without becoming trapped or restricted: a hospitable dwelling place whose doors are never absolutely closed. The circulation of meaning in a text confounds any single or final interpretation; the possibility of a reader who is always yet to come, and always approaching the text from an unforeseen perspective, keeps the text open to the feminine economy of something arising from (apparently) nothing, a departure without return, a circulation without closure. In this sense, writing is "infinitely charged with a ceaseless exchange of one with another—not knowing one another and beginning again only from what is most distant, from self, from other, from the other within" (Cixous 1975, 86). The body of the text opens a door to elsewhere: to a transformative space from which a newly-born woman may emerge.

I have briefly sketched two possible approaches to the question of birth as the gift of the Other. While neither Derrida nor Cixous take the question of birth as their central theme, their texts suggest different ways of conceiving the question: as a gift of time made impossible by the circle of economic exchange, or as a feminine gift that opens the space of a generous "elsewhere" in the midst of exchange. These articulations of the gift inform my reading of hospitality in the work of Levinas. Hospitality makes room for the Other in the midst of a dwelling that is otherwise meant to contain and support a masterful, self-sufficient individual. The home is for Levinas both an *oikos* and an *ethos*; it is the seat of my power and possession, but also the site of my dispossession by an Other who commands me—and teaches me—to give. For Levinas, the ethics of hospitality opens up in the midst of a relatively (but not absolutely) closed economy of dwelling; the gift does not exclude economy, but rather presupposes it as the material basis for giving.

And yet in *Totality and Infinity*, both the economy of dwelling and the gift of hospitality already presume the discretion and withdrawal of a feminine Other whose dwelling is not masterful (but provides the condition for my mastery) and whose generosity is not ethical (but provides the condition for my ethics). The self's gift of hospitality already rests on a certain forgetfulness of the feminine Other without whom neither generosity nor selfishness would have been possible. In what follows, I interpret this forgetfulness as a clue for understanding philosophy's apparent reluctance to think of birth as the gift of the Other; precisely for this reason, however, I also seek an occasion for remembering the gift of birth with thanks. To remember the feminine welcome is not necessarily to integrate her gift into the economy of the same, as if gratitude were always a restitution circling back to the giver. As I shall argue, giving thanks for my birth does not amount to the repayment of a debt; rather, it asks me to extend generosity to a stranger, to embody the gestures of feminine welcome for an Other who "deserves" my hospitality just as little as I have deserved the gift of birth. As Jean-Luc Marion writes in his book, *Being Given* (2002): "The

acceptance of the gift does not consist in ratifying it by sending it back upstream (toward the giver), but in repeating it by sending it downstream (toward a givee yet to come)" (93). The best response to generosity is not to calculate what I owe in return to the giver, but rather to pass this gift on to another, and another, in a discontinuous line. Alphonso Lingis (2000) makes a similar point: "What gifts give is the ability to give gifts" (181), and not just the obligation to return them in kind. To become responsible, on this view, would be to transform the masculine economy of dwelling into a feminine economy of open-ended—and even infinite—hospitality. If ethics means welcoming the stranger into my home, and if the feminine Other is, as Levinas says, "the welcoming one par excellence" (TaI 157; TeI 169), then ethics would require me to become "feminized" by my encounter with the stranger. This feminine (or feminist) economy of ethics both questions the virility of a self who dwells in the home as if it were his own, and also calls on us to rethink the significance of birth to an Other.

LEVINAS AND THE GIFT OF HOSPITALITY

In *Totality and Infinity*, Levinas develops an ethics of hospitality that does not arise from a calculation of means and ends, credit and debit, but rather from the encounter with a singular Other who faces me, and who calls on me to give more than I possess. This ethics of hospitality demands a generosity for the stranger that is prior to any consideration of whether he "deserves" my attention, or is able to reciprocate in kind. For Levinas,

> The relationship with the Other is not produced outside of the world, but puts in question the world possessed. The relationship with the Other, transcendence, consists in speaking the world to the Other. But language accomplishes the primordial putting in common—which refers to possession and presupposes economy. (TaI 173; TeI 189)

Language already implies a gesture of hospitality; by referring to things in general or thematic terms, I already let them slip beyond my own private or exclusive awareness. The designation of a thing with a sign "permits me to render the things offerable, detach them from my own usage, alienate them, render them exterior" (TaI 209; TeI 230). In this sense, language offers "a primordial dispossession, a first donation" (TaI 173; TeI 189). This dispossession for the sake of the Other is the condition for a meaningful existence, a world that is not deprived of meaning by the privacy of the individual (as in Arendt's account of domestic life). But how precisely does this first donation arise? The gift of the world, or language, brings about a dispossession that is "primordial" and yet already "refers to possession and presupposes economy." What is the relation between gift and economy, such that the gift is both prior to economy and already presupposes it?

My response to this question demands an account of the feminine Other who both *gives* me a home and allows me to *make a gift* of my home to the

stranger. The feminine welcome is situated at the limit between *ethos* and *oikos*, between the primordial gift of the world and the economy it presupposes. But while the stranger teaches me to give and respond, Levinas describes the language of the feminine negatively, as "a language without teaching, a silent language, an understanding without words, an expression in secret" (TaI 155; TeI 166). The feminine Other would not command me to responsibility, but only provide a quiet place where this responsibility might emerge in the face-to-face encounter with an (implicitly masculine) stranger. And yet, as I shall argue, the silent language of the feminine—her "expression in secret"—bears more ethical significance than it seems to contain. I suggest this argument from two directions, examining first the passage from feminine welcome to the virile economy of dwelling, and then the passage from dwelling to hospitality for the stranger. I will argue that the stranger who commands me to give welcome also commands me—if only silently—to remember the gift of the feminine Other: not by returning it to the source, but by passing it on to another.

I AM WELCOMED: FROM *ETHOS* TO *OIKOS*

For Levinas, the primary world of the self is not the existentialist world of alienation and abandonment, or even the political world of action, but rather an enjoyment and immersion in the stuff of life: an abundance of food, warmth, and comfort. The self lives from the world and on it; it enjoys its dependence upon food, water, air, sunlight—on what Levinas calls "the element." The element is not yet a well-defined object standing over–against an equally well-defined subject; rather, it evokes the sheer materiality and fullness of the world as an enveloping environment. I can never possess or assimilate the element, for there is always more than I can grasp: a surplus from which I live. Immersed in the element, I exist entirely for myself and for the pleasure of the moment. My dependence on the world, and my inability to grasp it as a whole, is not initially experienced as the curse of passivity but rather as the very stuff of happiness. The plenitude of the element indicates a dimension of "the non-possessable which envelops or contains without being able to be contained or enveloped" (TaI 131; TeI 138). Being immersed in the element does not mean that I am indistinguishable from it; the self remains separate, even in the midst of its dependence on the world. Indeed, it is already separate before it *represents* itself as such—before it represents anything to itself at all. Enjoyment is an intentionality prior to representation, prior to the possibility of reconstituting the intentional object (or its own existence, for that matter) as arising somehow in itself, through its own powers of representation.

While representation tends to elide the difference between the represented object and the subject's own representation of it, enjoyment holds onto the exteriority of the object; it *lives from* this exteriority, and can only depend on a world that is really, materially separate from itself.[13] The neediness of the self immersed in the element, its vulnerability and its nakedness, affirm the

sense in which the world is not merely a projection or extension of myself but is stubbornly different and separate from me. My dependence on the world does not compromise my separation from it; rather, this dependence *requires* separation, just as the body requires a real, material world—and not just a world of representations—from which to live.

This ambiguity between separation and dependence characterizes existence in the element; it also teaches us something important about birth. As a child born into the world, I do not spring up fully formed, nor do I begin in a state of indistinction or fusion with my surroundings; rather, I begin by enjoying and living from the open-ended surplus of "good things" in the element. Levinas emphasizes the sense in which the born self emerges ex nihilo, such that the child is "not simply caused or issued forth from the father [or mother], but is absolutely other than him [or her]" (TI 63; TeI 58). But at the same time, the child is also not its own cause; its independence and otherness "would not be equivalent to the idea of causa sui, which, moreover, is belied by birth, non-chosen and impossible to choose (the great drama of contemporary thought)" (TI 223; TeI 247). Ex nihilo but not causa sui, the born self is both created and capable of forgetting or neglecting its creator in what Levinas calls the possibility of "atheism." As such, the born self exists *thanks* to an Other, but not as the Other's product, issue, or effect:

> But the idea of creation *ex nihilo* expresses a multiplicity not united into a totality; the creature is an existence which indeed does depend on an other, but not as a part that is separated from it. Creation *ex nihilo* breaks with system, posits a being outside of every system, that is, where its freedom is possible. Creation leaves to the creature a trace of dependence, but it is an unparalleled dependence: the dependent being draws from this exceptional dependence, from this relationship, its very independence, its exteriority to the system. (TI 104–5; TeI 108)

Not finitude but *separation* is the mark of this dependent independence, this birth that is given but not caused.[14] For Levinas, the challenge of selfhood is not to overcome the ambiguity between separation and dependence by somehow laying claim to one's own birth as self-authored or self-initiated. Rather, the challenge is to open the resources of this separate *and* dependent self to the Other, in the generosity of giving welcome to a stranger. The ambiguity between separation and dependence, or between atheism and creatureliness, holds open the freedom of the self to be more than either an object caused by another or a subject caused by itself. More important, it reserves for the Other the freedom to be there or not be there, to exceed my representation, and to be other than I expect or project her to be.

While enjoyment teaches us much about what it means to be born into the world, it does not yet consider what it means to be born *to an Other*. Immersion in the element is not yet the interiority of a home; it is not yet a world that I inhabit with Others. "In enjoyment I am absolutely for myself,"

with the naïve egoism of a newborn child (TaI 134; TeI 142). For Levinas, the first exception to this egoist enjoyment is the feminine welcome. I do not float for an eternity in the womb of the element, nor do I extricate myself from the element on my own; rather, I am welcomed out of the element and into a home by a feminine Other who antecedes me, and who makes my dwelling possible. No longer wholly immersed in the element, I gain a spatial and temporal distance from my surroundings that allows me to postpone enjoyment and save it for later, to labor now and enjoy the fruits of my labor when I choose.[15] The self who dwells in a home has control over the terms of its existence to the degree that it can distinguish between inside and outside, now and later, mine and not-yet-mine. The laboring self does not merely consume or "use up" the element; it *puts* the element to use, working on it and refashioning it to serve his own needs. This use alters the significance of the element *as* element. The water that runs from my tap, the food in my cupboard, the wood I convert into fuel: these are no longer aspects of an indefinite element in which I am immersed but rather items at my disposal, possessions, things that I keep ready-to-hand to suit my needs. I may still enjoy the food in my cupboard, but the enjoyment and the storage of food are two fundamentally different modalities of existence.

The feminine Other makes this economy of dwelling possible by welcoming the self into an interior space that she creates by withdrawing herself, by remaining "discrete" and unimposing. The feminine gives by receiving and making room; her face simultaneously reveals itself and withdraws, "breaks through its plastic image" and conceals itself in shadows, allowing itself to be glimpsed but not directly seen (TaI 155; TeI 166). The modesty and discretion of the feminine face let the self feel "at home with himself" (TaI 152; TeI 162); it gives him "solitude in a world already human" (TaI 155; TeI 165). Precisely by *not* confronting the self—by asking nothing of him, making no demands—the feminine Other allows the self to dwell in the home as if it were his own, as if he were king of the castle. As such, the feminine welcome provides the conditions for what Levinas calls the "virile and heroic I" (TaI 270; TeI 303): the self endowed with the ability to represent itself as if it were causa sui, as if it depended on no one but itself, as if it had even chosen its own birth.

In her book, *Family Values*, Kelly Oliver gives a critique of virility in the context of the phenomenological tradition: "The virile subject relates to itself and its world as its property; virility is defined in terms of ownership and ownness" (Oliver 1997, 119).[16] Since my existence is given to me at birth by an Other, the most basic condition for laying claim to my existence as property is the capacity to represent my birth as if I had given it to myself, as if I were "the only one."[17] And yet, "behind the ownership so dear to Phenomenology is something other, something that cannot be possessed. In the face of this otherness, the virile subject loses his control" (134). One response to this loss of control is to *assert* one's control, to deny the alterity of the Other

at the expense of the ambiguity between separation and dependence. Oliver observes: "The literature and myths of Western culture are full of images of males giving birth to themselves through an attempt to control that which cannot be controlled, the creation of life" (128). And yet the trace of the Other cannot be fully expunged; the circularity of self-ownership is fractured from the beginning—or before the beginning—thanks to the feminine welcome without which there is no self to be owned or disowned. I argue that in *Totality and Infinity*, Levinas both challenges philosophical virility by acknowledging the welcome of a feminine Other, and also reinscribes this virility by presenting the feminine Other as little more than a condition for the self's future mastery.[18] While Levinas lays bare the logic of virile subjectivity in his analyses of dwelling, he does not escape this logic to the extent that he denies the feminine welcome an ethical (and not merely pre-ethical) significance. But I will argue that, far from disappearing on the horizon of ethics, the feminine Other provides both its condition and its privileged example. Ultimately, responsibility for the Other requires not that I forget the feminine Other but rather that I become *like* her in giving hospitality to an Other.

But before this argument can unfold, we need to look more closely at the constitution of the virile subject as one who requires but also denies the feminine welcome. Who is the virile self in *Totality and Infinity*, and how (if at all) does this moment of virility support Levinas's argument for an ethics of radical responsibility? The self emerges as virile by learning to play tricks with time. "Possession masters, suspends, postpones the unforeseeable future of the element—its independence, its being" (TaI 158; TeI 170). Thus, possession, and the dwelling in a home that makes it possible, lift me out of the indefinite future of enjoyment, allowing me to keep this future at a comfortable distance. Dwelling lets me regard even the present moment—which is nearly all-absorbing in enjoyment—*as if it were yet to come*, still at a distance, still a future of possibility. This future-present is the relation to time proper to representational consciousness:

> To be conscious is to be in relation with *what is*, but as though the present of *what is* were not yet entirely accomplished and only constituted the *future* of a recollected being. To be conscious is precisely to have time—not to exceed the present time in the project that anticipates the future, but to have a distance with regard to the present itself, to be related to the element in which one is settled as to what is not yet there. (TaI 166; TeI 179)

To be immersed in the element is to be suspended in the non-I, absorbed in the continuous flow of the present, troubled only by the faint rumblings of an indefinite future. But to exist as a conscious self is to have gained a distance from this present, representing it to myself as if it were yet to come, and as if it were mine to possess. The ability to represent is thus the hallmark of consciousness; it is the ability to push the present into the future but also

to dispose of the past as if I had constituted it myself, as if I had somehow existed in advance of myself, as my own cause.

But this temporal distance is only possible given the context of the interior space that dwelling in a home offers, and which the feminine Other grants to me:

> The feat of having limited a part of this world and having closed it off, having access to the elements I enjoy by way of the door and the window, realizes the extraterritoriality and the sovereignty of thought, anterior to the world to which it is posterior. *Anterior posteriorly*: separation is not thus "known"; it is produced. Memory is precisely the accomplishment of this ontological structure. A marsh wave that returns to wash the strand beneath the line it left, a spasm of time conditions remembrance. Thus only do I see without being seen, like Gyges, am no longer invaded by nature, no longer immersed in a tone or an atmosphere. (TaI 169–70; TeI 184)

Gyges—the mythical shepherd in Plato's *Republic* (359d–360e)—finds a ring with the power to make him invisible; he uses this ring to seduce the queen and murder the king, thus taking possession of his kingdom. Gyges represents the eternal temptation of one who dwells in a home, who can lock the door and peer out the window. To be like Gyges is to be virile; it is to see without being seen, to posit the world without being posited by it. Is this not precisely the temptation that Gyges holds out to me: the temptation of representing myself as *anterior* to the very world which I could have only followed upon posteriorly? The world must be there in order for me to represent it; and yet the structure of representation posits itself as the transcendental "origin" of what was already there. As Gyges, I am no longer born into a world beyond my choice or control; rather, I represent myself as having given birth to a world in myself, and to myself in the world.

This representation implies a "spasm of time" that returns to the past as if it were still a future coming toward me, as if I could still hand down to myself the conditions of my own existence. To represent is, for Levinas, to account for an object "as though it were constituted by a thought" (TaI 128; TeI 134): more precisely, by *my* thought, as though I were the origin of the object that I repeat or reconstitute in my own consciousness. In this sense, the logic of representation lays bare the logic of virile self-birth: a logic that is already at work, in different ways, in both Sartre's self-authorship and Arendt's self-initiative. And yet this virile representation already refers—despite itself—to the residue of an Other whom it must suppress in order to posit itself as virile. As Levinas explains, the "transcendental pretension [of representation] is constantly belied by the life that is already implanted in the being representation claims to constitute. But representation claims to substitute itself after the event for this life in reality, so as to constitute this very reality" (TaI 169; TeI 183). As we shall see, the possibility of representing oneself as one's own origin rests not only on the anteriority of the "world" but also on the anteriority of the

feminine welcome that lets me dwell in the world as if I were the "master" in "my own" home. Without this welcome, the temptation of Gyges would not be possible, nor would it be possible to resist the temptation.

For the space of dwelling carved out from the world at large—the space that allows me the distance necessary to represent and recollect—is not carved out or constituted by me, nor is it a natural consequence of elemental existence. Rather, this space is always "an intimacy with someone. The interiority of recollection is a solitude in a world already human. Recollection [*Le recueillement*] refers to a welcome [*un accueil*]" (TaI 155; TeI 165). I can be "alone" and at home with myself only because I have always already been welcomed by an Other. The feminine welcome both gives me autonomy and attests to the fact that I am never absolutely autonomous, despite what I might assert. Precisely by *giving* the self this capacity to assert its radical autonomy, the feminine welcome also *gives the lie* to this assertion, reminding us of the sense in which all mastery depends on an Other who *lets* one be masterful, and so implicitly undermines the totality of this mastery in advance.

While Levinas does not develop this point explicitly, I suggest that the feminine welcome embodies this double significance only by exposing itself to the risk that it might be betrayed, taken for granted, never quite recognized. This is the irony of the feminine welcome: the generosity of its gift makes possible an economy of dwelling that nevertheless breaks with the circle of debt and repayment that Cixous identifies with a masculine economy, and that Derrida identifies with economy as such. The feminine welcome leaves open the possibility that the received guest might deny the importance and even the existence of the welcome. By allowing for this denial "anterior posteriorly"—in effect, by letting itself be airbrushed out of the picture after the fact—the feminine welcome gives me both the possibility of egoism and the promise of ethics. She does not merely determine me as Gyges, nor does she determine me in advance as an ethical being. Rather, the feminine welcome gives me both the temptation of being like Gyges, and the promise of being otherwise. This ambiguity saves responsibility from becoming the fate, or ontological character, of humanity. It lets ethics emerge as a response to the Other: the impure possibility of a self who is both separate and dependent, autonomous and welcomed, responsible and free. The risk that the feminine welcome might be betrayed and taken for granted, absorbed into the projects of a virile and egoist self, attests to an ethics of ambiguity in which the self remains separate even in the midst of its dependence on Others in the home and its assignment to Others in responsibility. The radical generosity of this welcome recalls the feminine economy that Cixous describes as giving "without calculating, without hesitating . . . renouncing all security—spending without a return—the anti-Ulysses" (Cixous 1975, 75). It also echoes Derrida's desire to give the impossible, transforming lack into surplus, without the circular demand for reciprocity.

The possibility of forgetting or overlooking the feminine welcome prevents hospitality from closing over itself into a circle of mutual reciprocation; it makes

the gesture of welcoming Others discontinuous with the fact of being welcomed. When the feminine Other offers me a home in which to dwell, she does so without any assurance that she will get something in return, or even that her gift will be recognized as such. To give in this way is not the same as self-sacrifice: for even sacrifice brings with it the prestige, and even the pleasure, of being a martyr. Rather, the feminine welcome gives what was never hers to have or possess: she gives time and space to the Other, for the sake of the Other. This welcome is the ethical gesture par excellence because it is a truly generous gift: a gift that was never mine to give, and does not claim to give me anything in return.

We have seen how the feminine welcome makes possible an economy of dwelling, possession, and representation. But how does it allow for the transformation of this economy into an ethics of responsibility? Levinas writes: "But in order that I be able to free myself from the very possession that the welcome of the Home establishes, in order that I be able to see things in themselves, that is, represent them to myself, refuse both enjoyment and possession, I must know how to give what I possess" (TaI 170–71; TeI 185). How do I learn to open the doors of my home to an Other, to give the food that I have saved for myself to an Other? For Levinas, responsibility does not arise in response to a face barely glimpsed, a face that welcomes me into a home as if it were my own; in short, it does not arise in response to a feminine face. Instead, I am commanded to responsibility in the face-to-face encounter with an absolute (and pronominally masculine) Other who teaches me to how to give by asking *more* from me than I can possibly give. In what follows, I will describe this encounter with an absolute Other; I will also suggest that the generosity of the feminine Other already opens the home to an ethical economy of welcome, and that her silent language—far from subordinating itself to the stranger's gift of the world—may even hold its secret.

YOU ARE WELCOME: FROM *OIKOS* TO *ETHOS*

The home, understood as the economic space of dwelling, is the seat of my possession and mastery. But the absolute Other interrupts my self-satisfied dwelling at home; he "paralyses possession, which he contests by the epiphany of the face" (TaI 171; TeI 185). By facing me directly, without the discretion or withdrawal characteristic of the feminine, the Other puts in question my right to mastery in the home. Appearing with empty hands, naked and impoverished, he does not give me anything tangible but rather commands me, with the eloquent revelation of his face, to give what I possess. This command affects me with a passivity that is more radical than the fluid receptivity of enjoyment. The commanding Other is not an elemental otherness from which I live; rather, he resists my attempt to consume, incorporate, or comprehend him. The command of the Other exposes me to his poverty and vulnerability, to the point where I am unable to avert my eyes. Levinas calls this impossibility of failing to respond to the Other *ethics*:

> A calling into question of the same—which cannot occur within the egoistic spontaneity of the same—is brought about by the other. We name this calling into question of my spontaneity by the presence of the Other ethics. The strangeness of the Other, his irreducibility to the I, to my thoughts and my possessions, is precisely accomplished as a calling into question of my spontaneity, as ethics. (TaI 43; TeI 33)

My passivity before an Other who questions me does not preclude my going to great lengths for him; indeed, it commands me to give more than I have, to the point of exceeding what is reasonable or even, strictly speaking, possible. The command of the Other teaches me something absolutely new and unanticipated: the idea of infinity, and of my infinite responsibility for the Other. This idea alters both the temporality of my existence and the meaning of selfhood. "Infinity presents itself as a face in the ethical resistance that paralyses my powers and from the depth of defenceless eyes rises firm and absolute in its nudity and destitution" (TaI 199–200; TeI 218). The idea of infinity refers to the sense in which the face of the Other always exceeds its own expression or presentation, overflowing any idea I might have of him. The excessive presence of the Other addresses me with an infinite command, a command that grows larger in proportion to my response. I can never satisfy this command; and this *in*ability to act properly transforms the very significance of the self from one who is "able" and resourceful into one who is responsible for the Other. "The idea of infinity implies a soul capable of containing more than it can draw from itself" (TaI 180; TeI 196). This idea of infinity does not lie dormant in me, waiting for the Other to awaken it; rather, it comes to me from beyond my own finite subjectivity:

> To approach the Other in conversation is to welcome his expression, in which at each instant he overflows the idea a thought would carry away from it. It is therefore to *receive* from the Other beyond the capacity of the I, which means exactly: to have the idea of infinity. But this also means: to be taught. (TaI 51; TeI 43)

In calling my possession into question and teaching me the idea of infinity, the Other also teaches me how to give to the Other, how to be responsible for a stranger whom I cannot grasp or comprehend. The Other *gives to me* the capacity to *give to him* infinitely, in response to his impossible command. This gift both paralyzes my powers of representation and possession, and at the same time "offers new powers to a soul no longer paralytic—powers of welcome, of gift, of full hands, of hospitality" (TaI 205; TeI 224). By questioning my mastery, the Other frees me for responsibility, inverting my active abilities into the deep passivity of ethics, in which I am *given* the very capacity to give.

The Other gives to me by calling my possession into question, asking me to put the world in common by thematizing things or stating them in general terms. This generalization of "my" world detaches me from exclusive possession

of this world; indeed, it detaches me from exclusive possession of my own being, puts me at a distance from myself, as though I hovered over my own existence like a ghost (or a guest) in my own home.

> The subject must find itself "at a distance" from its own being. . . . In order that objective distance be hollowed out, it is necessary that while in being, the subject be not yet in being, that in a certain sense it be not yet born—that it not be in nature. If the subject capable of objectivity *is* not yet completely, this "not yet," this state of potency relative to act, does not denote a less than being, but denotes time. (TaI 209; TeI 230)

Time opens up in the delay between my response to the Other and my own grasp on the world as a possessive and self-possessed ego. This signification opens up a distance within my own existence, a "not yet" by virtue of which my birth is not simply a represented fact, but rather a moment whose full significance is always yet to come.[19] As one who "is" not yet, I am incapable of grasping or representing my existence all at once. But this very incapacity frees me from the self-enclosed restriction of a virile subject; it releases me from the compulsion to mastery and possession or (in Arendt's language) from the deprivation of a paterfamilias who might otherwise seem trapped in the private sphere by the logic of his own domination. In this sense, the command of the Other both asks the world of me and also *gives* me what I would not have been able to make for myself: time, and "the inexhaustible future of infinity" (TaI 210; TeI 231). This infinite future does not belong to me, even if it releases me from the narrow circle of my belongings; nor does infinity belong to the Other who gives or commands. Rather, the time of infinity opens up in the command for infinite responsibility; it suggests a time when the self might become otherwise than it is at the present moment, a time when I might exist for the Other *before* existing for myself.

For Levinas, responsibility does not merely follow from what I have caused or chosen in the world. Rather, ethics entails responsibility for an Other whom I have *not* caused or chosen, but who approaches me from the Outside. This responsibility for the Other is not "mine" and does not originate in me, but rather comes from the Other who interrupts my projects and puts me in question. To be responsible is not to "take" responsibility for my own existence, as if I had authored or made it myself; responsibility does not follow on action the way an effect follows on its cause. For Levinas, I am responsible especially there, where I have done nothing to incur responsibility through my own actions or existence. Ethics requires that I have not produced myself, but have been given to Others, welcomed by strangers in hospitality. While I may not immediately recognize my existence as given, I am brought back to this givenness by a stranger who arrives as naked, indigent, even offensive, and commands me to give him a place in my home. I give this welcome not to get anything in return, but because the Other has commanded it of me, because he has arrived on my doorstep with nothing and looked at me face-to-face. Thus,

the gift of hospitality—the gift that, for Levinas, constitutes ethics itself—is given by me *despite myself*, and not on my own initiative. In commanding me to ethics, the Other gives me the very means by which to receive him in welcome, beyond my own capacity to receive, with an excessive, ever-augmenting responsibility. The passivity of this welcome, this gift, this hospitality, is unanticipated, yet it is not altogether unheard-of. For these gestures of welcome have already been extended *to me*, albeit in a different way, by the feminine Other. What is absolutely new in the epiphany of the absolute Other is that now *I* have been commanded to extend hospitality to Others. I am no longer only welcomed into the home and given the chance to dwell there as if in my own domain; now I am commanded to open my home to Others, and to give what I possess. What is the relation between the feminine welcome and this welcoming of Others?

For Levinas, the feminine welcome is not yet ethics; for the feminine Other does not face me directly and command me to respond. The feminine Other gives me the *ability* to possess while the absolute Other gives me the ability to respond—*responsibility*—by calling my possession into question. This marks the difference between the feminine welcome (as a "pre-ethical" condition for ethics) and the welcoming of the stranger (which is ethics itself). Levinas writes of the feminine: "The Other who welcomes in intimacy is not the you [*vous*] of the face that reveals itself in a dimension of height, but precisely the thou [*tu*] of familiarity: a language without teaching, a silent language, an understanding without words, an expression in secret" (TaI 155; TeI 166). He adds: "The discretion of this [feminine] presence includes all the possibilities of the transcendent relationship with the Other"; and yet, "in the woman," these possibilities "can be reserved so as to open the dimension of interiority" (TaI 155; TeI 166). The feminine Other does not approach me from above; instead, she retreats silently within, into a space that she seems to give without having ever possessed it for herself.

Who is the feminine Other before she welcomes me into "my" home? Was there another feminine Other who once welcomed her? And, if so, then how does the self who is welcomed by a feminine Other—and, presumably, given the virile possibilities of dwelling and representation implied by this welcome—eventually turn into a feminine Other for the next stranger who comes along? There is a mystery here, which Levinas does not explicitly address but which is crucial for my own understanding of what it means to be born. For Levinas, the feminine welcome remains a silent gesture, "an expression in secret." But this silence and secrecy need not indicate an ethical insufficiency on the part of the feminine. For the stranger's command does not merely displace the feminine welcome, but rather commands me to become *like* her for another. The stranger interrupts the virility that the feminine welcome made possible; but it interrupts this virility in order to pass this welcome on to an Other, in a new generation of giving. In effect, the stranger commands me to become feminine.

The stranger's face inverts the mastery of dwelling into the generosity of hospitality, yet this generosity is only possible with something to give, something to invert. Levinas writes: "The 'vision' of the face as face is a certain mode of sojourning in a home, or—to speak in a less singular fashion—a certain form of economic life. No human or interhuman relationship can be enacted outside of economy; no face can be approached with empty hands and closed home" (TaI 172; TeI 187). I can only extend my welcome to an Other if I have already *been welcomed* by the feminine Other, such that I have something material to give, resources to share, a home of "my own" to open for the Other in hospitality. Precisely by letting me labor and gather possessions, the feminine Other lets me acquire things that can be given away. And yet the fact of possession alone does not yet teach me how to give, or even how to *want* to give. As I have suggested, the feminine Other also gives, along with the possibility of mastery and possession, the promise of dwelling otherwise: the possibility of giving what is "mine" to another. It is the *intimacy* of the feminine welcome, its generosity and gentleness, which give us a glimpse of something more in the feminine welcome than the conditions for economic dwelling. For the feminine welcome introduces "a new and irreducible possibility, a delightful lapse in being, and the source of gentleness itself" (TaI 155; TeI 166). This gentleness, this exception to the totality of being, singles out the feminine Other as "the welcoming one par excellence, welcome in itself" (TaI 157; TeI 169).

What does it mean to welcome the stranger in this way? In his book, *Adieu to Emmanuel Levinas*, Derrida observes that the stranger makes me like a guest in my own home by giving me the capacity to make room for him. Playing upon the ambiguity of the French word, *hôte*, which means both host and guest, Derrida writes:

> [T]he *hôte* who receives (the host), the one who welcomes the invited or received *hôte* (the guest), the welcoming *hôte* who considers himself owner of the place, is in truth a *hôte* received in his own home. He receives the hospitality that he offers in his own home; he receives it from his own home—which, in the end, does not belong to him. The *hôte* as host is a guest. The dwelling opens itself to itself, to its "essence" without essence, as a 'land of asylum or refuge' [*terre d'asile*]. (Derrida 1999, 42)

The host is welcomed by the guest into his own home. For he can only be a host *for* the Other by receiving this capacity for generosity *from* the Other. The capacity to give hospitality, coming as it does from the Other, attests to the glory not of the self but of the Other who comes from elsewhere. To welcome is not so much to open oneself up, as one opens a door or a window, but to *be opened* in response to the Other.

This account of hospitality for the stranger is insightful and provocative. But is the self not already a guest in its "own" home thanks to feminine hospitality? While the anterior posteriority of representation may obscure this fact

and insert itself as the transcendental origin of itself and the world, we must remember that it can only do so thanks to the feminine welcome that makes this representation possible. Indeed, the "land of asylum or refuge" to which Derrida refers in this passage is opened not only—and indeed, not primarily—by the stranger, but by the *feminine* Other. For this phrase—this "land of refuge or asylum"—is written by Levinas in reference to the *feminine welcome*, and not yet to the welcome I extend to the stranger. The passage from *Totality and Infinity* reads as follows:

> To dwell is not the simple fact of the anonymous reality of a being cast into existence as a stone one casts behind oneself; it is a recollection, a coming to oneself, a retreat home with oneself as in a land of [asylum or] refuge [*terre d'asile*], which answers to a hospitality, an expectancy, a human welcome. In human welcome the language that keeps silence remains an essential possibility. Those silent comings and goings of the feminine being whose footsteps reverberate the secret depths of being are not the turbid mystery of the animal and feline presence whose strange ambiguity Baudelaire likes to evoke. (TaI 156; TeI 166–67)

Already in the feminine welcome there is a "human" welcome, a land of asylum or refuge: a silent language, but nevertheless a language. My existence in the home is always already a *response* to this welcome from the feminine Other; the fact of this response already opens a dimension beyond virile mastery. The modesty of the feminine Other may allow the self to represent itself as the origin of its own existence, but the generous *welcome* of the feminine Other attests to the impossibility of such a representation, and even to the impossibility of presenting ethics as the "serious" business of hospitality among men. The silence of the feminine is not the same as its effacement; perhaps, precisely as a language that "keeps" silence, it does not merely withhold speech but actually harbors silence, keeps it "as in a land of asylum or refuge," as the remainder of a language that—like the commanding language of the absolute Other—cannot be fully comprehended by the self.

How might language "keep silence," while still opening an ethical dimension of infinity? Recall Cixous's account of writing as the "passageway, the entrance, the exit, the dwelling place of the other in me" (Cixous 1975, 85–86). Writing opens an elsewhere—an effraction of the circle—in which the Other may find shelter *in* the same, without thereby becoming the Other *of* the same. As Derrida suggests, writing leaves behind a remainder or trace that resists integration into the circle of reciprocal exchange and holds open the promise of a gift without debt or repayment. Perhaps, in this sense, writing "keeps silence" even as it signifies to the Other or holds open a space, an elsewhere, through which the Other may come or go. In the silent language of the feminine Other, nothing is "said" and nothing is "taught," but there is nevertheless a transcendent dimension of alterity that opens in this silence and calls for a response. Already before I have been put in question by the absolute Other—

like a response *before* questioning—I have already answered to this silent hospitality of the feminine. I would like to suggest that, in response to the silent language of the feminine, I *will have been* called to responsibility, in the future anterior.[20] I *will* have been: not now, in the present moment, because for now she lets me dwell in the house as if it were my own. But later, when I encounter an Other who puts me in question, perhaps I *will have* heard the language of the feminine in a way that is not insignificant despite its silence. Perhaps we could think of the feminine welcome as a kind of message in a bottle: sent in a past *before* representation, and arriving only *after* my representations have been put into question by a stranger who calls me to presence and demands that I justify myself. Like an echo re-echoing, both startlingly new and older than the present, feminine writing will have inscribed me in an economy of excessive giving that is both prior to the restricted economy of virility and disruptive of it.[21]

To be sure, Levinas does not compare the "silent language" of the feminine Other to writing; nor does he acknowledge writing as a possible mode of ethical contact. In *Totality and Infinity*, he explicitly favors the ethical immediacy of speech over the ambiguity of writing; for in speech I cannot evade the presence of the Other who calls on me to justify my existence and stand behind my words. In speech, "I am the unfailing source of ever renewed deciphering. And this renewal is precisely presence, or my attendance to myself" (TaI 182; TeI 199). Levinas states quite clearly that the written work fails to call me to responsibility like the presence of a speaking face. The work of the Other does not present the face of the Other *as* a face, but remains

> delivered over to the anonymous field of the economic life, in which I maintain myself egoist and separated, identifying in the diverse my own identity as the same, through labour and possession. The Other signals himself but does not present himself. His works symbolize him. . . . To be expressed by one's life, by one's works, is precisely to decline expression. Labor remains economic; it comes from the home and returns to it, a movement of Odyssey where the adventure pursued in the world is but the accident of a return. (TaI 176–77; TeI 192)

For Levinas, the written work remains caught in the closed circle of economy and possession. And yet, as I have argued, the economy of dwelling is never absolutely closed; the *oikos* of possession already responds to an *ethos* of feminine welcome, a "silent language" that fractures the circle of economy precisely in its silence. This feminine language suggests the possibility of a writing that resists the logic of the "work," a writing that departs without the assurance of an Odyssean return. We should remember that Levinas, too, offers his critique of the work *in writing*, in a book that orients the reader toward the face of the Other, and (while it may not present the face as such) sends a reminder of the face's ethical significance to its readers. As the product of a single author, the book may be understood as merely a work; as writing

that already (silently) responds to the words of Others, and remains open to a reader who is always yet to come, the book will have been more than a work. Even if the author is not "there" to defend it, the book will have called for exegesis from a potentially infinite readership. Levinas acknowledges this point at the end of his preface to *Totality and Infinity*:

> The word by way of preface which seeks to break through the screen stretched between the author and the reader by the book itself does not give itself out as a word of honor. But it belongs to the very essence of language, which consists in continually undoing its phrase by the foreword or exegesis, in unsaying the said, in attempting to restate without ceremonies what has already been ill understood in the inevitable ceremonial in which the said delights. (TaI 30; TeI 16)

The writer remains both present and absent in the text, speaking from the past but also from the future: and not speaking at all, but writing, in this mute or silent language. And yet there is a reader. Even if I do not intend to write for a reader, all writing exposes itself to the possibility of a reading or exegesis by the Other. This exposure to the eyes of an Other who is yet to come, and whose response I cannot control, might well be interpreted as a misfortune, since I will not always be there to annotate my words or correct a false impression. But this exposure of the written text to the eyes of an Other is precisely what opens an ethical dimension in writing, an exterior, a plurality of readers who will have responded to what I write "at this very moment."[22]

This account of the ethical potential in the "silent language" of the feminine Other raises the question of how to read, interpret, or listen to this language, responding to her (possible, and possibly silent) command. We find a clue in Levinas's account of listening to the (masculine) stranger. Levinas claims that my response to the absolute Other's questioning *engenders* me for responsibility:

> The face [of the stranger] I welcome makes me pass from phenomenon to being in another sense: in discourse I expose myself to the questioning of the Other, and this urgency of the response—acuteness of the present—*engenders* me [*m'engendre*] for responsibility; as responsible I am brought to my final reality. This extreme attention does not actualize what was in potency, for it is not *conceivable* [*concevable*] without the Other. (TaI 178; TeI 194, my emphasis)

The question of the Other *engenders* me as a responsible self; it makes this responsible self *conceivable*. I receive responsibility from the Other by listening with a kind of extreme attention. Later in this passage, Levinas writes: "To be attentive is to recognize the mastery of the Other, to receive his command, or, more exactly, to receive from him the *command to command*" (TaI 178; TeI 194, my emphasis). To receive a command from the Other is to let it be engendered in me, such that I might be said to "give birth" to

commanding. This is not merely a repetition of the same, but rather a new generation of command, an inheritance I do not keep for myself but rather pass on to another, with a temporality that is discontinuous and infinite. To receive from the Other the command to command is both to respond to her and to demand a response from another self in whom I, too, engender the command to command.

How do these reflections on writing and listening bear on the self's delayed response to the feminine Other? The welcome of the feminine "engenders" in me a welcome that I am commanded to pass on to another. As I have argued, the feminine welcome does not straightforwardly *make* the self responsible, nor does it merely make him virile and self-possessed. The very fact that she *gives* me the possibility of mastery indicates that this mastery is already questionable, thanks to the ambiguity of the feminine gift. The self's ability to possess a restricted *oikos* is already founded on a certain *dis*possession, an anarchic response to the *ethos* opened up by the silent language of the feminine Other. That this response is not immediately recognized as a response, but rather represented as the autonomous mastery of the self, is the genius of a feminine gift that refuses to circulate in the closed economy of debt and repayment, and that thus allows—or even commands—the engendering of welcome for another stranger. In this sense, the ethos of welcome is both *prior* to the economy of dwelling, and also *presupposes* this economy. The feminine welcome will have made possible the dwelling where I welcome the stranger, giving more than I could ever possess for myself. While my own gesture of welcome may in a sense repeat the gift of the feminine Other, it does not return this gift to its origin; rather, it carries the welcome forward to another, and another, and another—in an infinite but discontinuous movement beyond the closed circle of a restricted economy.[23]

If this is the case, then to respond to the Other is, in a certain sense, to be *feminized* by the face-to-face encounter, to the point where I welcome the stranger without reserve: not simply as a guest, but rather as a master who turns me into a guest in my own home. If the feminine Other is "the welcoming one par excellence," then to welcome the Other is to become *like* the feminine for a stranger. Just as the feminine Other once welcomed me "naked and indigent" into the home (TaI 127; TeI 133), so, too, do I welcome the stranger in his "nakedness," "hunger," and "destitution" (TaI 75; TeI 73). This welcome may be silent; it may be articulated only by an open hand, or by the gesture of withdrawal. But it is nevertheless a welcome that makes me like a guest in my own domain, prior to the sense in which I am a master there. I only become responsible for the Other by having this virile mastery called into question, but perhaps this means that I only become responsible by becoming somehow *like* the feminine Other who welcomed me—becoming receptive, discrete, and withdrawing for a stranger without expectation of return. In this sense, to respond ethically to the stranger in a face-to-face encounter would mean opening up a feminine economy of nonreciprocal, asymmetrical generosity. To

put this another way, the ethical response involves a *feminization* of the self, to the point of welcoming the stranger *as* or *like* a feminine Other.[24]

If the feminine welcome could not be forgotten or taken for granted, then the economy of hospitality might threaten to close over itself in a circle that excludes any interruption from strangers. But if the feminine welcome could not be *remembered* as well as forgotten, there would be no intimacy, no gentleness to extend to the stranger who interrupts my dwelling. I am welcomed by the feminine Other in such a way that I can fail to perceive the welcome *as* a welcome, representing myself as autonomous, masterful, causa sui. And yet even this representation is already a response, though a poor one, to the feminine welcome. To respond well to the gift of the feminine Other would be to receive birth as a gift that commands me to give to Others: a welcome that engenders welcoming in me, and commands me to become for a stranger "the welcoming one par excellence." The feminine welcome already articulates ethics as a response that underlies virile mastery and troubles it in advance: a response that makes questionable the very mastery that it also makes possible. This question may be a silent question; it may be implicit in the generosity of the feminine welcome. But it is nevertheless a question that bears listening—or, indeed, reading.

CHAPTER FOUR

Fathers and Daughters: Levinas, Irigaray, and the Transformation of Paternity

For Levinas, the responsible self exists *for the Other* prior to existing in- and for-itself. While this sense of responsibility marks a radical break with traditional ethics and metaphysics, the fact still remains that in the history of the West, women have long been expected to exist for-the-Other, and often prevented from ever existing in- and for-themselves. Only in recent decades have women been able to approach the "virile" possibilities that have been the prerogative—and the ethical pitfall—of European men for centuries. Women have for too long been expected to give selflessly, without reciprocation and as the seemingly natural consequence of social or biological imperatives. We may identify this mode of hospitality as somehow feminine, recognizing that the significance of such generosity is exhausted by neither social mores nor biology; we may even recognize hospitality as an ethical command, insisting that the virile self be feminized by the encounter with an Other in becoming responsible. But despite our best intentions, any simple identification of ethics with femininity would risk reinscribing the patriarchal image of the good mother who is ethical by default and so not really ethical at all. Given the historical position of women in the West, how can a woman reader of Levinas respond to the images of femininity in his work without reducing these images to a simple reflection of the patriarchal oppression that has designated, and in many ways continues to designate, women as the "second" sex?

The urgency of this question intensifies when we begin to consider the significance of paternity and maternity in the work of Levinas. In *Totality and Infinity*, parenthood is understood almost exclusively as the transcendent relation of a father to his son. Despite the implicit figuration of given birth as a welcome from the feminine Other, *giving* birth would seem to be a wholly masculine affair. The feminine Other offers herself in erotic "voluptuosity"; but for Levinas, it is the paternal self who is truly "fecund," giving birth to a

son who renews the father's own relation to past and future time. I will consider the relation between birth, time, and gender in detail in the chapters to come. For the moment, I want only to suggest that we need something like a *renewal* of time for women: a renewal of the sort that Levinas describes in relation to paternity, but does not yet seek for the feminine Other. We need a new and altered relation to the past for mothers in particular: a time when maternal generosity is no longer forgotten or discounted. This new, feminist past would refer to a time that never *was* but that *will have been* thanks to a future transformation of the past. In this future anterior lies the promise that the feminine Other will be remembered not only as a condition for the responsibility of an implicitly masculine self, but rather as herself *responsible* for the Other, both an inspiration for ethics and already its accomplishment. Is this not precisely what feminism seeks: hope for a different future that is not merely continuous with the past, and for a past that can be infused with a new and altered significance? We do not seek virile transcendence for women, but rather an alternative to virility and to the image of femininity that is required to sustain it. Perhaps the ethical temporality described by Levinas can help us to think through this alternative, even if he himself stops short of it.

In this chapter, I bring these manifold feminist concerns to a critique of paternity in *Totality and Infinity*. For Levinas, birth signifies neither mindless biological repetition nor the existential need to choose one's own origin. Rather, giving birth engenders my responsibility for an Other to whom I am related across a *discontinuous temporality*. The child is both myself and a stranger; he is both here before me and already beyond me, ahead of me, pointing toward a time that is not merely a repetition of the past, but promises a radically new and different future.[1] While I can in some sense partake in the transcendence of the Other as child, this transcendence is not *my own*; I do not immortalize myself or transcend my own death through the birth of the child. Rather, the child makes a new beginning, calling me forth to a transformative renewal of the self and to an ethical alteration of past, present, and future time. However, for Levinas, the relation between parent and child is unequivocally stated as a relation between *father* and *son*. Giving birth is *paternity*. It is not a relation between bodies, and it is not a relation of which the feminine Other is capable; rather, it is an ethical relation between men, for which women seem to be merely the pre-ethical condition. Through eros and voluptuosity, the feminine Other gives a son to the father; but, for Levinas, the erotic relation with the feminine remains too close, and the separation between lovers too ambiguous, to make room for a discontinuous relation between man and woman—or even, it would seem, between woman and child. Drawing on Irigaray's critique of eros in *Totality and Infinity*, I will argue that the discontinuous temporality that Levinas describes as a "paternity" cannot be coherently restricted to fathers and sons. The exclusion of mothers and daughters from fecundity is not only unjust; it also threatens to turn the radically discontinuous relation between parent and child into a closed economy of giving and being-forgiven.

In the final section of this chapter, I consider Levinas's reference to Isaiah 49, repeated twice in his account of paternity. There are no fathers or sons mentioned in Isaiah 49. Rather, there is Zion: a mother and a daughter who welcomes her children home from exile as distantly familiar strangers. A close reading of this verse disrupts the representation of sexual difference in Levinas's account of "paternity," allowing us to think differently about the gift of birth, both within the text of *Totality and Infinity* and beyond it. Throughout this chapter, I seek a more ethical treatment of Levinas' ethical relation, and a more generous interpretation of the feminine Other than Levinas is often willing to give.

PATERNITY AS INFINITE DISCONTINUITY

For Levinas, the child is not merely the offspring of biological repetition, or the cultural product or "work" of the parent. Rather, the child to whom I give birth is an Other whose arrival alters my own existence; he is myself become an Other, but with neither the existential transcendence nor the alienation to which Beauvoir refers in her account of reproduction. For Levinas, the alterity of the child engenders in the parent an alteration of the self, a transformation from one who is welcomed to one who welcomes an Other; this transformation also alters the self's relation to past and future time. Rather than plunging me into the endless circularity of the species, the birth of the child opens up for me an *ethical* temporality of forgiveness and promise. Who, then, is the child? Levinas writes:

> My child is a stranger (Isaiah 49), but a stranger who is not only mine, for he *is* me. He is me a stranger to myself. He is not only my work, my creature, even if like Pygmalion I should see my work restored to life. The son coveted in voluptuosity is not given to action, remains unequal to powers. No anticipation represents him nor, as is said today, projects him. (TaI 267; TeI 299)

The child is neither my project nor my work. As Arendt has already pointed out, the child is not an artifact that is made as the poet makes a poem, nor as Pygmalion makes his beloved statue; he is not the product of a single author or storyteller. Nor can the child be understood within the existential language of anticipation or projection. The time that the child opens up is not my own future, but rather a new and unprecedented time: the future of the Other. This time, which is not mine but which I engender in the child, brings forth something "new under the sun." This sense of the child as stranger and newcomer recalls Arendt's concept of natality; it also reaches beyond the active initiative implied by natality, remaining (as Levinas says) "unequal to powers," affected by the Other in the deep passivity of givenness (TaI 267; TeI 299). For Levinas, the child is not primarily an actor; giving birth to a child exceeds the category of praxis by invoking responsibility for the Other, which is less an action than an affectation, a passivity that comes to me from the Other and disables

my capacity to undertake action. From this persepctive, birth marks the double passivity of receiving and being received; neither the welcoming one nor the welcomed can be said to initiate, but only to be initiated *by* the Other.

The child, neither project nor work nor outcome of action, arrives as a stranger to the one who gives birth. But unlike the stranger who comes from above to put me in question, the child is *both* me and not-me, both a stranger and myself: "He is me a stranger to myself" (TaI 267; TeI 299). But how can the child "be" me without endangering the sense in which he also remains a stranger, or *not* me? In order for the logic here to work, the child must alter the significance of the pronoun "me" or the verb "to be"—or both. If I am a stranger, then the identity of the I must be split apart to accommodate this stranger. There is no room for the "I" to "be" an Other if the ego clings possessively to itself.[2] But the coming of the child not only alters my self-identity; it also alters the very significance of being, the substantiality of substances. To "be" the Other while still remaining myself—and while still letting the Other escape my grasp as a stranger—gives the verb "to be" an *ethical* as well as ontological significance. In this context the phrase, "he is me," does not express an identity between myself and the Other but rather a displacement of my identity for the sake of the Other: "He is me *a stranger to myself.*" In giving birth to a child who is both familiar and strange, the self becomes like a stranger to itself, a guest in its own home. Levinas calls this alteration a *trans-substantiation* rather than alienation or transcendence; it transforms the very substance of the self from a virile ego with abilities, interests, and powers into a responsible "me" who responds to and for an Other. Levinas explains: "The relation with the son in fecundity does not maintain us in this closed expanse of light and dream, cognition and powers. It articulates the time of the absolutely Other, an alteration of the very substance of him who can—his trans-substantiation" (TaI 269; TeI 309).

This transubstantiation of the self does not merely bring about a change within me, but also engenders the Other as a stranger for whom I am responsible. As Robert Gibbs puts it, "The relation to the child represents fecundity not of my life nor of my being but rather of my responsibility. I am responsible for my child's responsibilities" (Gibbs 1999, 11).[3] "Being" my child means being responsible, not only for the child himself but for the child's own responsibilities, which I have not chosen or initiated myself. I cannot control how the child will respond to an Other, but in giving birth to him, my responsibility extends beyond what I have done or what I am, such that I respond even for the responsibility of the child. This is the precise reversal of inherited guilt or original sin; here, the sins of the father are not visited on the son but rather the father is given, along with the son, a responsibility for the son's own responsibilities. While guilt refers to the past, responsibility opens up a future. For Levinas, the relation between parent and child is irreversible and asymmetrical: "The son is not me, and yet I am the son" (TaI 277; TeI 310). My existence goes forth toward the child, but this does not mean that the child's existence therefore returns to me; filiality is not the same as paternity. While the father breaks free

from his I through the birth of a son, the son himself is only entering into the drama of selfhood and egoism; he, too, will someday become responsible for an Other. The future means something quite different for the father and for the son, even if it emerges from the encounter between them.

To be responsible for the Other's responsibility—both to be my child and to be transubstantiated by the child—is to have my identity disrupted, but not dissolved altogether. I am still me when I give birth to the Other, but I am no longer a virile I. To become a parent is to be brought back to myself but thrown out of my self-possession, relieved of my "tragic egoity," released from the burden of my own desire for mastery (TaI 273; TeI 306). Levinasian paternity interrupts the economy of representation in which I would depart from my home only to return, newly enriched by my adventures in otherness. But it also interrupts the circle of biological time described by Beauvoir and Arendt, in which the self would be trapped by reproduction in the endless time of the species. Levinas writes that, in giving birth to an Other, "the I does not disappear but *is promised* and called to goodness, the infinite time of triumph without which goodness would be subjectivity and folly" (TaI 280; TeI 313, my emphasis). The parent neither dies nor is reincarnated in the child, but rather finds himself displaced from his egoism and bound to the Other with a *promise*. In giving birth, I am given the hope but also the responsibility of knowing that time does not end with me, that there will be new and different times that neither alienate me nor belong to me. To promise is to give one's word, to send oneself forth toward an Other. My responsibility for the child's responsibility promises me to the Other beyond any future that I could anticipate or guarantee; this contingency of the future produces a time that is new and full of hope: the time of the Other. Thus, my promise *to* the child is bound to the promise *of* the child: the promise of a new and undisclosed future. In his newness, the child is unlike anyone who came before, and so this child—any child—brings with him the promise that the future may be otherwise than the past. The child is not merely the "repetition" or "reiteration" of the self (TaI 268; TeI 300); he is a stranger and a newcomer, and as such he brings a future that is discontinuous with the past and the present. Levinas calls this future of the child an "absolute future" (TaI 268; TeI 300); it opens an infinity of generations beyond the limited future of projects represented by the phrase "I can." The absolute future is not merely an extension of the present moment, nor is it an ecstatic future of projection and anticipation. Rather it is an infinite future, radically discontinuous with the past and present; it marks the time of the Other, and not of myself. Levinas writes:

> The I as subject and support of powers does not exhaust the "concept" of the I, does not command all the categories in which subjectivity, origin and identity are produced. Infinite being, that is, ever recommencing being—which could not bypass subjectivity, for it could not recommence without it—is produced in the guise of fecundity. (TaI 268; TeI 300)

The identity of the father is neither extended nor extinguished in the son; rather, it recommences or starts anew. This recommencement does not return the father to his own origin in birth, but rather marks a certain *rebirth* of the self in giving birth to an Other.[4]

The infinite recommencement of the father in the birth of the son does not only happen *in* time; it happens *as* time, as the renewal of a time released from fate. While Heidegger's analysis of Being-towards-death may account for the finite time of individual Dasein, Levinas's analysis of fecundity opens up an infinite dimension *within* time, where infinity is understood not as an eternal circle but as the discontinuous renewal of the finite self. Levinas writes: "Infinite time does not bring an eternal life to an aging subject; it is better across the discontinuity of generations, punctuated by the inexhaustible youths of the child" (TaI 268; TeI 300). Between my time and the time of the child an unbridgeable gap remains: the "discontinuity of generations." Thanks to this gap, time is punctuated; it can recommence, not as the extension of my own life into a timeless eternity but precisely as the *difference* between myself and the Other, a difference that ensures a multiplicity of times. Levinas writes:

> Infinite being is produced as times, that is, in several times across the dead time that separates the father from the son. It is not the finitude of being that constitutes the essence of time, as Heidegger thinks, but its infinity. Resurrection constitutes the principal event of time. There is therefore no continuity in being. Time is discontinuous; one instant does not come out of another without interruption, by an ecstasy. In continuation the instant meets its death, and resuscitates; death and resurrection constitute time. But such a formal structure presupposes the relation of the I with the Other and, at its basis, fecundity across the discontinuous which constitutes time. (TaI 284; TeI 317)

Fecundity is not merely the ontic structure that accompanies the ontological discontinuity of time. Rather, time *presupposes* fecundity—fecundity *produces* time. The infinity of time, understood in terms of a discontinuous recommencement, depends on the birth of the child, but also on the death of the parent. Time "is" the birth and rebirth of the instant, not in accordance with the logic of Being, but rather thanks to the capacity of the child to start again, and to forgive the father's past rather than inherit his sins.

Because infinity is engendered by the child, and by the child of the child, birth is not the endless repetition of the same but rather the arrival of difference and of hope. The father does not "make" the son as Pygmalian makes his statue; rather, the son brings forth in the father a desire that does not consist in "being satisfied and in thus acknowledging that it was a need, but in transcending itself, in engendering Desire" (TaI 269; TeI 302). In giving birth to the child, I give birth not only to another "me" but also to desire for an Other whose desires go beyond me and do not return to me, desires which might even contradict my own. Levinas explains: "The other that Desire desires is again

Desire; transcendence transcends toward him who transcends—this is the true adventure of paternity, of the trans-substantiation which permits going beyond the simple renewal of the possible in the inevitable senescence of the subject" (TaI 269; TeI 302). This is what infinity means concretely: desire engendering desire in an Other, responsibility engendering responsibility for an Other. The parent is not only responsible for the child and the child's responsibility; he also *engenders* responsibility in the child, such that the child may bring forth a new generation of responsibility. This does not mean that I should be able to foresee or forestall any actions my child might undertake; rather, it is precisely insofar as they are unforeseeable and unknowable that I am responsible for my child's actions. Ethical responsibility does not arise out of action, but rather despite my actions, despite what I have caused or what I deserve. In giving birth to the child in fecundity, the parent gives the child the capacity to give to Others: "Fecundity engendering fecundity accomplishes goodness: above and beyond the sacrifice that imposes a gift, the gift of the power of giving, the conception of the child" (TaI 269; TeI 302). My responsibility for the child engenders responsibility *in* the child.

The radical promise of the child not only brings hope for the future, but also hope for the past: hope that the significance of the past might be altered in forgiveness, rather than endlessly repeated. As Arendt observes, no one can forgive herself; I can only be forgiven by an Other who gives this gift freely and, along with it, gives an altered significance to my past. Forgiveness from the Other gives my past back to me, not as my own possession but as an undeserved and unanticipated gift. Thus, forgiveness disrupts the fateful circularity of biological time drawn in Beauvoir's account of birth, not by allowing me to reverse the flow of time at will or to "take back" what was once lost, but rather by arresting these powers of appropriation. Forgiveness is not a time capsule; rather, it is

> constitutive of time itself. The instants do not link up with one another indifferently, but extend from the Other unto me. The future does not come to me from a swarming of indistinguishable possibles which would flow toward my present and which I would grasp; it comes to me across an absolute interval whose other shore the Other absolutely other—though he be my son—is alone capable of marking, and of connecting with the past. (TaI 283; TeI 316)

Understood in terms of promise and forgiveness from the Other, time acquires an *ethical* significance. This ethical time comes to me from the Other, not as my own possession but as a time of responsibility *for* the Other. To speak of time as "my own" would be to deny this sense in which time is the gift of the Other, such that there would be no meaningful future without this Other who forgives me and to whom I am bound by a promise.

To be forgiven is not to extend one's powers back over the past nor to take it back as my own, but rather to be dispossessed of my powers, exposed to an

Other who alters my substance and gives back the past as a free or unearned gift. The forgiven self is not removed from time, as if it were no longer affected by time's passing. It remains as a self who ages, who bears a past and a future that it cannot escape altogether. Thus, forgiveness does not relieve me of my responsibility, but rather redoubles it; I am responsible not only for my own existence and actions, but first and foremost for the time of the Other, and even for the time that the Other gives to me. "This recommencement of the instant, this triumph of the time of fecundity over the becoming of the mortal and aging being, is a forgiveness, the very work of time" (TaI 282; TeI 315, translation slightly altered). Even if the child does not make the burden of my past disappear, perhaps he makes this past lighter for me to bear. Lighter *for me*: because I still remain, altered but *there*, no longer an integrated, masterful self, but nevertheless *someone*. There must be someone to bear responsibility; ethics does not exist in the abstract. But this responsibility cannot be borne by one who remains unchanged by the bearing.

Forgiveness loosens the significance of past and future time from any definitive identity or fate. Levinas explains: "Without multiplicity and discontinuity—without fecundity—the I would remain a subject in which every adventure would revert into the adventure of a fate. A being capable of another fate than its own is a fecund being" (TaI 282; TeI 314). As one who gives birth, I do not control this future of the Other; rather, I bear responsibility for it despite this absence of control. The renewal of time in paternal forgiveness suggests a different kind of anterior posteriority from that of representation. Levinas continues: "[T]he paradox of forgiveness depends on its retroaction; from the point of view of common time it represents an inversion of the natural order of things, a reversibility of time" (TaI 283; TeI 315). But unlike the reversal of time found in representation, forgiveness does not buttress the powers of the virile self; it challenges my powers and releases me toward a future and a past that are not entirely of my own making. While representation effaces and forgets the Other whom it nevertheless requires, forgiveness would disappear without the memory of the one who forgives. And yet, as I will argue, Levinas's account of paternal forgiveness does implicitly forget the Other whom it requires for fecundity. In what follows, I trace this problem to Levinas' exclusion of the feminine Other from the fecundity of time.

The problem with forgiveness in *Totality and Infinity* concerns a certain reciprocity in the relation between father and son. The father gives birth to the son, engendering in him desire and responsibility; but it is the son who gives time to the father by forgiving him and so releasing him from the burden of his own past. Levinas writes:

> Forgiveness refers to the instant elapsed [*écoulé*]; it permits the subject who had committed himself in an elapsed instant to be as though that instant had not elapsed, to be as though he had not committed himself. Active in a stronger sense than forgetting, which does not concern the reality of the event

forgotten, forgiveness acts upon the past, somehow repeats the event, purifying it. But in addition, forgetting nullifies the relations with the past, whereas forgiveness conserves [*conserve*] the forgiven past in the purified present. The forgiven being is not the innocent being. (TaI 283; TeI 315–16, translation slightly altered)

Forgiveness does not erase or annihilate the past; it does not transform me into a blank slate, ready for reinscription. Levinasian repetition does not make a claim on the past, nor does it discard it; rather, it transfigures the self's own relation to pastness. The forgiven past does not restore my innocence or make my mistakes disappear, but rather alters the ethical significance of these mistakes, and so alters the significance of the past itself. Levinas claims that forgiveness "adds something new to being, something absolutely new" (TaI 283; TeI 316); yet it also "somehow repeats the event, purifying it." This "purification" of the past in forgiveness not only alters the significance of the past; it also "conserves the forgiven past in the present." Does the language of conservation and repetition here not moderate the alterity of the past in forgiveness, as if it were merely a past extended or even re-presented in the past?[5] The language of conservation, repetition, and purification raises doubts for me about the relation between paternity and the time of forgiveness. The son does not only release the father from the burden of past mistakes, but also allows him to regard his past commitments "as though he had not committed himself," as though the past had not "elapsed" or "flowed on" [*écoulé*]. Forgiveness would thus seem to let the father hold on to the past as if it were not quite lost, as if the past could belong to an elastic, conserving present. Even if the father depends on the son for this conserving relation to time, it is difficult to see how such a relation would avoid extending the powers of the self, rather than challenging them as Levinas claims. Indeed, on closer examination it appears that while the father gives birth to the son, the son *gives time* to the father, both purifying his past and renewing his relation to the future. Does this not begin to suggest a circle of mutuality between father and son, in which the "gift" of birth is exchanged for the "gift" of past, present, and future time?

There is a hint of circularity between father and son, a gift that is not extended to the daughter but only to the more familiar child: the son. In her reading of paternity in Levinas, Kelly Oliver comments:

> The father is his son and yet the son is a stranger to the father and the paternal relationship makes him a stranger to himself. Yet, how can the son be an absolute other if he is also the same? Is it the son's difference or his sameness that restructures the I through alterity? Wouldn't a daughter be a stranger child? (Oliver 1997, 213)

In the following section, I examine the exclusion of a feminine Other or mother from the generosity between fathers and sons through a reading of Irigaray's response to Levinas's phenomenology of eros. In addition to the questions that

Oliver poses above, and inspired by her own response to these questions, I ask: In what sense is the feminine Other forgotten or even sacrificed in *Totality and Infinity* so that the father can find forgiveness in the son? And if this sacrifice is required, how can paternity open up the absolute and infinite future that Levinas promises? So long as giving birth is understood solely in terms of the father and the son, it risks lapsing into a circular exchange that compromises the radical gift of birth. And yet I will argue that a different sort of promise may be found in Levinas's twice-repeated citation of a passage from Isaiah 49, in which the central figure of Zion is neither a father nor a son, but both a mother and a daughter.

OTHERWISE THAN PATERNITY: IRIGARAY READING LEVINAS

In *Totality and Infinity*, the relationship between father and son is only possible given an erotic encounter with the feminine Other, who appears to the self as a voluptuous beloved. The father alone cannot engender the child; this is part of what distinguishes the child from a work of art or the product of a single author. Without the feminine beloved, the transubstantiation of the self in paternal fecundity could not take place. Levinas acknowledges this when he writes:

> I love fully only if the Other loves me, not because I need the recognition of the Other, but because my voluptuosity delights in her voluptuosity, and because in this unparalleled conjuncture of identification, in this *trans-substantiation*, the same and the other are not united but precisely—beyond every possible project, beyond every meaningful and intelligent power—engender the child. (TaI 266; TeI 298, translation slightly altered)

Here, the transubstantiation of fecundity already occurs in the relation of voluptuosity that promises to engender the child. Thus, fecundity—and the transubstantiation of the self that it implies—requires *another Other* beyond the father and the son. Fecundity, like hospitality, requires a feminine Other who was already there by the time I notice that she has slipped away. And yet, as Levinas claims again and again, the self's relation to the feminine beloved only brings the promise of transubstantiation insofar as it also promises to engender a child. Voluptuosity—the relation to an Other whom I love and caress—does not yet bring forth the absolute future of fecundity; only a son promises this infinite renewal of time for the father. But as Irigaray argues in her reading of the section in *Totality and Infinity* entitled, "The Phenomenology of Eros," this hierarchy between feminine voluptuosity and paternal fecundity threatens to reduce the beloved woman to a means to an end, a condition for the lover's own ethical and temporal enrichment.

For Levinas, eros remains caught between immanence and transcendence, need and desire, voluptuosity and fecundity. The voluptuous relation

to a feminine Other pulls me back toward an enjoyment that is prior to ethics, even as it draws me forth toward the future birth of the child. But unlike the fecundity of birth, eros tends to lock the lover and beloved in a mutual embrace, a closed society that excludes all Others.[6] Voluptuosity is not yet (or no longer) an ethical relation; it circulates within a closed economy of mutual giving and receiving, touching and being touched. Levinas writes: "If to love is to love the love the Beloved bears me, to love is also to love oneself in love, and thus to return to oneself" (TaI 266; TeI 298). In eros, the self encounters an Other, but it already begins to rebound to itself through this encounter; as such, the self does not encounter the beloved as an absolute Other for whom it is responsible. Rather, the mutual enclosure of the voluptuous embrace seems to create a kind of solitude-together, a "dual egoism" (TaI 266; TeI 298). Together the lovers plunge back into the immanence of enjoyment, their voluptuous embrace suspending for a moment the demands of the world and of Others. For Levinas, voluptuosity does not obligate me to the beloved but rather signals a release from obligation, a brief suspension of serious concerns. Erotic life opens an ethical dimension only by becoming fecund and giving the father a son who alters his being and time. While Levinas admits that "the encounter with the Other as feminine is required in order that the future of the child come to pass from beyond the possible, beyond projects," nevertheless she is only "required" in order to give a son to the father (TaI 267; TeI 299). Levinas calls the feminine beloved herself "infantile" (TaI 259; TeI 289), "a bit silly" (TaI 263; TeI 295), an "amorphous non-I" (TaI 259; TeI 290), a "virgin" who remains "forever violable and inviolable" (TaI 258; TeI 289). She is almost not even human, resembling rather "an irresponsible animality which does not speak true words" (TaI 263; TeI 295). Levinas's language here is provocative and even offensive: "The frailty of the feminine invites pity for what, in a sense, is not yet, disrespect for what exhibits itself in immodesty and is not discovered despite the exhibition, that is, profaned" (TaI 262; TeI 294). The feminine Other—less than an Other and even less than a self—does not bring forth an infinite future but rather a time that is not yet accomplished until she produces a son.[7]

For Levinas, the central problem with eros would seem to be its equivocation and ambiguity. Eros places oneself "at the same time beneath and beyond discourse" (TaI 255; TeI 285). It demonstrates "the simultaneity of need and desire, of concupiscence and transcendence, tangency of the avowable and the unavowable . . . *the equivocal* par excellence" (TaI 255; TeI 285–86). The equivocation of eros seems to threaten the absolute distance between oneself and the Other. I am too close to the Other in voluptuosity; the gap that separates me from the absolute Other or stranger seems to disappear in the erotic embrace: "In voluptuosity the other is me and separated from me" (TaI 265; TeI 297). Only the emergence of a child transforms eros into fecundity and opens the radical alterity that ethics demands. And yet the ambiguity of eros is not completely resolved in fecundity, since the child is also "me a stranger to myself," or

"a stranger who is not only mine, for he is me" (TaI 267; TeI 299). If the ambiguity of the child alters the substance of the self, why would the ambiguity of the feminine beloved fail to bring about such a radical alteration?

In her essay, "The Fecundity of the Caress," Irigaray argues that the erotic encounter with an Other already engenders the infinite responsibility and discontinuous temporality that Levinas finds only in paternity. Irigaray writes:

> Prior to any procreation, the lovers bestow on each other—life. Love fecundates each of them in turn, through the genesis of their immortality. Reborn, each for the other, in the assumption and absolution of a definitive conception. Each one welcoming the birth of the other, this task of beginning where neither she nor he has met—the original infidelity. (Irigaray 1986, 235)

For Irigaray, the literal birth of a child is not required to make the erotic relation fecund. Already in the voluptuous caress both lover and beloved are "reborn," altered by their contact with the Other's flesh, given a hopeful future and a forgiven past. The relation between lovers need not produce a child in order to open the discontinuity of generations; the caress already gestures back toward the generation of the mother who gave birth to both lovers in different times.[8] Irigaray calls this fecund caress a "naïve or native sense of touch" (Irigaray 1986, 231). It remembers the caress of that "most intimate mucous threshold" between mother and child, and at the same time affirms its immemorial pastness, its reference to a time that was not yet my own (243). The caress of the lover:

> give[s] me back the borders of my body and call[s] me back to the remembrance of the most profound intimacy. As he caresses me, he bids me neither to disappear nor to forget but rather, to remember the place where, for me, the most intimate life holds itself in reserve. Searching for what has not yet come into being, for himself, he invites me to become what I have not yet become. To realize a birth still in the future. Plunging me back into the maternal womb and, beyond that, awakening me to another—amorous—birth. (Irigaray 1986, 233)

The lover's caress both calls me back to a remembrance of my immemorial birth and calls me forth to a new birth in a future that is infinite and unfinished (*infini*). For Levinas, the ambiguity of love is condemned to immanence without the emergence of a son; for Irigaray, the lovers' caress already refers to a time that is not one's own, a time of infinite discontinuity between the generations. This discontinuity need not refer ahead to the generation of the son, nor even necessarily to a daughter; most immediately, it refers back to the generation of the mother without whom there would be no son, no daughter, and no lovers. While I do not propose a full reading of Irigaray's conception of erotic fecundity here, I wish to mark the difference between the forgetting of the mother in Levinas and the impossible but necessary memory of the mother in the feminist work of Irigaray.

This memory of the mother puts pressure on Levinas's distinction between voluptuosity and fecundity. Of the former, Levinas writes: "Love remains a relation with the Other that turns into need" (TeI 254; TaI 284). For him, this ambiguity between desire and need does not respect the radical nonreciprocity of the ethical encounter; my relation with the feminine Other is more needy, more dependent, and so less ethically pure than my response to the absolute Other. But perhaps this ambiguity is the secret of love, which Levinas glimpses but does not appreciate as ethically significant. Love remains a relation with the Other whose alterity interrupts any closed economy of exchange; when I love the Other, I give this love without demanding equal compensation. In the words of Cixous, I love the Other "without calculating . . . giving everything, renouncing all security—spending without a return—the anti-Ulysses" (1975, 75). And yet, the lover is not an absolute stranger to me; we are strange to one another in the midst of our familiarity and our mutual need. I give my love without calculating on the investment; miraculously, I find myself loved in return. The other's love for me is not *the same* as my love for him or her; the return is not a mirror reflection through which I get just what I give. And yet loving is not only a matter of giving; when love is love and not tragedy or pathos, the lover also receives love from an Other. Does this mean that love forms a closed circle of mutual passion, into which no third party may enter? Both Cixous and Irigaray argue that this is not the case, that in the midst of the intimate alterity between lovers a relation to the third already passes through like a trace that is neither present nor absent. In the midst of the erotic caress the native/natal caress of the maternal body passes through, remembering the intimacy between mother and child without returning to its "origin," carrying this strange intimacy forward to an Other. In this sense, love does not so much turn away from the mother and find a replacement for her, but rather transfers or transubstantiates a mother's love to the Other—shifts it, carries it forward.

Levinas's neglect of the potential fecundity between lovers not only degrades the feminine Other as a "silly" and irresponsible animal; it also betrays Levinas's own account of fecundity as a discontinuous relation to time and the Other. For if the feminine is only "required" so that the father might be forgiven by the son, then this requirement would reduce the son as well to little more than a reflection of his father. Irigaray argues: "The aspect of fecundity that is only witnessed in the son obliterates the secret of difference. As the lover's means of return to himself outside himself, the son closes the circle. The path of a solitary ethics that will have encountered for its own needs, without nuptial fulfillment, the irresponsible woman, the loved one" (Irigaray 1986, 245). The father who merely encounters the feminine beloved in order to be given (and forgiven by) his son compromises the radical temporal and ethical significance of fecundity precisely by guarding it too closely for himself. The infinite time of fecundity would be bought at the expense of the feminine Other who becomes, in Irigaray's words, "an object, not a subject

in touch, like him, with time. Dragging the [feminine] lover down into the abyss so that, from these nocturnal depths, he lets himself be carried off into the future" (238).

For Levinas, a temporal being is a "being independent of and yet at the same time exposed to the Other," simultaneously closed and open, capable of both exercising its powers and holding them in check (TaI 224; TeI 247). But the feminine Other is capable of *only* holding her powers in check, *only* withdrawing, and never claiming any time or space as her own. The feminine Other as Levinas describes her is generous and good, but she is generous and good by default; she could not be otherwise. As a result, her relation to the Other is not the relation of a *self* to the Other; her goodness does not quite constitute an ethical gesture. Thus, the feminine becomes a condition for time, but for this very reason remains atemporal; she becomes the condition for ethics, but remains non-ethical or pre-ethical. At this point, it seems important to remember that the feminine Other that Levinas describes does not, and has never, existed except as this imagined condition for something or someone else. The feminine Other—forever discrete, modest, and generous—is yet another face of what Beauvoir would call "the myth of woman." To understand a woman as either my mother or the mother of my son—and nothing beyond these two designations—is to limit the possible social and philosophical meanings of being a woman, and of ethics itself. For if ethics must rest on the condition of an Other who is there only for the sake of my own transformation and is thus denied any transformation herself, then ethics would not quite be ethical.

A feminist ethics of birth means remembering that I am never the absolute origin of my actions, that I am always already a guest in "my own" home, and that it is only thanks to a mother who once bore me that I can bear another. It means remembering that, despite my not being the origin of myself, I am still responsible *as* a self. I can only give time to an Other thanks to the (feminine) Other who gave birth to me, and whose generosity may be newly embodied in the lovers' intimate caress. The acknowledgment of birth as a condition for ethical life does not reduce the mother to *merely* a condition—unless, of course, a further effort is made to exclude her from ethics proper. I have argued, along with Irigaray, that the intergenerationality of birth opens not only toward the child but also (and first) toward the parent of whom I am the child. Do we not require—for woman and mothers in particular, not only for fathers and sons—a kind of forgiveness, a renewed relation to the past that will release us from the fateful repetition of past time? This forgiveness would not merely "conserve" the past in the present, but rather bring forth *a past that was never present*, a past that never "was" but in which I will have been more than I ever was. This anarchic past arrives as if from the future, as a gift from the Other; I will address this past/future at length in chapter 5.

The remembrance of the mother's gift would disrupt the potential circle between father and son; it would remind me that even the capacity to respond to the child does not originate in me, but comes to me from an Other and

goes beyond me toward another Other. In what follows, I argue that, despite Levinas's explicit reduction of the feminine Other to a condition for paternity in *Totality and Infinity*, there is an implicit reference to mothers and daughters that complicates my critique of fecundity in his text. My way of remembering and renewing this figure of the feminine Other in Levinas's work is to follow up the trace of the mother and the daughter in *Totality and Inifnity*, through the citation of a passage from the Book of Isaiah.

FROM PATERNITY TO THE MATERNAL BODY: ISAIAH 49

In order to resist enclosure in a circle of exclusive masculine privilege, the gift of time must be extended beyond fathers and sons toward mothers and daughters. Levinas may not explicitly deny this possibility, but by neglecting to mention that the child or the parent could be a woman, and by presenting the feminine beloved as a requirement for paternity, he implies that the masculinity of paternity forms an important part of its concept within his own work. Levinas refers explicitly to the mother (or, at least, to the "notion of maternity") only once in *Totality and Infinity*. This single reference to maternity confirms what Levinas sees as a contrast between the temporal and ethical significance of paternity and maternity:

> [B]y existing an existence which still *subsists* in the father the I echoes the transcendence of the paternal I who *is* his child: the son *is*, without being "on his own account"; he shifts the charges of his being on the other and thus plays his being. Such a mode of existence is produced as childhood, with its essential reference to the protective existence of the parents. *The notion of maternity must be introduced here to account for this recourse*. But this recourse to the past, with which the son has nonetheless in his ipseity broken, defines a notion distinct from continuity, a way of resuming the thread of history—concrete in a family and in a nation. (TaI 278; TeI 311, my emphasis)

Levinas distinguishes between the "recapture [*reprise*]" of the past in the midst of a rupture or discontinuity that characterizes the "infinite recommencement" of paternity and the "recourse [*recours*]" to the past for which maternity is held to account. This recourse is not the same as continuity; maternity is not simply an "inauthentic" form of paternity. However, it does signal for Levinas a protective relation that is different from paternity, perhaps since the latter seems not necessarily to engage in bodily relations such as feeding and sheltering the child, but only in the purer temporal–ethical relations of promise and forgiveness. The encounter with the feminine beloved may be necessary for paternity, just as the welcome of the feminine in the home was necessary for ethics; however here, as before, the serious business of ethics is left to the men. And yet it may be precisely here, as in our reading of the feminine welcome, that we find room for another possibility.

This possibility arises through an interruption in Levinas's own text when the voice of paternity speaks neither as a father nor as a son, but rather as Zion—a woman who is a daughter and a mother, but whose words are lifted from their context in order to speak for paternity.[9] While Levinas may explicitly exclude the feminine Other from paternity, he implicitly refers to the feminine in order to give voice to the temporal and ethical significance of paternity. Thus, the father only emerges *as* a father in *Totality and Infinity* by speaking as a mother and a daughter. This imitation of the feminine voice recalls the feminization of the virile self in hospitality (discussed in chapter 3), where the self learns how to welcome the stranger by becoming "like" a feminine Other for him. It also looks ahead to the language of *Otherwise than Being* (discussed at length in chapter 5) in which Levinas calls ethics itself a "psychism, like a maternal body" (OB 67, AE 109).

What does it mean for the father to speak as a mother or daughter? I began this chapter with a reading of the following passage: "My child is a stranger (Isaiah 49), but a stranger who is not only mine, for he *is* me" (TaI 267; TeI 299). Later, Levinas makes another brief reference to Isaiah 49. Paternity is

> a relation with a stranger who while being Other ("And you shall say to yourself, 'who can have borne me these? I was bereaved and barren . . .'" *Isaiah*, 49) *is* me, a relation of the I with a self which yet is not me. In this "I am" being is no longer Eleatic unity. In existing itself there is a multiplicity and a transcendence. In this transcendence the I is not swept away, since the son is not me; and yet I *am* my son. The fecundity of the I is its very transcendence. (TaI 277; TeI 310)

This second passage gives a stronger sense of the asymmetry between parent and child such that my existence goes forth toward the future of my child but the child's existence does not simply return to me. In the child I encounter a time that is not my own, in which I am released from my possessive egoism but not altogether swept away, and where the very significance of my "being" in time is altered, its ontological unity disrupted. In fecundity, ontology gives way to the nontotalizing, asymmetrical, nonrelating relation of ethics. No longer do I seek to transcend my own birth by laying claim to my past as a possession; rather, I transcend my ego by giving birth to a stranger who is not the same for me as I am for him. The asymmetry between different generations makes responsibility possible not as an economic relation of reciprocal support, but as the openness to an Other who opens to another Other, engendering an unexpected, unanticipated, and infinite future. In this context, Levinas refers—not once, but twice—to Isaiah 49. This double reference is by no means incidental to the significance of his own text; as a student of the Talmud, Levinas does not refer to scripture lightly. What, then, is the significance of this repeated reference to Isaiah 49?

The verse opens with God giving comfort to the prophet Isaiah, assuring him that He "will have compassion on his suffering ones," the children of Zion

(Isa. 49:13). But, in the midst of her despair, Zion protests: "The Lord has forsaken me,/ my lord has forgotten me." God responds:

> Can a woman forget her nursing child,
> or show no compassion for the child of her womb?
> Even these may forget,
> yet I will not forget you.
> See, I have inscribed on the palms of my hands;
> your walls are continually before me. (Isa. 49:14–16)

In this passage, God compares himself to a nursing mother who would never forget her own child. The verse opens with what at first seems to be a rhetorical question: "Can a woman forget . . . ?" But the implication is that God's memory exceeds even a mother's memory of her own nursing child. The divine memory is infinite, yet it is still figured in the flesh, "inscribed on the palms of my hands." This embodied, but infinite memory of God restores to Zion the sanctity of her walls, rebuilding her body after destruction. Like forgiveness, this memory repairs the past and brings the hope of a different, more promising future.

In the next verse, God continues to address Zion; here we encounter the words that Levinas cites directly in *Totality and Infinity*. God says:

> The children born in the time of your bereavement
> will yet say in your hearing:
> "The place is too crowded for me;
> make room for me to settle."
> Then you will say in your heart,
> "*Who has borne me these?*
> *I was bereaved and barren*, exiled and put away—
> so who has reared these?
> I was left all alone—
> where then have these come from?" (Isa. 49:20–21, my emphasis)

The children of Zion, born in a time of devastation and bereavement, are like strangers to their mother. They have grown up in exile, in the home of a stranger. Zion asks: *Who can these children be?* Could she really have borne them? They want more than she can give; indeed, she has nothing at all to give. She is barren, solitary, without a home, and without resources to give to an Other. The Hebrew word *nisharti*, translated here as "left all alone," refers in a strong sense to being *left over*, not only solitary but bereft: a remnant, remainder, survivor.[10] Zion herself is like a stranger in exile. Wandering and "put away," her walls have been torn and her land devastated. Even though Zion is a mother to these forgotten children, she still remains a child who fears that she too will be forgotten by her parent. In the language of *Totality and Infinity*, Zion is both like a child who exists only in being born to an Other, and like a paternal/parental self whose responsibility goes forth toward

a new generation of strangers. She is both a child given to the Other and a parent responsible for the child who "while being Other . . . is me" (TaI 277; TeI 310). God promises Zion:

> I will soon lift up my hand to the nations,
> and raise my signal to the peoples;
> and they shall bring your sons in their bosom,
> and your daughters shall be carried on their shoulders.
> Kings shall be your foster fathers,
> and their queens your nursing mothers. (Isa. 49:22–23)

The returning children—children who *will be* in the future, even if it seems impossible that they could have never been in the past—these children will bring with them the promise of a restoration and renewal that is needed precisely to welcome them home. For the present moment, Zion is in exile and she believes herself to be the sole survivor, the last remnant. But her children, whom she has forgotten and who have been reared in exile by strangers, will return to her and restore her integrity so that she may welcome them, both as strangers and as the children of her body. They will bring with them a future—and even a past—that in her present destitution seems impossible, inconceivable. By *remembering* Zion, and by inscribing her ruined walls on the palms of Her hands, God promises Zion the capacity to welcome her children home from exile as intimate strangers, or as an estranged family. In this sense God becomes for Zion like a "feminine Other" in *Totality and Infinity*; She gives the capacity to welcome strangers whose arrival on the doorstep commands me to give beyond my present resources for hospitality. And yet the *oikos* that God supports with His/Her bodily memory here is quite different from the *oikos* of the virile subject who dwells in the home like a king in his castle. Zion does not begin with a naïve egoism that is invisibly supported by a feminine Other and put into question by a stranger. Rather, she begins as a woman in exile, her identity already displaced and fragmented; she has no possessions to offer the strangers who return seeking shelter—nothing for herself and nothing to spare for the Others. The end of her exile and the rebuilding of her walls do not give rise to a moment of virility that then must be put in question by an absolute Other. Rather, Zion turns from givenness to giving without passing through the moment of possession.

In the figure of Zion, we glimpse the possibility of a different passage from birth to responsibility, distinct from the virile passage through enjoyment, dwelling, mastery, questioning, hospitality and paternity. Already Zion begins in exile and destitution; she is welcomed not by a discrete, withdrawing feminine Other but by a God who claims resemblance to a nursing mother who never forgets her child.[11] Zion's restoration is at the same time a welcome extended to familiar strangers; there is no moment of virile egoism to intervene here between dwelling and welcome. Zion is a mother, a daughter, and a stranger—but she is not quite the same as the father whom Levinas

invokes her to describe. For while the father must be called back from virility by a masculine stranger, Zion is *called forth* to responsibility, both by the children whom she awaits and by the God who remembers her like a nursing mother. While the paternal self may "require" a feminine Other to give him a home and then give him a son, Zion does not make use of an Other "in order that the future of the child come to pass from beyond the possible" (TaI 267; TeI 299). Her story suggests a different logic of responsibility—and a different relation between economic life and the ethics of hospitality—than Levinas articulates in the passage from virile ego to responsible father. For Zion, material sufficiency is not a condition for hospitality; rather, this sufficiency already arises in response to the demand for welcome and the bodily memory of a (divine) third party. This does not make the material aspect of welcome any less important than it is in Levinas's explicit account; it does locate, however, the materiality of food, shelter, and so forth already within an *ethical economy* rather than an ego-centred *oikos* that must then be reduced to an Other-centred *ethos*. In Isaiah 49, dwelling is not distinct from hospitality; Zion's "own" home is restored through the gift of hospitality and not through a gesture of appropriation.

Again, the material dimension of hospitality should not be forgotten here. Zion *needs* the walls, the food, and the sheltered space that help to constitute a hospitable dwelling-place; these are the economic dimensions of ethical life without which we might find ourselves with empty hands, unable to support Others or ourselves. Hospitality requires the material resources of dwelling, even if it also prevents us from claiming these resources as an exclusive possession. In Isaiah 49, ethical dwelling is made possible by a kind of memory that restores material well-being and rebuilds the walls that shelter us. In many accounts of exile and diaspora, this sort of memory is deeply implicated in the reconstruction of a just and ethical dwelling-place. In her essay, "Homeplace," bell hooks remembers the black women who preserved a sense of home, even in the midst of slavery. She writes:

> The act of remembrance is a conscious gesture honouring [the] struggle [of these women], their effort to keep something for their own. I want us to respect and understand that this effort has been and continues to be a radically subversive political gesture. For those who dominate and oppress us benefit most when we have nothing to give our own, when they have so taken from us our dignity, our humanness that we have nothing left, no "homeplace" where we can recover ourselves. (hooks 1990, 43)

Slavery—like exile and sexist oppression, though each in their separate way—attacks even the human capacity to give to Others. It attacks this capacity by insisting on the gift of hospitality as a requirement, or even by denying that one has anything worth giving. Through much of recorded history, women have experienced a strange sort of exile, having been *locked into* the home, and at the same time *locked out of* the right to regard this home as our own

domain. When I am forced from my home—and even when I am forced *into* a home, bound by domestic service—then I am not only denied the *oikos* of basic material goods, but also the *ethos* of giving hospitality. For the sake of this hospitality, and not for the sake of property or possession, dwelling is an ethical and political requirement of the self. I will explore this more radical account of an always-already dispossessed responsibility at length in chapter 5 on *Otherwise than Being*. In this later text—as if aware of a certain residue of virility in *Totality and Infinity*—Levinas alters his account of birth and ethics, shifting from the language of paternal responsibility toward the trope of the maternal body. This is not to suggest that *Totality and Infinity* is merely a failed first draft of *Otherwise than Being*; by drawing our attention to Isaiah 49 in his own explication of paternity, Levinas himself opens this text to an interruption from the outside.

I have argued that the figure of Zion disrupts the terms of *Totality and Infinity*, at the same time giving them the possibility of a new or altered significance. Zion is like a parent who gives birth to strangers, but she is also like a child received by a welcoming parent. She is like a stranger, wandering in destitution and calling out for hospitality, but she is also like a feminine Other, welcoming her children into a home which they both demand and, in so demanding, make possible. This is not to say that Zion collapses each of these positions into one, blurring the difference between them. Rather, she articulates this difference and gives voice to the difficult tension between positions for which we must somehow make room, even if it seems that there is no room. Far from representing the "protective" notion of a maternity that would sustain ipseity without yet opening onto (paternal) infinity, the figure of Zion disrupts Levinas's discourse on femininity and paternity from within. When Levinas cites Isaiah 49 in his discussion of paternity, he makes room for a reader to suggest that the "father" in paternity might also be a mother, that the "son" might be a daughter, and that the parent's own parent, God, might be like a mother who inscribes the memory of this child on her hands, and never fails to show "compassion for the child of her womb." The language of paternity in *Totality and Infinity* speaks the words of a remembering mother who addresses her daughter in exile. These are prophetic words, in which God promises Zion a future when her children will return home as if for the first time, and a new beginning will have become possible. Perhaps what Levinas seeks in paternity can be found already in the silent teaching of the feminine Other, and in the fecund embrace of the beloved, both of which engender responsibility in and for the Other—if only between the lines.

CHAPTER FIVE

Ethics and the Maternal Body: Levinas and Kristeva Between the Generations

For Levinas, to be born is to be welcomed by an Other who, though crucial to my existence, is not my cause and remains ontologically distinct from me. This welcome opens up an ethical temporality of promise and forgiveness that Levinas articulates in terms of paternal responsibility. The concept of paternity raises problems of its own that will be further addressed in this chapter. In what follows, I will suggest that the exclusion of the feminine Other in *Totality and Infinity* is related to a certain neglect of the self's embodiment or—to recontextualize Beauvoir's words in *The Second Sex*—a neglect of the "flesh that exists by and for another fleshly being" (Beauvoir 1952, 467). While embodiment may seem only obscurely relevant to paternity, maternity implies an ethics *in and of the flesh*.[1] I argue that Levinas addresses his own neglect of the flesh in *Otherwise than Being*, and in particular with the figure of the maternal body.

Otherwise than Being was published in 1974, thirteen years after *Totality and Infinity*. In this text, the focus of Levinas's inquiry remains on the self's infinite responsibility for the Other, but the language of this inquiry has altered dramatically. The responsible self no longer emerges through a narrative of enjoyment, dwelling, facing, and paternity. The moment of autonomy and mastery in the home has yielded to a sense of the self as already (or still) homeless, exiled, torn up from its foundations, not dwelling comfortably in a home, and not even settled in its own skin. It is a persecuted self, more like Zion in Isaiah 49 than like the virile self who dwells "at home with himself" in *Totality and Infinity*. The feminine Other has all but disappeared from Levinas's philosophical vocabulary, transformed perhaps into the enigmatic figure of the maternal body. But while the feminine Other gives room to the stranger by withdrawing discretely into the shadowy recesses of the home, the maternal body *gives herself*, her skin stretching to make room for

an Other; she not only provides but actually *becomes* a dwelling-place for the stranger. For Levinas, the maternal body gives despite herself, without having chosen to give; she emerges as wounded, persecuted, vulnerable, exposed, held hostage by the Other. This image resonates in certain ways with Kristeva's account of maternity as a visceral experience of pain. In "Stabat Mater," she writes: "One does not give birth in pain, one gives birth to pain: the child represents it and henceforth it settles in, it is continuous" (Kristeva 1987, 241). This pain is mixed with pleasure and even joy, yet Kristeva claims that "a mother is always branded by pain, she yields to it" (241). Both Levinas and Kristeva find an ethical (or, in Kristeva's case, a "herethical") significance in maternal persecution or pain.

How do we respond as feminists to these accounts of maternity that both recognize the importance of maternal embodiment for ethics and also seem to accept the image of maternity as a painful sacrifice of the self for the Other? What—if anything—separates this connection between ethics and maternal suffering from yet another recapitulation of the "myth of woman" that Beauvoir contests, in which feminine sacrifice justifies and compensates for masculine transgression?[2] Many feminists have been critical of both Levinas and Kristeva for their apparent acceptance and even celebration of women's self-sacrifice for the greater good of others. Stella Sandford argues that feminist readers of Levinas have been too willing to apologize for Levinas's persistent subordination of femininity and maternity to (implicitly masculine) "humanity" and paternity (Sandford 2000, 84–92); Elizabeth Grosz warns that Kristeva's account of the maternal body accepts too quickly the image of pregnancy as "the overtaking of women's identity and corporeality by a foreign body, an alien intruder" (Grosz 1990, 162). By moving between the work of Levinas and Kristeva, I suggest a different approach that acknowledges the importance, and indeed the goodness, of radical responsibility for the Other without accepting the claim that women ought to bear a greater share of the burden on account of our reproductive capacity. Rather, I look to the maternal body for inspiration in formulating an ethics of responsibility in which everyone, male and female, is called on to bear the Other in the flesh and "like a maternal body" (OB 67; AE 109). This is not to say that sexual difference does not matter; rather, it matters in such a way that no one is absolved in advance of the Other's demand for responsibility. The ambiguity of the word "like" in Levinas's phrase signifies both a similarity and a difference that promises to destabilize any simple identification between women and mothers, or between mothers and the ethical maternal body. A careful consideration of the *ethical temporality* involved in maternal bearing yields an account of responsibility that neither exalts nor excludes the possibility of a painful and difficult generosity for Others.

I begin this chapter with an account of the different or, as Levinas puts it, *diachronic* temporalities of gestation and pregnancy. While the gestating child may in some sense share the same space as the pregnant woman's body, they

do not share the same time; indeed, birth gives rise to a new time, a future that exceeds expectation and opens a dimension of hope. While Levinas does not claim to give an account of maternal experience as such but only of ethical maternity, my reading resituates this metaphor in relation to the embodied maternal experience from which it emerges. In this way, I hope to explicate the concepts of anarchy, diachrony, psychism, and inspiration while remembering where these concepts come from. The second section of this chapter addresses the connection between maternal bearing and ethical persecution or pain in the work of Levinas and Kristeva. For Levinas, persecution functions as a hyperbolic expression of the radical asymmetry and nonreciprocality of ethics; the pain of persecution keeps the gift of time from returning to the self and enriching its own identity. But, for Kristeva, it is not a problem if the self feels enriched by giving to the Other, or even finds pleasure in the pain of radical generosity. Indeed, a certain form of narcissistic pleasure (or affectation *with* the Other, and not just *by* him/her) may be required for the heretical ethics of maternal love. Kristeva acknowledges that the responsible, maternal self is also the child of an Other; the lover is also the beloved of an Other, and both draw on the generosity of maternal love for their own gift to Others. This fecund relation between loving and being loved does not close into an exclusive circle but rather spirals infinitely outward in a disrupted continuity (or fluid discontinuity) between the generations.

A closer look at both Kristeva and Levinas suggests that the relation between bearing and being borne, or giving and givenness, is best articulated through a recursive yet nonrepetitive temporality of forgiveness. In forgiveness the past is remembered but not repeated; the significance of pain or persecution is altered in response to an Other who may not be able to prevent or erase suffering, but who nevertheless allows for its transformation. In this sense the temporality of forgiveness holds the promise of a rebirth or renewal of the self that is given *by* the Other and transforms my existence *for* the Other. In the third and final section of this chapter, I look at the way maternal substitution unfolds in the Book of Numbers, which Levinas cites in the course of explaining how one might become "like" a maternal body for people whom one has "neither conceived nor given birth to" (Numbers 11:12, cited in OB 91; AE 145). As I will argue, the story of Moses in Numbers and Exodus refers to past and future generations of maternal responsibility in which the gift of the Other both commands and inspires the self to reproduce this gift for an Other.

TIME AND THE MATERNAL BODY

In *Otherwise than Being*, Levinas gives an account of maternal temporality that differs in important ways from the time of paternity in *Totality and Infinity*. The father engenders responsibility in the child to whom he gives birth; he is infinitely responsible for the child's own responsibilities. But the father also receives a future of promise and a past of forgiveness *from* the child, and

this gift risks lapsing into a closed economy of exchange to the extent that it excludes the mother, the daughter, and the feminine beloved from the concept of paternity. Levinas implicitly addresses this risk in *Otherwise than Being* with his interpretation of maternity as an *anarchy* in which the parent gives time to the child to whom she gives birth. The gift of time in maternal bearing is more radically removed from the circularity of exchange than the gift of Levinasian paternity; it disrupts in advance the possibility of a past that could be "conserved" in the present. As I will argue, maternity points both to a past that was never present and to a future that resists all expectation of a reciprocal gift from the child. This account of maternity radicalizes the paternal responsibility of *Totality and Infinity* by proposing an infinite responsibility for the Other whom I bear *in the flesh*, to the point of suffering for the child's own suffering. I begin this section by exploring the asymmetrical difference between the anarchy of the child and the anarchy of the mother through a phenomenology of gestation and pregnancy. In the course of this phenomenology, I articulate the ethical implications of birth's anarchic temporality and develop these implications though a reading of a passage from *Otherwise than Being* in which Levinas compares responsibility to bearing the Other "like a maternal body." Finally, I return to the concept of paternity in order to compare the embodied, maternal infinity of *Otherwise than Being* with the paternal infinity of *Totality and Infinity*. In the end, I argue that maternity does not merely form the condition for paternity, but already disrupts the exclusivity of the father–son relation in advance—or *anarchically*.

What does anarchy mean for Levinas, and in what sense might birth be considered an anarchic event? Anarchy refers to the ethical temporality of response to an Other, a time that antecedes and disrupts the temporality of consciousness and its logic of representation. Before I can confirm my own identity through self-awareness or any other kind of self-relation, I find myself exposed to the Other, passive and vulnerable before him or her. Levinas describes this as a "[p]assivity anterior to all receptivity. Transcendent. *Anteriority anterior to all representable anteriority*: immemorial" (OB 122; AE 195, translation altered, emphasis in original).[3] The double meaning of the Greek word *arche*, indicating both *origin* and *rule or principle*, gives anarchy the sense of an unruly time, an anteriority without origin, an immemorial past without initiative or beginning. Thus, anarchy—like the time of my own birth—suggests a past without a present, a time that is always already lost by the time I attempt to grasp it. But anarchy need not only refer to the past; it may also refer to the disruption of the present order, to that margin of time just beyond the "now" by virtue of which the present moment can never be definitive. In this sense, the word anarchy points in two directions. It refers *back* to a time before representation and *ahead* to a disruption of the present or represented order. In *Totality and Infinity*, the face of the Other disrupts the order of representation and opens an ethical time of responsibility that exceeds this order in both directions. In this sense, the face of the Other may

be considered anarchic; it antecedes that which it disrupts, challenging my claim to possess time by re-presenting it as my own. The face of the Other both draws me forth into a future of generosity and brings me back to the immemorial givenness of my own capacity to give. In what follows, I explore the anarchy of birth by suggesting a phenomenology of that which does not quite appear as a phenomenon: the gestation of the child and the pregnancy of the woman.[4] In so doing, I do not wish to force birth into appearance, but rather to consider the ethical and temporal implications of its non-appearance, and the challenge which this poses to traditional conceptions of the self as an autonomous, self-made man.

The anarchy of gestation refers to a time that is anterior to the time of existence as such. The child's gestation in the body of a woman unfolds prior to the activities of consciousness and representation; it antecedes the remote possibility of grasping one's existence as one's own. And yet without this time of gestation, no consciousness—and indeed no existence at all—would be possible. The gestating child has not yet appeared in the world as a person with this or that recognizable identity; and yet the child already responds to a maternal Other, shifting as she sits or stands, moving in her body both with and against her own movements. Before the child exists as present in the world, she or he already makes demands on an Other, kicking and squeezing and pressing against her ribs. Already, the child depends on this Other to make room within her body, so that the child may grow to the point of sustaining an independent existence. Dependence, separation, response, and command are all part of the child's selfhood even before the child exists as a Being-in-the-world. These relations do not cause or "make" the child but rather give the anarchic condition for the child's future existence and future responsibility for Others.

In pregnancy and gestation, the woman and the child do not occupy exactly the same time; for the child "is" already when she or he has not yet been born, and the child "is not yet" even when she or he has begun to exist in the womb. The temporality of gestation points to a past without a present and without self-presence, but without which there could be no future self. From the side of the child, gestation refers to the anarchy of the past, to the gap of time *before* time without which one could not exist, but with which one's existence as a self does not quite coincide. Gestation marks the immemorial, irrecuperable lapse of time that prevents me from positing my own existence and disrupts in advance the representation of birth as chosen or produced. The gestating child is unable to exist on its own without the constant exchange of fluids, nutrients, and waste products through the placenta.[5] Even as a newborn, the child is exposed in his or her flesh to the Other, starving unless someone feeds her, crying until someone comforts him. But the pregnant woman is also, in a different sense, exposed to the passivity of the gestating child. Her body gives of itself without first deciding what and how much to give; its shape is altered in ways that might feel alien or uncomfortable. Short of terminating her pregnancy altogether, she cannot limit or arrest her bodily exchange

with the fetus. Both the child and the woman are in different senses vulnerable, passive, exposed to the Other; the passivity of gestation and the passivity of maternal bearing are different modes of exposure, however, with different implications for time and ethics.

I have suggested that for the fetus, the anarchy of gestation refers to a time before experience, consciousness, and even before its own independent existence. What does the anarchy of birth look like from the side of the woman? In pregnancy, a woman is exposed to an Other whom she has never seen but with whom she is in the closest proximity; she bears this Other in her body, perhaps by choice and careful planning, perhaps by a happy or unhappy accident. In any case, she does not (or not until very recently) choose this particular child from a range of possible children, nor does the child itself choose to be born, or to be born to this mother in particular. The gestating child and the pregnant woman are like strangers who only meet at the moment of birth, even if they have already been in the closest proximity to one another. Like gestation, pregnancy suggests an anarchic time that resists representation and cannot be made entirely one's own; it refers to time spent with an Other who is not yet "there" but still coming-to-be. While gestation refers to the anarchy of the past—a time before the beginning, without presence or origin—pregnancy suggests the anarchy of disruption, a time that exceeds and breaks up any continuity with the present. The future of the child to whom the pregnant woman will someday give birth does not quite belong to her, even if it does implicate her in a future of responsibility. As in Levinas's account of paternity, the future of the child is the future of a stranger; it exceeds the parent's own powers of representation and expectation. When we say of a woman that she's "expecting," we speak imprecisely. For in a strong sense, the pregnant woman does not expect a possible child who will later become "actualized." The child whom she awaits (and, in the best of situations, also hopes for) will never arrive as an object for consciousness but only as an Other whose possibilities exceed what can be grasped in terms of her own. The unexpected future of the child—a future that does not belong to me, but for which I am nevertheless responsible—interrupts the time of representation for the pregnant woman, bringing forth the anarchy of ethical life.

This *interruption* of representation is different from the *antecedence* of representation on the side of the gestating child. For unlike the child, the pregnant woman already inhabits a world that can be captured, recorded, and re-presented by consciousness. She already participates in what Levinas calls the time of "essence and monstration of essence," where "nothing is lost, everything is presented or represented, everything is consigned and lends itself to inscription" (OB 9; AE 22). Into this time of representation and consciousness, the anarchy of birth erupts. In pregnancy, the temporality and even the identity of the woman is altered; suddenly, a gap opens up between what *is* and what *is represented*. We can see the woman but not the child *in* the woman; we can see the child only by making the woman virtually disappear, as on the screen

of an ultrasound machine.⁶ The pregnant body defies adequate representation; it both remains itself and becomes *more* than itself. As Kelly Oliver observes, "With the maternal body, the notion of 'one' becomes problematic and so does the notion of 'two'" (Oliver 1997, 162). In pregnancy, the body no longer coincides neatly with itself; it slips out of joint, exceeding its own boundaries even while splitting apart its identity or self-sameness. This disruption is not the same as alienation; the body that bears the Other is still itself, still "me" but no longer exclusively "mine," released from being my property but also prevented from becoming the property of an Other. Levinas refers to this disruption as "alterity in the same" (OB 67; AE 109); it provides the key figure for responsibility in *Otherwise than Being*: the bearing of an infinite Other in the finite, mortal body of the same.

The pregnant woman bears an Other who is both in her womb and not straightforwardly present there as an existent; she responds to an Other who has not yet spoken, appeared, or made itself known. The pregnant body, precisely as a body, *feels* the Other whom she cannot see; she feels his weight, or her pressure against skin, against backbone. But what she feels is in fact neither existent nor nonexistent; it is like the ghost of a self who has not yet been, the passing of a future that has yet to come. The woman has no extra room to give to the child; her body is dense, complete, full in its own skin. And yet the imperative for accommodation makes room for the child, even in advance of the child's existence in the world. In pregnancy, the body contracts to make space for the Other within itself, but it also contracts to let the Other go, as in the contractions of labor that both allow the child to separate and still confirm its dependence. No one can share with the woman this intimate, embodied exposure to the Other, not even the child. For the woman's experience of pregnancy does not match or mirror the child's experience of gestation; they do not even occur in the same time. For the child, anarchy refers to an immemorial past before presence, even before existence itself. But for the mother, anarchy signifies a disruption of presence by an unforeseeable future when the child will arrive, and she will meet him or her face-to-face. This time is unforeseeable not because gestation is open-ended and interminable but because the otherness of the Other cannot be predicted or expected, because when the child arrives it will come as someone utterly and unrepeatably new. The birth of a child is the arrival of a stranger whom I welcome from within and without, whom I have already and not yet touched, who will have come into being in the immemorial time of gestation. Thus, pregnancy accomplishes what Levinas calls in *God, Death and Time*, "[a] deference of the immemorial to the unforeseeable," a time which disrupts representation to make room for the irrecuperable past and unexpected future of ethics (Levinas 2000, 19).⁷

The anarchic and immemorial time of the child yields to its unforeseeable arrival and welcome into a home; and the mother's future welcome already refers back to the welcome extended to her, in the immemorial time of her "own" birth to a mother. To give birth is to grant to the Other a time in which

she will have found asylum or refuge, as in the gestation of a child in the body of a woman. This time of refuge does not belong to the woman who gives it any more than it belongs to the child who is received into it; for the woman herself only receives the time she gives from *another* Other, from the woman who once gave *to her* the time of gestation and birth. The gift of asylum and refuge may be demanded by the arrival of a child, but it can only be extended by someone who has received this gift *as* a child and now passes it along as a mother. Gestation in the maternal body points to an anarchic time before the child "was" and without which it could not have come into being; it also invokes, if only indirectly, a time before the mother herself existed, a time when she was gestated in the sensible flesh of another maternal body. She too was borne and welcomed into a home, even as she now bears and welcomes an Other. What is the relation between the unforeseeable time of giving birth and the immemorial time of being born? I will explore this question further in the second part of this chapter; for now, I wish only to note that if we open up the infinite temporality of gestation in one direction, toward the unforeseeable child of the child, then we might also open it up in the other direction, toward the immemorial (but equally unforgettable) mother of the mother.

What does the anarchy of birth teach us about the time of ethics? In *Otherwise than Being*, ethical maternity is the figure of "bearing par excellence" (OB 75; AE 121); it articulates the complex relations of receiving, carrying, welcome, and support that I have found in the anarchy of birth. Ethical bearing refers not to a present re-presented but rather to the gift of an immemorial past and unforeseeable future. This gift is at once ineffable and material; like the gift of birth, I do not possess it for myself but only pass it along to the Other, with the material generosity of the flesh. The gift of time does not originate in me; it is not something that I "have" first and "give" later. Rather, the giving of time *to* the Other is made possible *by* the Other. Despite myself, the Other inspires me to give what is not mine to possess: refuge in a home, a future of hope and possibility, a renewed and forgiven past. The Other invites me to "mak[e] a gift of my own skin," to invert the significance of my body from a means of enjoyment and survival into a corporeal gift for the Other (OB 138; AE 217). "Here what is due goes beyond having, but makes giving possible" (OB 109; AE 173). The generosity of the self does not originate in itself but rather arises as an anarchic response to the Other, a response that begins before I begin to comprehend it.

The anarchy of time is thus a *diachrony* or splitting of time by the difference between myself and the Other, to the point where I and the Other cannot be said to occupy the same time but rather speak and respond across the gap or "lapse" between times. Diachrony refers "to a recurrence in the dead time or the meanwhile [*le temps mort ou l'entre-temps*] which separates inspiration and expiration, the diastole and systole of the heart beating dully against the walls of one's skin" (OB 109; AE 172). This diachrony gives to the Other a time that is not my own, a time in which I will not have always already been

"there." This construction—"will have been"—marks a different kind of return to the past than a simple repetition of the same; it suggests a hope that the past might be altered and forgiven, not for my own sake but for the sake of the Other. Already it refers to the anarchy of the future, in which something that "is" not present will have been the past of some future time. This anarchic, diachronic future cannot be expected or represented. It does not belong to me or to the Other but to the dispossession of giving-away, the time of birth and of ethics. In this anarchy of time, the Other may appear (or not appear) on her own terms, without falling into my grasp.

The gap between myself and the Other does not offer a distance from which I could represent her to myself. For the gap is also a proximity; the stranger is also my closest neighbour. Proximity with the Other marks a difference not only *within* time, but *between* times, between the time of consciousness and the time of the Other who calls on me to respond. "In proximity is heard a command come as though from an immemorial past, which was never present, began in no freedom. This way of the neighbour is a face" (OB 88; AE 141). The Other faces and commands me before I have time to begin, in an anarchy that both interrupts the projects of consciousness and brings me back to a time that is not yet my own—like the time of gestation. I can repeat or represent the image of this Other, but I cannot adequately represent the proximity of the Other as such. For by the time I think of her, the Other has already escaped, retreated beyond my grasp. The urgency of bearing the Other is immediate, yet "I do not have time to face it" (OB 88; AE 140). I am summoned by "the urgency of the assignation already missed" (OB 91; AE 145): missed, because as soon as I encounter the Other she slips away into the past or future, into a time that is not my own nor even accessible to consciousness. Already by the time I recognize it, I am too late to fulfill my infinite obligation to the Other; the more I try to fulfill it, the more my obligation grows. And yet this impossible delay between myself and the Other is the only time in which responsibility could take place. Levinas writes:

> The face of a neighbour signifies for me an unexceptionable responsibility, preceding every free consent, every act, every contract. It escapes representation. . . . My reaction misses a present which is already the past of itself. This past is not in the present, but is as a phase retained, the past *of* this present, a lapse already lost which marks ageing, escaping all retention, altering my contemporaneousness with the other. It reclaimed me before I came. The delay is irrecuperable. (OB 88; AE 141)

The face of the Other demands a responsibility that is prior to representation and beyond its grasp. My response to the Other "misses a present which is already the past of itself." The time in which I respond to the Other is not a moment of presence that might later be re-presented. Rather I respond in a time that is *before* and *beyond* any present, like the past of gestation, in which I already respond to an Other whom I have not yet seen or heard. This past is

not *in* the present, but *of* the present. A past *in* the present would be a past re-presented, brought back or even "conserved" in the domain of presence.⁸ But the past *of* the present signals a time already gone, lost, slipped away—without having ever been there in the present. This past "reclaimed me before I came," before I could have initiated a claim for myself. The past of the present marks a gap or delay between my time and the time of the Other, such that we are diachronous or noncontemporaneous. "The delay is irrecuperable." It gives to the Other a time that was never mine to possess: a time in which I am not always already there, expecting her.

I have done nothing to chase the Other away, and everything in my power to make her present to myself, yet the Other escapes me. I am too late. But this is precisely Levinas's point: the Other is not in my sphere of power. This is indeed what obsesses me about her: the sense in which she exceeds me, escapes me, approaches but transcends me, remaining always just ahead or beyond my grasp. The temporal delay between myself and the Other is not a distance that would allow me to take hold of the situation as my own, but rather a diachrony that commits me to an Other who is inescapably close but not together with me in my time. For Levinas, this proximity between self and Other signifies as

> pure passivity or susceptibility, passive to the point of becoming inspiration, that is, precisely alterity-in-the-same, trope of the body animated by the soul, psychism in the form of a hand that gives even the bread torn from its own mouth. Psychism, like a maternal body [*Psychisme comme un corps maternel*]. (OB 67; AE 109, translation altered slightly)

The time of diachrony—the anarchic lapse between my time and the time of the Other—unfolds in the space of proximity, in the nearness but also the irrecuperable delay between self and Other. This proximity is not a neutral space; it signifies my exposure and responsiveness to the Other, as if space as well as time had an ethical dimension. In this proximity I am accused and commanded by the Other: accused of my desire to possess myself through time, and commanded to *give* time by responding to an Other. The Other's power to accuse and command consists not in her superior strength but rather in her destitution and need, in her own vulnerability and exposure before me. The Other commands me not as a punishing father, but as a newborn child whose cries single me out as the only one who can respond. This command exacerbates the passivity of the self by exposing me to the anarchy of an Other who wants more than I can give. The passivity of the self is not the absence or opposite of activity, but rather a *questioning* of activity by passivity "to the point of inspiration."

What does inspiration mean in this context? The Other breathes into me, altering my identity and inverting consciousness into responsibility for the Other. No longer do I exist merely in and for myself. Rather, despite myself and without having initiated the process, I find myself inspired by the Other, transformed into a self who is *for-the-Other*, to the point where my

own identity is expressed as a relation to the Other: "alterity-in-the-same." In responsibility I am both myself and more-than-myself; like the pregnant body, I am myself *bearing* the Other without assimilation but also without alienation. I am transformed from a self who is concerned about my own freedom into a responsible self who is concerned for the freedom of the Other. Even my ability to respond to the Other does not begin in me but comes as *the gift of the Other*, a gift of inspiration. Just as the gestating child gives me the capacity to bear him or her, making room in an otherwise solid body, the Other gives me the ability to respond and to bear him or her "like a maternal body." Responsibility is not an innate characteristic of the self, nor is it acquired by "taking" responsibility for my own actions. Rather I become responsible only thanks to an Other who approaches me from the outside and says, *I am more than you can bear. Bear me.*

Inspired by the Other, my hand "gives even the bread torn from its own mouth." This bread, which I enjoy and which sustains my own existence, is given to the Other despite myself, but with my own hand. For this is the surprise of inspiration: that the Other, beyond and before me, could alter me; that the hand that seeks to help itself could help an Other; that the self whose concern is to maintain itself as the same could be inspired by an Other whom it bears as alterity-in-the-same. Even as I bear her, the Other is more than I can bear. My responsibility for the Other is infinite, and I have arrived too late to respond adequately, already delayed behind the command. But in this delay, the Other inspires me, and opens in me the capacity to give beyond my means. Thus, my gift *for* the Other—the gift of bread, of material nourishment and care—is also a gift *from* the Other, the gift of the inspiration to give. Levinas calls this gift: "Psychism, like a maternal body." What does this phrase mean for ethics, and what does it imply for the temporality of birth?

The word "psychism" is rooted in the Greek *psuchein*, to breathe; it is also related to the word *psyche*, or soul. The diachrony or delay between self and Other is thus the very breathing of time, the opening of the self to inspiration by an Other who is already gone by the time I have opened.[9] The psychism is an expression of the gap between self and Other, where the self who is inspired *by* the Other becomes responsible *for* the Other. How does the passivity of inspiration turn into responsibility for the Other without passing through activity? How does a gift received *from* the Other turn into a gift *for* the Other without passing through the jealousy of possession? Just as the past and future of birth bypass representation, so too does the generosity and passivity of ethics bypass possession and activity: anarchically. Recall the phrase: "My reaction misses a present that is already the past of itself." The Other has already escaped into the future or receded into the past by the time I arrive. The anarchy of time, which precedes and disrupts the regime of presence, makes room for responsibility as "Psychism, like a maternal body." The word "like" is important here. It holds open a gap or delay between responsibility and maternity. To bear the Other ethically is not *the same* as literally bearing

a child in pregnancy. To ignore the word "like" in this phrase would be to collapse the distance between birth and ethics, perhaps insisting on a maternal "duty" to procreate. This approach would resolve the difficulty of ethics to the point at which it is no longer ethical—where the Other would appear no longer as an Other, but merely as a term in an equation. The ethical, social, and political issues surrounding birth are too complex to support such a straightforward identification between birth and ethics. The word "like" in the phrase, "Psychism, like a maternal body," holds open a proximity as well as a *difference* between birth and ethics. I become like a maternal body for the Other by responding to her before I know who she is or what she does—by giving to her materially, with the bread from my own mouth, before wondering if she deserves this gift of bread. I become like a maternal body by *giving time* to the Other, opening for her a future that exceeds expectation, and a past that exceeds representation. To bear the Other as if she were my child is to discern in the face of the stranger a demand for responsibility so extreme that to turn away would be like turning away from my own flesh and blood.

This tells us something about ethics; it also says something about maternity. The parent is responsible for the child not because she has committed an act that produced him, but rather inasmuch as the child is a stranger who faces her. In this sense, the maternal body is not the cause or origin of the child; rather the child as Other *inspires* the maternal self, comes toward her from within and without, before and beyond. Inspiration by the Other arises in the anarchy of ethical time, disrupting the logic of representation to make room for an Other who surprises me and gives me hope for the future. In this sense, pregnancy is more than the expectation of one who will present himself as actual in nine months' time; rather, it is a time of hope for an Other who will never quite arrive as present and actual, but who faces me anarchically with the urgency of a demand for responsibility. It is precisely *not* as a vessel that the maternal body is maternal; the relation between mother and child is not, therefore, a relation of containment but of inspiration by an Other who has always already slipped away. The time of maternal bearing is not a time of mute biological repetition or of heroic existential transcendence, but rather of *hope*. As Levinas writes in *God, Death and Time*, "Time is pure hope. It is even the birthplace of hope" (Levinas 2000, 96). Hope is not ontological; it does not refer to a fate or destiny but rather to the possibility that no "fate" is ultimate or decisive. Levinas explains, "This hope occurs in time and, in time, goes beyond time" (61). To give birth is, in effect, to give time to the Other; it is to give her hope for the future, even in a past that has not yet begun. This gift of time is not abstract or ineffable; it implicates me materially in the flesh, as time *for* and *from* an Other for whom I am commanded to respond. This ethical time is diachronous—not one time but many times—signaling the irrecuperable lapse of time between myself and the Other for whom I am always already responsible, and behind whom I am always already "too late." The diachrony of ethics requires the patience to endure time, and to endure the

infinite *in* time. The infinite in time is not endless or eternal but rather finds its articulation in a finite body who bears in its flesh the infinite and un-bearable Other. This ethical and maternal bearing opens an infinite dimension between myself and the Other, not an eternal "beyond" but an infinity *in* time and in the flesh. To endure the infinite is to bear the Other who cannot be contained, but for this very reason inspires me; it is to await an Other who cannot be expected or anticipated, but for whom one can only hope. "This is to await, in its transcendence, that which is not a that, a term, or something awaited. It is an awaiting without something being awaited" (Levinas 2000, 115). The gift of time uproots possession for the sake of a future that is not mine, but in which I may find hope.

Like paternity, maternal responsibility points to a future in which my responsibility is multiplied across the generations. But there are significant differences between paternity in *Totality and Infinity* and maternity in *Otherwise than Being*. In paternity, the self is infinitely responsible for the child to whom it gives birth; this infinity emerges in both the parent's responsibility *for* the child, and the responsibility the parent engenders *in* the child. The discontinuity of the generations does not limit the infinity of paternal responsibility, but rather engenders it. The new generation of the son brings the promise of a new and unanticipated future, and also renews the father's own relation to time by forgiving him. But, as we have seen, this forgiveness implies a prior *forgetting* of the feminine Other whom Levinas excludes from the gift of paternity, even though he refers to a biblical mother in his account of paternity. In *Otherwise than Being*, the discontinuous and infinite responsibility of giving birth is produced in the maternal body itself, in the inspired flesh that bears an Other who is by all accounts impossible to bear. The embodied infinity of maternal responsibility bears the discontinuous infinity of generations in the flesh without collapsing this discontinuity into sameness. Maternity produces an infinite, anarchic, and diachronous time that makes room for the Other without incorporating her into the same. While paternity may on Levinas's account largely disregard the flesh, the figure of maternity gives birth to an infinity in and of the flesh; it suggests an ethics of hospitality that makes room for the Other in her home and within her body.[10] Levinasian paternity resurrects the past, exposing the father to the inexhaustible youth of future generations, but it does so at the expense of a feminine Other who is both required and excluded by paternity.

In *Otherwise than Being*, the figure of maternity suggests a responsibility that does not forget the mother, but remembers her precisely as immemorial. Maternal bearing radicalizes the concept of paternity; it does not forget the mother but remembers her as one who is beyond representational memory. This maternal bearing does not receive forgiveness in exchange for her gift of birth but rather multiplies this gift by forgiving *for* the child. To forgive for the Other—or as Levinas says in *Otherwise than Being*, to "expiate" for the Other, in a sense that I will address at length in the following section—is to become

responsible even for the pain with which the Other afflicts me. The radical nonreciprocity of this gift exposes the maternal self to what Levinas calls a persecution by the Other whom she bears. Persecution prevents the generosity of the self from turning into an economy of exchange, in which I give to the Other in order to receive forgiveness for myself. And yet the pain and violence of persecution in Levinas's account of the maternal body raise questions about the justice of invoking maternity as a figure for ethics. In the section that follows, I explore the connection between maternal pain and maternal ethics in the work of Levinas and Kristeva.

ETHICS AND *HERETHICS*

What would it mean to give time to the Other by giving with one's flesh without expectation of return? For Levinas, the material gift of time inverts the materiality of the self for an Other who commands me simply by virtue of arriving or nesting in my body. More extreme than hospitality, this gift of the flesh verges on persecution and obsession. No longer merely a host or a guest in my own home, I am held hostage by the Other, painfully and against my will. This hyperbolic responsibility for the Other is only possible given an embodied self who suffers and enjoys, who tastes her bread but also tears it from her own mouth in the midst of enjoyment to give this bread to an Other. For Levinas, the sensibility of the maternal body is both a persecution *by* the Other and an ethical substitution *for* the Other. Persecution refers to the extreme vulnerability and exposure of the responsible body before the Other whom it bears in its flesh, to the point of becoming a hostage who expiates even for the pain inflicted on itself by the Other. This responsibility extends to the point of taking the Other's place—not only forgiving her but forgiving *for* her—and becoming responsible for the Other's responsibilities. But how does the maternal self bear the Other in her body without being crushed under the weight of this infinite obligation? How does she remain enough of a self to bear the Other, especially if this bearing is felt as a persecution and obsession? And how does she "substitute" for the Other without taking over the Other's place and threatening the sense in which both the Other and the self are singular, unique, and irreplaceable? Even more questions arise with the suggestion that maternal responsibility—and not necessarily paternal responsibility—is akin to persecution. How does this violence avoid merely reinforcing the myth of a mother's passivity, self-sacrifice, and martyrdom, her "unique" (read: unshared) responsibility for the child she bears? I have disputed Beauvoir's interpretation of the mother as the "victim of the species." What good, then, can arise from Levinas's interpretation of the mother as the persecuted hostage of the child?

The work of Julia Kristeva makes an ambivalent contribution to this discussion. While Kristeva may be critical of the maternal "self-sacrifice involved in becoming anonymous in order to pass on the social norm" (Kristeva 1987,

160), she nevertheless maintains that a *certain* sacrifice of the mother is necessary for the child to emerge as a separate individual. In *Black Sun*, she writes: "For man and for woman the loss of the mother is a biological and psychic necessity, the first step on the way to becoming autonomous. *Matricide is our vital necessity*, the sine-qua-non of our individuation, provided that it takes place under optimal circumstances and can be eroticised" (Kristeva 1989, 27–28; my emphasis). In my reading of Kristeva, I do not seek to resolve this ambivalence, but rather to open within it the possibility of "losing" the mother not merely to facilitate my own individuation but rather to let *her* emerge as an Other whose radical gift commands me to give radically. In returning to Levinas through this reading of Kristeva, I argue that the persecution of the self, far from destroying it altogether, brings about what Levinas calls the "latent birth" of the self as uniquely responsible for the Other. While Levinas does not elaborate on this latent birth at any great length, I will suggest a reading of the concept that resists the tendency even in *Otherwise than Being* to forget or obscure the maternal body.

Maternity as (Ethical) Persecution

As we have seen in *Totality and Infinity*, the self who enjoys is not the foundation or cause of itself; it remains both separate and dependent in the element from which it lives. But the sensible self of *Otherwise than Being* is more radically passive than the self in enjoyment; it is exposed not only to the faceless, anonymous element but already to the body of the Other with whom it is in proximity. Sensible proximity does not collapse the distance between oneself and the Other, but exacerbates this distance to the point where it splits me from myself, assigning me to the Other while putting my own identity into question. The Other affects me even if I cannot touch or grasp her; the space of our proximity is contoured, such that the distance from me to her is not the same as the distance from her to me. This irreversibility recalls the paternal relation where I "am" my child but my child is not me. But the language with which Levinas describes maternal proximity is more extreme, more visceral than the calm felicity of father and son. Maternal proximity is the "closer and closer" that is "[n]ever close enough" (OB 82; AE 131). It is restless, uncomfortable, more hospitable than hospitality; proximity tears me from any place I could call my own, even as it pushes me back into my body with the command to bear the Other materially. This bearing of the Other is not an abstract figure of speech, but is rather inscribed on the body and in the flesh. "The sensible—maternity, vulnerability, apprehension—binds the node of incarnation into a plot larger than the apperception of self. In this plot I am bound to others before being tied to my own body" (OB 76; AE 123). Incarnate generosity for the Other gives to the body an ethical significance prior to its ontological status, yet this body is also a condition for ethics, since without a body that enjoys and dwells I would have nothing to give to the Other. It is only as someone who eats that

I can give the bread torn from my mouth to the Other, but my own enjoyment of bread already puts me in touch with the Other to whom I give it away:

> The immediacy of the sensible is the for-the-other of one's own materiality; it is the immediacy or the proximity of the other. The proximity of the other is the immediate opening up for the other of the immediacy of enjoyment, the immediacy of taste, materialization of matter, altered by the immediacy of contact. (OB 74; AE 120)

In giving bread to the Other, I also give her the very immediacy of enjoyment and taste; she will savor the bread whose loss I have suffered. At the same time, the significance of my own enjoyment depends on this loss. Sensibility is "mine" only in being given by an Other; however, it is meaningful only in being given up by me *for* the Other. It is not enough, then, to "give one's heart" in sympathy for the Other; one must give materially, in the flesh. "Signification signifies, consequently, in nourishing, clothing, lodging, in maternal relations, in which matter shows itself for the first time in its materiality" (OB 77; AE 124). I am a material, sensible self because the very significance of materiality arises in a (nonrelating or nonintegrating) relation for-the-Other; I can only signify to the Other thanks to this materiality that lets me both suffer and enjoy, both savor my food and give it away.

Levinas suggests a relation between maternity, sensibility, and persecution that already edges toward substitution:

> [S]ensibility is being affected by a non-phenomenon, a being put in question by the alterity of the Other, before the intervention of a cause, before the appearing of the Other. It is a pre-original not resting on oneself, the restlessness of someone persecuted—Where to be? How to be? It is a writhing in the tight dimensions of pain, the unsuspected dimensions of the hither side. It is being torn up from oneself, being less than nothing, a rejection into the negative, behind nothingness; it is maternity, gestation of the Other in the same. Is not the restlessness of someone persecuted but a modification of maternity, the "groaning of entrails," wounded by those it will bear or has borne? In maternity what signifies is the responsibility for Others, to the point of substitution for Others and suffering both from the effects of persecution and from the persecuting itself in which the persecutor sinks. Maternity, which is bearing par excellence, bears even responsibility for the persecuting by the persecutor. (OB 75; AE 121)

In this passage, maternal sensibility exceeds the bounds of generosity; it gives more than the tearing of bread from my mouth. Sensibility becomes persecution, obsession, ripping into the self and wounding its entrails, tearing the self not only from its place but from its own body. Levinas calls this persecution "a modification of maternity," where the maternal body bears responsibility even for the pain she suffers at the hands of an Other. Recall the pain of Zion, who was a remnant of herself, "bereaved and barren, exiled and put away" (Isa.

49:21). Her suffering was the pain of a mother whose children have been taken from her or left her behind. But the suffering that Levinas calls "maternal" is different from this suffering; it is the pain of one whose children are too close, under her skin, tearing up her entrails. She has nowhere to go, no way to escape from this "writhing in the tight dimensions of pain." The Other is more than she can bear, yet she bears him or her, enduring her own pain, the pain of the Other, and even the pain of the "persecuting itself into which the persecutor sinks." The maternal body may be like a host for the Other, a place of "refuge or asylum" for the one who suffers; but she is also like a hostage to the Other, taking on this suffering despite herself, offering herself as a substitute for both the victim and the persecutor. I will address the concept of substitution momentarily; for now I wish to consider what it means to call sensibility, now understood as persecution, a "modification of maternity."

As one who is exposed to the Other, I make room for him or her in my body even while remaining exiled from my own place and home. I bear the Other in the flesh, even though my body is bursting at the seams in a skin that is never big enough to contain both of us. Levinas calls this impossible bearing *infinity*: the accommodation of the Other in the body of the same, in the flesh of a finite being who cannot possibly contain the Other but bears her nevertheless. This infinite bearing unfolds in "the tight dimensions of pain, the unsuspected dimensions of the hither side." It brings a pain that can only be felt by one who has also enjoyed herself; it is the pain of being divided, not destroyed but also "not resting on oneself," remaining both separate and dependent in the midst of becoming for-the-Other. To bear the Other in maternity is to be affected by the Other to the point where this exposure turns into a bearing of responsibility not only for the Other, and not only for the Other's responsibility, but for the very violence with which the Other affects me. The maternal body welcomes an Other whom she did not make or cause; she bears this Other who remains a stranger despite her bearing, unseen and perhaps even violent: kicking at her ribs, altering the shape of her body, shifting her bones from within. She bears this weight of the Other not because she enjoys the pain as such, but because she looks forward with hope to the arrival of the child. She bears the pain of the Other *for the sake of the Other*; in this bearing, she becomes responsible for the child, for the child's responsibility, and even for the pain that the child inflicts.

There is more than an echo here of the patriarchal image of the Good Mother: a quiet and patient martyr who bears my suffering and even my sins without protest, despite all the pain I cause her. And yet Levinas warns against such an interpretation. He insists: "The for-the-Other characteristic of the subject can be interpreted neither as a guilt complex (which presupposes an *initial* freedom), nor as a natural benevolence or divine "instinct," nor as some love or some tendency to sacrifice" (OB 124; AE 198). Unlike the Levinasian maternal body, the idealized Good Mother is not torn or divided between itself and its substitution for-the-Other. The traditional image of the mother as pure

selflessness, pure sacrifice to the Other, amounts not to ethics but to the empty ideal of a nonself. We may imagine her as a virgin queen, untainted by eros or enjoyment, disembodied after pregnancy, with no carnality, no jouissance, no desire of her own.[11] This is clearly not what Levinas means by maternity, insofar as it articulates the very knot between enjoyment and suffering, between sensibility and responsibility for the Other. And yet the words of Levinas are haunted by the specter of this idealized mother, so we must inquire more deeply into the relation between maternity and pain in this passage. If Levinas merely reinscribes a tired myth of women's suffering and lack of choice with respect to maternity, then what can be ethical about maternal substitution? A closer reading of the passage in question goes some distance toward resolving this question; I will take up these questions from several different directions throughout this chapter.

In *Otherwise than Being*, persecution by the Other disrupts any attempt on the part of the self to represent itself as a virile ego; in persecution, "[o]ne can no longer say what the ego or I is. From now on one has to speak in the first person" (OB 82; AE 131). My proximity to the Other deprives me of a ground on which to stand; it disrupts any sense of mastery in "my own" home. And yet this exile from my home and ground would also make me who I am: *myself* but no longer an ego, a term in a relation with the Other but also "more, or less, than a term." Proximity goes beyond any sense of a "relation" that would include the Other in my own identity. For in proximity with the Other, I am both backed into my skin and chased out of my identity; I am forced to speak in the first person but denied my "right" to the pronoun *I*. Like Zion in Isaiah 49, I am called on to give to the Other even when there is nothing I could possibly give, even when my own identity is at risk. And yet I become *uniquely myself* only through this risk of singular responsibility for the Other. This responsibility goes even to the point of substituting myself for the Other, suffering for her suffering, bearing even the persecution with which the Other afflicts me. The language of persecution emphasizes the radical asymmetry and nonreciprocity of substitution; for no one can take my place as I substitute myself for the Other, nor can I expect substitution in return. Substitution marks the turning of affectation *by*-the-Other into responsibility *for*-the-Other. In this sense, it holds the secret to understanding how the passivity of being born engenders the deeper passivity of giving birth to the Other, bearing even the stranger like a maternal body. Indeed, substitution demands *especially* that I bear the stranger, and especially the one who gives me nothing in return but pain and suffering. For I am most responsible precisely there, where my gift is least deserved, where the one whom I welcome ignores or rejects my generosity. I become uniquely myself in exposure and proximity to the Other, even to the point of taking the Other's place and suffering for/from their wounds. Levinas writes: "In substitution the being that belongs to me and not to another is undone, and it is through this substitution that I am not 'another,' but me" (OB 127; AE 201).

Substitution releases my identity from the logic of possession and representation, even as it forces me back into my skin. As such, substitution marks "the very fact of finding myself while losing myself," becoming unique while standing in for an Other (OB 11; AE 26). To substitute myself for the Other does not mean collapsing my identity into hers; to do so would betray the alterity of the Other who commands me to substitute. If my selfhood were to disappear altogether, so too would the distance between myself and the Other. Therefore, substitution means standing in for the Other without expecting her to return the favor, offering her a place of asylum or refuge without incorporation and without reciprocity. "No one can substitute himself for me, who substitutes myself for all" (OB 126; AE 200). In substitution, I offer myself as a hostage for the Other's suffering even if she also inflicts suffering on me. It is as if I were to say to the Other: *This is not my suffering, but I suffer it as if it were my own*, despite myself, as if I were a hostage to release you from your persecutor. I do this not because I want to or because it is my duty, or even because I get a particular pleasure from martyrdom. Rather I substitute myself for you because your suffering affects me, obligates me, addresses me, commands me to do something. In substitution, I say to the Other: *Here I am*, at your service; I am myself only in being *for* you. To "say" this is to give signs to an Other, exposing oneself anarchically, in proximity to the Other. In this sense, saying is less an action I perform than a passivity I undergo.[12] "Saying is the passivity of passivity and this dedication to the Other, this sincerity" (OB 143; AE 223). To say to the Other, *Here I am*, is "to exhaust oneself in exposing oneself, to make signs by making oneself a sign, without resting in one's very figure as a sign" (OB 143; AE 223). Only a sensible self who knows both pain and enjoyment can perform this substitution for an Other: "Only a subject that eats can be for-the-other, or can signify" (OB 74; AE 119). In giving the bread from my own mouth to the Other, I *signify myself* materially to the Other. In this signification, the food that sustains my own existence turns into an ethical sign and gift for the Other: the gift of substitution.

But substitution does more than offer me as a hostage for the one who suffers; it also offers me as a hostage for the persecutor himself. In substitution I also say to the Other: *This is not my fault*; I did not cause this suffering, I did not undertake this persecution, and I do not condone it. *And yet I take even this fault on myself*, as if I were both the persecutor and persecuted. For if I do not expiate for this sin and bear this suffering, then who will? To expiate is both to forgive the Other and to forgive *for* the Other, as if I were responsible for his or her own responsibility. In expiation I forgive the other strangers whom the Other has wounded but neglects or refuses to forgive; I forgive the Other *of* the Other, altering the past of both persecuted and persecutor, atoning for a sin that the Other commits against someone else and releasing her from an endless traumatic repetition of this sin. What obligates me to forgive for one who fails or even refuses to forgive? Nothing—and yet everything—obligates me. As we have already seen, the imperative to give or forgive does not follow from

an act I have committed or a debt I have incurred. Rather, I am responsible precisely where I have not been the cause of events. The most extreme form of substitution takes place when I am the one who suffers at the hands of a persecutor, and I nevertheless expiate for the one who persecutes me. Torn between the positions of victim, hostage, and persecutor, I am most substantially not-myself in becoming uniquely myself, with nowhere to turn but toward the Other to whom I say, *Here I am*—I am *for* you, even if you are against me. This is the ultimate significance of proximity: an encounter with the Other who "forces me to speak before appearing to me" (OB 77; AE 124), who makes the anarchic and infinite demand that I respond, without letting me know why or to whom I respond. "The more I answer the more I am responsible; the more I approach the neighbour with which I am encharged the further away I am. This debit which increases is infinity as an infinition of the infinite, as glory" (OB 93; AE 149).

But even if we interpret the ethical significance of persecution as a sign of the radical asymmetry and anarchic disruption of responsibility, must we accept the connection of persecution with a maternal body that suffers for the suffering of Others? Why should expiation be specifically *maternal*—and why should we call the painful writhing of a maternal body "ethics"? If the mother forgives for all, then who will forgive for the mother? In responding to these questions, I refer to the work of Julia Kristeva, whose own ambivalence toward maternal pain has already been noted.

Turning to Kristeva: Motherhood and Melancholia

There is nothing new or surprising in the connection between motherhood and the pain of suffering. But who is suffering for whom—and why? Like Levinas, Kristeva associates maternity with an ambiguous mixture of suffering and enjoyment in relation to the other-in-the-same; like him, she draws an ethical (or herethical) significance from the maternal body. But while Levinas's asymmetrical, nonreversible ethics of responsibility forbids a return to the self even to the point of requiring maternal persecution, Kristeva's herethics does not exclude the possibility of a return to self, and even a kind of narcissism, which is nevertheless oriented toward the Other. Kelly Oliver describes this maternal herethics not as a responsibility to the point of persecution but rather as a mother's "love for herself but also the willingness to give herself up" (Oliver 1993, 65). This ethical narcissism does not exclude the Other or neglect her call to responsibility; rather, it implicates the Other in the love of the same without incorporating or denying the Other's alterity. As in Irigaray's account of the mutuality between lovers in "The Fecundity of the Caress," this love traces a discontinuous or open circle between self and Other: a spiral in which the mother's love for me transmutes into my love for an Other who is my child and also a stranger to me. Oliver explains: "If the mother loves an Other, it is her own mother. And she loves her mother not only as an Other, but also as

herself, now a mother. This love, which is narcissism, within patriarchal analysis 'the inability to love,' is the basis of Kristeva's herethics" (Oliver 1993, 66). In what follows, I trace this herethical approach through Kristeva's account of the institution and experience of maternity in "Stabat Mater" and through her analysis of melancholia in *Black Sun*. In melancholia, the refusal to "lose" the mother or separate from her precipitates a loss of the self, given which neither the mother nor the child may emerge as an Other. While Kristeva suggests several possibilities for a way out of melancholia (including poetry or art), I will focus on the possibility of *forgiveness*, which transforms the past significance of pain and loss for the Other and releases her for a new and different future. By working through Kristeva's account of maternal forgiveness, I will return to the question of maternal persecution in *Otherwise than Being*, approaching this question from a new direction in which expiation for the Other brings about a renewal or "latent birth" of the responsible self.

THE PAIN OF GIVING BIRTH

The text of "Stabat Mater" is divided into two columns. The right side analyzes the psychic and social role played in Western Christian culture by the figure of Mary as the Mother of God, virgin queen, and *mater dolorosa*, while the left side (printed in bold lettering) offers a more poetic and personal account of motherhood as an experience with complex pleasures and pains. While it is tempting to classify the left column of text as the "semiotic" side of a predominantly "symbolic" discourse on motherhood, this classification would risk overlooking the sense in which all language involves both symbolic and semiotic dimensions, both adhering to a meaningful linguistic structure and also discharging the bodily drives through rhythm, color, and style.[13] In this sense, we could interpret the spatial and stylistic distinction between the columns of "Stabat Mater" as a textual embodiment of the heterogeneous forces that motivate and structure the process of signification. Moving through the words we speak or write, configuring and reconfiguring their arrangement, we find sensible traces of a relation to Others: in particular, to the body of the mother and the law of the father. Without the structure and rules of the symbolic, semiotic rhythms would not constitute a language; they would bring forth only inarticulate gurgling or psychotic babble. But without the generative impulse of the semiotic, there would be no motivation to speak or signify. The symbolic gives order and recognizable meaning to our utterances; the semiotic provides the *bodily* (or, as Levinas might say, the *sensible*) impulse to communicate, discharging the psychic and biological drives that might overwhelm us or tear us apart if left unexpressed. Semiotic rhythms and impulses transform the biochemical energies of the body into language by inflecting words with a certain tone, pitch, and rhythm whose most immediate "content" is my embodied life in relation to others. This semiotic dimension of language can disrupt the meaningful coherence of the symbolic, as in moments of nonsense or babble, but it

also gives me a reason to symbolize, without which I might just as well remain silent. Moving between the semiotic and the symbolic—between the relations to mother and father, body and law—the text of "Stabat Mater" unfolds.

In the left column of the text, Kristeva interrogates the fantasy of motherhood as a "lost territory" (Kristeva 1987, 234) and the idealization of the mother as a virginal queen, "alone of her sex" (253). For hundreds of years, the image of Mary has worked to sublimate maternal pain, giving it a meaning that was tolerated and even encouraged by the patriarchal order. The virgin mother gives birth without being tainted by dangerous and disruptive sexual impulses; her body signifies erotically only through the ear that receives an immaculate conception, the breast that gives milk to a son, and the eyes that shed tears for the loss of this son. While critical of the idealization that desexualizes the mother or eroticizes her body without allowing for a desire of her own, Kristeva also criticizes "some avant-garde feminist groups" for implicitly accepting the identification of maternity with an "idealized misconception" (234) and rejecting the experience of maternity itself rather than challenging the misconception.[14] For Kristeva, the maternal signifies "the ambivalent principle that is bound to the species, on the one hand, and on the other stems from an identity catastrophe that causes the Name to topple over into the unnamable that one imagines as femininity, nonlanguage, or body" (Kristeva 1987, 235).

On the one hand, maternity maintains a certain continuity of "the species" by reproducing generations upon generations; on the other hand, maternity disrupts the coherence and unity of the symbolic order within which this apparent continuity of generations becomes meaningful. The ambivalence of maternity may perpetuate the existing social order in some sense by bringing forth more workers, more soldiers, more brilliant artists, but it also disrupts this order by introducing a heterogeneity of bodily drives that resist naming but nevertheless register within signifying processes as their semiotic underside, as the nonlanguage *within* language.

In its ceaseless generation of rhythmic or repetitive patterns, the maternal body suggests a cyclical temporality, but the heterogeneity and discord of semiotic impulses prevent this from ever becoming a *closed* circle. The process of reproduction does not merely recapitulate the same but repeats it with a difference, opening fractures within the symbolic order. Neither circle nor line, the figure of the spiral turns back on itself without returning home (like Ulysses) to the point of departure; it reproduces a pattern without making an exact copy. This ambivalence between continuity and rupture registers in the language of "Stabat Mater," as well as providing one of its explicit themes. On the one hand, Kristeva emphasizes an apparently conservative link between continuous generations; she insists, for example, on "the [maternal] self-sacrifice involved in becoming anonymous in order to pass on the social norm, which one might repudiate for one's own sake but within which *one must* include the child in order to educate it along the chain of generations" (Kristeva 1987,

260, emphasis in original). Without this education, "society will not reproduce and will not maintain a constancy of standardized household" (260).[15] Kristeva clearly regards this disruption of the household as a misfortune that a feminist rejection of maternity would only exacerbate. But, on the other hand, the heterogeneity of the maternal body disrupts any simple constancy of the household (or anything else); the fractured logic of maternity introduces into the "chain of generations" or the "standardized household" the possibility of disruption, change, and even revolution. This disruption may remain unnameable, and so might threaten the Name with an "identity catastrophe"; nevertheless, it is articulated in the semiotic resonance of the pains and pleasures of maternal bearing. As one who gives birth to an Other, the mother is not merely a potential vehicle for social continuity but also "a continuous separation, a division of the very flesh. And consequently a division of language—and it has always been so" (Kristeva 1987, 254). Even while sustaining the rhythm or cadence that links the generations together, the maternal body also opens up a "continuous separation" (strange oxymoron) that lets the child—and, as I shall argue, the mother—emerge as an Other. Even the powerful image of the Virgin Mother, which worked for centuries to legitimate the demand for women's self-sacrifice and perpetuate the patriarchal order, nevertheless articulates a rupture or separation, "a catastrophe of being that the dialectics of the trinity and its supplements would be unable to subsume" (260).

This catastrophe of being and/or identity recalls the "otherwise than being" of ethical responsibility, which Levinas has described in terms of a maternal bearing to the point of persecution and substitution for the Other. Both Levinas and Kristeva agree that the mother gives birth to an Other who is separate from the beginning, even in the midst of its dependence and helplessness. In the voice of a mother, Kristeva asks:

> What connection is there between myself, or even more unassumingly between my body and this internal graft or fold, which, once the umbilical cord has been severed, is an inaccessible other? My body and . . . him. No connection. . . . The child, whether *he* or *she*, is irremediably an other. (Kristeva 1987, 254–55)

But unlike the stranger who approaches me from outside and beyond in *Totality and Infinity*, for Kristeva the child emerges as an Other within my own body: "for such an other has come out of myself, which is yet not myself but a flow of unending germinations" (Kristeva 1987, 262). Kristeva locates the possibility of ethics not in the Other's radical alterity, or in the pain and persecution that interrupt the flow of reciprocity, but rather in a discontinuity that emerges *in the midst of* continuity, an alterity that Ewa Ziarek has called the "*infolding*" of the other and the same, or "the imprint of the other *within* the same" (Ziarek 1999, 337). In light of this ambivalence between alterity and identity, Ziarek draws attention to "the impossibility of thinking the otherness of the child (and, consequently, the mother's "sameness") in terms of relations;

the alterity is neither inaccessible to me nor similar to me, but radically interrupts 'my relation' to myself, to 'my' body" (Ziarek 1999, 337).

This interruption of maternal self-identity need not be experienced as a painful persecution in order to bear an ethical significance; rather, for Kristeva, the very ambiguity between same and other, or between continuity and rupture, within the maternal body "extracts woman out of her oneness and gives her the possibility—but not the certainty—of reaching out to the other, the ethical" (Kristeva 1987, 259–60). Similarly in *Otherwise than Being*, the Other disrupts the identity of the self by emerging as the Other-*in*-the-same, such that I am already "bound to the Other before being tied to my own body" (OB 76; AE 123). This entanglement between self and Other does not blend into a continuous sameness, but rather binds me to the Other with the urgent demand—but not the certainty—of infinite responsibility.

Throughout "Stabat Mater," in both columns of the text, Kristeva draws attention to "the need of an ethics for this 'second' sex which, as one asserts it, is reawakening" (Kristeva 1987, 262).

> Now, if a contemporary ethics is no longer seen as being the same as morality; if ethics amounts to not avoiding the embarrassing and inevitable problematics of the law but giving it flesh, language and jouissance—in that case its reformulation demands the contribution of women. Of women who harbour the desire to reproduce (to have stability). Of women who are available so that our speaking species, which knows it is mortal, might withstand death. Of mothers. For a heretical ethics separated from morality, an *herethics*, is perhaps no more than that which makes bonds, thoughts, and therefore the thought of death, bearable. (Kristeva 1987, 263)

Kristeva calls for an heretical approach to ethics: not as a system of morality that rests implicitly or explicitly on the identification of women with a self-sacrificing virgin mother, but as an embodiment of the desire for others, the desire to reproduce the Other in the same, both in language and in the flesh. But to the extent that the "desire to reproduce" is equated here with a desire "to have stability"—and to the extent that the aim of herethics is to make the thought of death more bearable (for me)—then we might ask whether Kristeva's herethics is heretical enough. Does it sufficiently challenge the conservative demand for a "constancy of standardized household" in which the economy of the self would find a stable equilibrium thanks to the painful sacrifice of a maternal body who suffers *for me*? Kristeva shifts the emphasis of ethics away from the persecution of the maternal body that I have noted in Levinas toward an ambivalent mixture of pleasure and pain in the embodied experience of maternity. Her account of the infolding or ambiguity between self and Other departs from the image of the maternal body as one who is radically and irreversibly *for* the Other despite bearing the Other-in-the-same. But in finding pleasure in the pain of self-sacrifice rather than the nonsacrificial persecution of substitution, does Kristeva sketch a circular return to the

interests of the self (for constancy, stability, and a more bearable death)? In bringing self-love together with the maternal love for another, can Kristeva maintain the distance and heterogeneity required to twist the circle into a spiral? In what follows, I argue that Kristeva's herethics *does* move in a spiral that constantly reopens the self to Others, but that it does so only through a forgiveness of mothers and *for* mothers.

The Pain of Being Born

While "Stabat Mater" (1976) analyzes the pain of maternal bearing, *Black Sun* (1987) focuses on the pain of being born to and separating from a maternal body. In order to emerge as a distinct self with the possibility of an ethical life, the child must separate from the mother. For Freud, this entails mourning the loss of my first and most intense love object—the source of my infantile pleasure and sense of fullness—and finding a substitute love object to compensate for my loss. This compensation sets up a psychic economy, a stable "household" in which the self may withstand the pain of loss and gain a measure of self-sufficiency. Freud contrasts this process of mourning with melancholia, the latter of which arises through the inability or refusal to find an adequate compensation for one's loss. In both cases, the one who suffers loss initially withdraws into herself, having suddenly found the world empty and meaningless, no longer filled with the presence of the beloved. In time, the mourner returns to the world, "gets on with her life," and finds something else to love, someone to replace her lost love object, but the melancholic remains stuck in the pain of loss to the point of becoming unable to say precisely what or whom she has lost.[16] Almost by definition, the lost object of melancholia is unknown, unnameable; like the maternal body itself, it resists adequate symbolization, shatters identity, "causes the Name to topple over into the unnameable" (Kristeva 1987, 235). In *Black Sun*, Kristeva relates melancholia to a "nostalgic dedication to the lost mother" (Kristeva 1989, 24); she suggests that the melancholic has not lost an object at all but rather the pre-object, the "Thing" that exists prior to the distinction between subject and object, self and other, inside and outside. The Thing is the primal attachment of infantile love: the breast, not yet recognized as the breast of another person but as the source of my own life and pleasure. Having lost her attachment to the maternal Thing, "the depressed person has the impression of having been deprived of an unnamable, supreme good, of something unrepresentable, that perhaps only devouring might represent, or an *invocation* might point out, but no word could signify" (Kristeva 1989, 13; emphasis in original). The loss of such a Thing cannot be mourned because it cannot be adequately symbolized or substituted; once the Thing has been lost, the world is divided into subjects and objects, and the pre-object no longer exists as such. The loss of this pre-objective Thing is the very condition for an objective world and a speaking, knowing, self-identical subject. To compensate the loss of the maternal Thing with an object would be like attempting to explain prehistory in

historical terms, or describing Minoan-Mycenaean civilization in Greek terms:[17] the latter is not adequate to the task of representing the former and so renders it incomprehensible, inaccessible, recognizable only as a vague nostalgic longing. For what—or for whom? One literally cannot say.

But if the source of melancholia is the loss of the maternal Thing, then why do some of us become melancholic while others do not? Melancholia is produced not by loss but by the self's refusal to acknowledge loss as such, or by the denial that a loss has even occurred. The melancholic denies this experience of loss by identifying with the lost Thing and incorporating it into herself as if interring it in a crypt; she splits off a part of her ego and lets this part of herself *become* the loss. This leaves the self fragmented, split from itself, emptied and impoverished, as if it had spent all its resources on a losing battle. Rather than compensating for her loss, she compounds it through the sacrifice of a part of herself, or an identification with loss as such. This refusal to compensate in any way means that the loss of the beloved Thing can never be healed because it has never been acknowledged *as* a loss; the Thing resides within me, has become me, and I have become like a thing to myself. Likewise this loss of self cannot be addressed, for if I acknowledge that I have sacrificed a part of myself, then I remove the mask from the initial loss, forcing myself to admit that I have feigned possession of something that is no longer there—and this I cannot bear. And so the melancholic traps herself in a vicious circle of loss compounding loss, a radical expenditure without return or compensation; she does so to keep the Thing present and alive, even to the point where there is no I, no self to enjoy what has been so lovingly preserved.

In response to this melancholic impasse, Kristeva writes: "Matricide is our vital necessity, the sine-qua-non of our individuation," the "first step on the way to becoming autonomous" (Kristeva 1989, 27–28). If I do not consent to lose the maternal Thing, I will never become an individual self capable of relating and responding to distinct Others. And yet, how can there be an adequate compensation for this loss, when even the thought that I might exchange her for another love object already betrays the irreplaceable uniqueness of the beloved? Could one not understand the melancholic refusal differently, not as a refusal to grow up but as a recognition of the mother's irreplaceable singularity? This latter approach risks overlooking the sense in which the maternal Thing is not the same as a mother who is already recognized as a distinct beloved, but I wish to at least raise this possibility as a way of emphasizing the ambiguous relation between ethics and melancholia. There is a sense in which melancholia refuses to let the alterity of the mother be reduced to a term in my own psychic equation, a commodity to be traded within my psychic economy. At the same time, the refusal to accept the loss of the mother *as* a loss nevertheless fails to allow her an existence that is separate from my own. While melancholia may be seen as a refusal to submit the alterity of the Other to the terms of my own libidinal economy, perhaps this alterity can only emerge as such if I loosen my hold on her enough to let her go. By identifying a part of

myself with the maternal Thing from whom I cannot bear to be parted, I also deny the mother her own existence as an Other. Ewa Ziarek calls this refusal to accept separation from the mother "a negation of the loss of the other . . . a forgetting of the loss of the mother" (Ziarek 1993, 69). By forgetting this loss, the melancholic refuses to register the loss of the mother *as* a loss; this refusal makes it impossible to recover from loss in some way. "What loss?" It never happened, and so the pain can never be healed, the damage never repaired. By forgetting the loss of the mother, I also forget the *gift* of the mother and my dependence on another who cared for me when I could not take care of myself. This forgetfulness overlooks the ethical significance of birth as a generous gift, and feels only the intense pain of separation or abandonment. However, my loss of the maternal Thing need not signify only (or predominantly) a violent act of matricide; the pain of loss might also be interpreted as a mark of alterity, an acknowledgment of the embodied and sensible difference between self and Other. As Ziarek suggests, "the mark of alterity points to the subject's indebtedness to the other, to a forgotten maternal gift, which enables our ethical orientation in the world" (74).

Remembering the gift of birth would mean remembering the alterity of the mother who gives birth to me and with whom I am nevertheless linked in what Kristeva calls "the chain of generations" (Kristeva 1987, 260). This "chain" is continuous in a way that does not exclude discontinuity or rupture but rather requires it; its rhythm is only possible given the regular interruption of silences or gaps that are not included in the song, but without which there would be no singing. By refusing loss and rejecting life as a separate ego, the melancholic also rejects that which would make separation bearable: the semiotic pleasures of language. The melancholic refusal to lose the maternal breast forecloses the possibility of signifying this loss to Others and with Others, in what Abraham and Torok (1994) call "a community of empty mouths":

> The transition from a mouth filled with the breast to a mouth filled with words occurs by virtue of the intervening experiences of the empty mouth. . . . Since language acts and makes up for absence by representing, by giving figurative shape to presence, it can only be comprehended or shared in a 'community of empty mouths.' (127–28)

Kristeva's account of recovery from loss concurs with this analysis: "I have lost an essential object that happens to be, in the final analysis, my mother. . . . But no, I have found her again in signs, or rather since I consent to lose her I have not lost her (that is the negation), I can recover her in language" (Kristeva 1989, 43). The mother is the unnameable Thing that must be lost to register this loss in language as a semiotic nonlanguage, or as the unnameable that disrupts the identity of the Name. But the resulting articulation of loss opens an ethical dimension of language in which the signification of a separated and divided self gives the mother a chance to emerge as lost but not forgotten—as a beloved who is irreplaceable but whose loss is not absolutely unbearable.

This approach to the loss of the maternal body is distinct from both mourning and melancholia; it suggests the possibility of a different route, a different relation to the pain of being born to an Other from whom I must also separate—for her sake as much as for my own. To remember birth as a gift, I must acknowledge the loss or distance of the mother as a mark of her alterity and not merely as a condition for my own individuation or autonomy. This suggests an ethical interpretation of Kristeva's call for "matricide," not necessarily as a requirement for setting up my own stable household, but as the herethical condition for a response to the mother as an Other. Kelly Oliver (1993) comments on this ethical potential of "matricide":

> It is possible, however, that if the dependence on the maternal body can be separated from the dependence on the mother, then the necessary "matricide" can take place and a woman can lose the maternal body and still love her mother. This means that she can lose the maternal body as maternal container or maternal Thing and love her mother's body, her own body, as the body of a woman. (64)

In this sense, matricide would not signify a hatred or resentment of the mother who abandons me or threatens my autonomy, but rather a "narcissistic" love for the Other-in-the-same, and for the same as an Other. The memory of a painful loss, far from obscuring the sense of birth as the gift of the Other, may open a space in which the mother emerges not as my origin or container, or as the support for my existence or my ethics, but rather *as an Other*. This memory could allow for a transformation of loss in response to the Other, which in previous chapters I have called *forgiveness*.

Forgiveness transforms the past in response to an Other whose alterity resists idealization or replacement; it does so, however, only on condition of admitting a loss, admitting that there is something to be transformed. This transformation is distinct from both the melancholia that refuses to admit a loss and the mourning that finds an adequate compensation for loss in the symbolic order. In *Black Sun*, Kristeva relates forgiveness to the "tact" of analytic listening, which responds to the patient's speech by "giving in addition, banking on what is there in order to receive, to give the depressed patient (that stranger withdrawn into his wound) a new start, and give him the possibility of a new encounter" (Kristeva 1989, 189). The patience of listening and forgiving refers just as much to the future as to the past; it releases the melancholic patient from an endless repetition of the past, and releases her toward an unexpected future. In a moment that recalls Levinas's language in *Totality and Infinity*, Kristeva compares the event of forgiveness to a "transubstantiation" (Kristeva 1989, 207). In forgiving the Other, I give her the chance to become otherwise: "to live a second life, a life of forms and meaning, somewhat exalted or artificial in the eyes of outsiders, but which is the sole requisite for the subject's survival" (207–8). Here, the subject's survival is not just a matter of committing matricide for the sake of one's own autonomy, but rather undergoing a

transubstantiation and renewal of possibilities through the analytic conversation. In this context, forgiveness breaks with the repetition of a past and opens the way to a different future, an entry into "the economy of psychic rebirth" (190). This break with the past in forgiveness does not forget or erase the pain of loss but rather transforms its significance:

> Forgiveness does not cleanse actions. It raises the unconscious from beneath the actions and has it meet a loving other—an other who does not judge but hears my truth in the availability of love, and for that very reason allows me to be reborn. Forgiveness is the luminous stage of dark, unconscious timelessness—the stage at which the latter changes laws and adopts the bond with love as a principle of renewal of both self and other. (Kristeva 1989, 205)

This "timelessness" of forgiving does not bring time to a standstill, but rather disrupts the linear order of historical time, where history is understood as a "concatenation of causes and effects, crimes and punishments" (Kristeva 1989, 200). Forgiveness disorders the image of time as either a line or an endlessly repeating circle; it suggests a discontinuous spiraling of time in which the past may be revisited and resignified but not exactly repeated, and where a new departure is always possible. Kristeva relates this spiral of forgiveness to the process of writing:

> Its spiraled temporality is accomplished within the time of writing. Because I am *separated* from my unconscious through a new transference to a new other or a new ideal I am able to *write* the dramatic unfolding of my nevertheless unforgettable violence and despair. (Kristeva 1989, 206)

In writing, I revisit my loss but also transform it into something else. Writing has recourse to the past without repeating exactly; it carries the past forward into a future where I may or may not be present to comment on what I have written. Writing puts me in proximity with an Other whom I may never encounter face-to-face, but whose possible readership promises to alter the significance of my words, transforming the possibilities of my writing in ways that I cannot anticipate or control. Kristeva writes: "Because it is forgiveness, writing is transformation, transposition, translation" (Kristeva 1989, 217). And because it is writing, forgiveness cannot be confined to a closed circle of speaker and listener/analyst, but rather extends itself to any reader who happens to come along, and in any possible context. Kristeva calls writing an "immoral forgiveness" (Kristeva 1989, 216), perhaps because it refrains from passing judgment on the one who has failed or transgressed. Writing may be immoral, but if there is nevertheless a sense of *herethics* that exceeds morality (narrowly conceived as rules for good behavior), then perhaps the immorality of writing as forgiveness is also a sign of its goodness.

The transformations of writing bear an ethical as well as an aesthetic or literary significance; writing implies orientation toward the Other in the midst of which a renewal of the self becomes possible. Kristeva compares forgiveness

to "the suffering and affection of the other for the stranger" (Kristeva 1989, 215). Because forgiveness carries within itself a trace of the traumatic loss that it repairs—because it remembers the past, as well as releases or detaches from it—forgiveness suggests an ethical signification of pain *for the Other*:

> By including them [pain and horror] it displaces them; by absorbing them it transforms them and binds them for someone else. 'There is a meaning': this is an eminently transferential gesture that causes a third party to exist for and through an other. *Forgiveness emerges first as the setting up of a form.* It has the effect of an acting out, a *poiesis*. (206, emphasis in original)

In light of this passage, Kristeva's essay, "Stabat Mater," appears as a poetic response to the pain of maternity and perhaps also to the pain of losing one's own mother; it also suggests a forgiveness for this loss, a renewal of the writer's relation with her own mother. The ethical alteration of time in forgiveness and writing does not compensate for loss (as in mourning), nor does it deny that a loss has taken place (as in melancholia), but rather signifies it for an Other, as "an additional, free gift. I give myself to you, you welcome me, I am within you. Neither justice nor injustice, forgiveness would be a 'fullness of justice' beyond judgment" (Kristeva 1989, 216). This analysis of forgiveness opens a way beyond Freud's alternatives of either replacing the Other or losing oneself; it suggests a renewed relation to "matricide" not as a crime or sacrifice, but as the gift of alteration for both mother and child. Kristeva writes:

> Through my love I exclude you from history for a while, I take you for a child, and this means that I recognize the unconscious motivations of your crime and allow you to make a new person out of yourself. So that the unconscious might inscribe itself in a new narrative that will not be the eternal return of the death drive in the cycle of crime and punishment it must pass through the love of forgiveness, be transferred to the love of forgiveness. (Kristeva 1989, 204)

In this passage, the analyst ("I") recognizes the patient ("you") as a child who requires forgiveness either because the child committed matricide for the sake of autonomy or because the child refused to commit matricide and so killed a part of him/herself along with the alterity of the Other. To move beyond these deadly alternatives, the self needs love or forgiveness, as if the mother (or mother substitute) were to say: *Look, you didn't kill me, I'm right here*, I am still an Other despite your failure to encounter me as such. In this way, the child is reborn or renewed, absolved of its crime of refusing to let the mother emerge as an Other. The forgiveness of the child also brings forth an alteration of time for the mother, releasing her toward new possibilities in which she is not merely a support for the self, not just "a condition for reconciliation with one's self" (Kristeva 1989, 199), more than just "our dear, good little mother" (Dostoyevsky, cited 199). In this transformation, the mother would find herself renewed and forgiven by Others, released from the crimes that

were committed against her and for the "crime" of being a separate person or distinct Other. The analyst's careful listening forgives for the patient who no longer knows how or whom to forgive; by taking the place of the lost mother, the analyst offers herself as the source of a new beginning. This gesture of forgiveness recalls the maternal body's expiation for a persecution she herself did not cause and which may even be brought against her, a forgiveness *for* those who refuse to forgive or fail to hear the demand for forgiveness. In *Otherwise than Being*, this expiation for the Other brings about the latent birth of the maternal, responsible self—*by* the Other, but also *for* the Other. We may return now to Levinas's account of an ethical persecution that turns into expiation—one that brings about the renewal or latent birth of the self.

Returning to Levinas:
Recurrence and the Latent Birth of the Self

For Levinas, the maternal body forgives even the one who persecutes her; she expiates for the Other who refuses to acknowledge his or her own fault or transgression. This forgiveness does not destroy the one who is persecuted, but rather brings about an unexpected recurrence or "latent birth" of the maternal, responsible self. In recurrence, I am both chased back into my skin and thrown outside of my "own" identity; I emerge as uniquely myself (that is, uniquely responsible for the Other) even as my own self-identity breaks up under the pressure of persecution. As I will argue, recurrence brings me back to the anarchic past of my birth to an Other, while calling me forth to the anarchic future of responsibility for an Other. How does this recoiling of time in recurrence help to transform the pain of persecution into an ethical renewal of the responsible, maternal body?

As one who is born to a mother, I am unable to form myself or posit my own existence; already in the womb, I am exposed to an Other who bears me. This bearing is like a welcome given in advance of my own existence by a maternal body who contracts to make room for me within herself. As one who is gestated in the body of a woman, I am passive, sensible, and exposed to the Other before I have a chance to find (or lose) myself. Levinas writes:

> The self involved in maintaining oneself, losing oneself or finding oneself again is not a result, but the very matrix of the relations or the events that these pronominal verbs express. The evocation of maternity in this metaphor suggests to us the proper sense of the oneself. The oneself cannot form itself; it is already formed with absolute passivity. In this sense it is the *victim of a persecution* that paralyses any assumption that could awaken in it, so that it would posit itself for itself. This passivity is that of an attachment that has already been made, as something irreversibly past, prior to all memory and all recall. It was made in an irrecuperable time which the present, represented in recall, does not equal, in a time of birth or creation, of which nature or

creation retains a trace, unconvertible into a memory. Recurrence is more past than any rememberable past, any past convertible into a present. The oneself is a creature, but an orphan by birth or an atheist no doubt ignorant of its Creator, for if it knew it it would again be taking up its commencement. (OB 104–5; AE 165–66, my emphasis)

As one who is born, I am already "the victim of a persecution" in the sense that any initiative to posit myself as self-made is already spoiled by the fact of my passivity before the mother who bears me in her flesh. The stranger who commands me to respond both recalls the passivity of anarchic persecution and introduces an altogether new form of persecution in which I find myself responsible even for the one who interrupts my identity and afflicts me with pain, commanding me to bear her "like a maternal body." In this sense, the stranger who interrupts me both calls me *forth* to maternal persecution, and calls me *back* to an infantile persecution at the site of my birth to an Other.

Recall Levinas's description of persecution as "a writhing in the tight dimensions of pain, the unsuspected dimensions of the hither side" (OB 75; AE 121). Could these "tight dimensions" not refer both to the maternal body whose skin is stretched beyond its capacity and to the child who is writhing in a space that is never quite big enough, already in proximity with the mother even before it exists? Levinas writes that in recurrence, "The oneself takes refuge or is exiled in its own fullness, to the point of explosion or fission" (OB 104; AE 165). This phrase also suggests an ambiguity between the self as the mother of an Other, and the self as the child of an Other. As one who is responsible, I am full like a maternal body, even "to the point of explosion or fission." But I am also full with myself, having found refuge "or" exile in my own fullness, trapped (or hiding) in my own skin. And yet even this fullness with myself is already an exposure to the maternal Other in whose body I have been "formed with absolute passivity." This natal exposure disrupts the mastery of the self in advance, anarchically turning it into a guest or even a hostage in its own home: "the victim of a persecution." Here, the word "persecution" could refer back to the anarchy of being born, but it could just as well refer ahead to the anarchy of bearing the Other like a maternal body. This double reference paralyzes any attempt to posit oneself as a fully autonomous subject who exists on its own account and so owes nothing to Others; the natal passivity of birth is not cancelled or transcended in recurrence but rather *redoubled* as the maternal passivity of responsibility. In recurrence I am pushed back into my skin as one who is uniquely responsible for the Other, even as I emerge out of suffocating entrapment in my own skin through a gift of the flesh that makes my suffering meaningful by signifying it to an Other. Recurrence signifies that I am "accused of what the Others do or suffer, or responsible for what they do or suffer.... This accusation can be reduced to the passivity of the self only as a persecution, but a persecution that turns into [*se retourne en*] an expiation" (OB 112; AE 177). The persecution of the hostage is not the same as self-sacrifice;

in bearing the fault of the Other and forgiving *for* him, I become uniquely myself. My own flesh acquires a new, ethical significance in being given to the Other whom it bears.

As Levinas suggests in the previous passage, "The oneself cannot form itself; it is already formed with absolute passivity" (OB 105; AE 166). This passive formation occurs *both* in response to the mother who bore me *and* in response to the Other whom I will someday bear. In the exposure of maternity, there is a recurrence to the exposure of the child who is born or reborn as a uniquely responsible self. The tightness of a gestating body, confined in the skin of an Other, inverts despite itself into the tightness of a pregnant body bearing an Other too great to be contained; it does so not in obedience to something like the ontological structure of birth, but rather in response to a concrete and singular Other. The passivity of persecution *by*-the-Other turns into the passivity of responsibility *for*-the-Other through a recurrence of the self to the unrepeatable and immemorial site of its natality, not in order to repeat its own birth as a self-production, but instead to give time to an Other, by bearing her like a maternal body.

Levinas calls the self "a creature, but an orphan by birth or an atheist no doubt ignorant of its Creator, for if it knew it it would again be taking up its commencement" (OB 105; AE 166). The self is both creature and orphan, both born to an Other and also capable of denying this passivity (if only misguidedly), by positing its own originality, autonomy, and mastery. If the self were incapable of this betrayal—immune to this desire to forget or erase my birth to another—then the time of birth would not be irrecuperable; it would be still mine, or already mine. Without this revolt, this temptation of virile egoism, the self "would again be taking up its commencement." It would already *be* what it wants to become in representation: a self that can start over on its own terms, positing for itself a blank slate on which to write its own life story, a time when it will not have been born to an Other but rather self-born or self-made. But, as I have argued throughout this book, such an effort to "start over" does not so much offer a renewal of the self as a denial of the Other, and a denial of the self's anarchic entanglement with Others. Ironically, the self is only absolved from the fate of virile self-possession by the temptation to start over by positing itself as atheist and orphan—a temptation that is reduced, again and again, by the proximity of Others who command me to responsibility and offer me something I could not have expected: a renewal of the self *by* the Other and *for* the Other, rather than *despite* her.

As we saw in *Totality and Infinity*, the father is forgiven by the son to whom he gives birth. But in *Otherwise than Being*, the maternal body both gives and forgives, both promises and expiates for the Other whom she bears. This double passivity prevents a closed circle from forming between mother and child; it also raises further questions for Levinas's ethics of substitution. If the sensible, maternal body forgives for the Other to the point of forgiving even the persecution inflicted on her, then who—if anyone—will forgive

for her? Who will expiate her suffering? How can the self survive this ethical ordeal of persecution and expiation without making some sort of claim on her own behalf? Levinas suggests that in substitution, "in which identity is inverted, this passivity more passive still than the passivity conjoined with action, beyond the inert passivity of the designated, the self is *absolved of itself*" (OB 115; AE 181, my emphasis). The self, responsible for the Other, is absolved of its ego in a recurrence to the immemorial and anarchic time of birth. I am absolved by forgiveness for the Other who persecutes me, released from a past that might otherwise repeat itself as a traumatic fate. Absolution is not the same as forgiveness; it comes as a surprise to the one who forgives for the Other. The recurrence of the natal/maternal body breaks the spell of a virile subjectivity that would depart from its origin only to return there, enriched by its travels through otherness; it absolves the self of its compulsion to repeat its own birth, even as it brings about a rebirth of the self as one who is uniquely responsible. To be absolved in recurrence and rebirth is not to find oneself without a past, but rather to find the significance of one's past altered by responsibility for an Other, such that I bear in my body, in my inspired flesh, a time that could not have been expected or calculated. A time in which I, too, will have found "asylum or refuge" in the body of the Other, both like the child of a stranger and like a maternal body for the stranger.

Levinas refers to this time of recurrence and absolution as the "latent birth of the subject" (OB 139; AE 218). Chased back into its skin and called forth to bear the Other, the self is "reborn" as a responsible, maternal self.

> Signification as proximity is thus the latent birth of the subject. Latent birth, for prior to an origin, an initiative, a present designatable and assumable, even if by memory. It is an anachronous birth, prior to its own present, a non-beginning, an anarchy. As latent birth, it is never a presence, excluding the present of coinciding with oneself, for it is in contact, in sensibility, in vulnerability, in exposure to the outrages of the other. The subject is the more responsible the more it answers for, as though the distance between it and the other increased in the measure that proximity was increased. The latent birth of the subject occurs in an obligation where no commitment was made. It is a fraternity or complicity for nothing, but the more demanding that it constrains without finality and without end. The subject is born in the beginningless of an anarchy and in the endlessness of an obligation, gloriously augmenting as though infinity came to pass in it. (OB 139; AE 218–19)

The latent birth of the self marks a recurrence to the anarchic gift of birth, even as it absolves the self from taking possession of this birth as its own. In this latent birth to the Other, the immemorial past of the child yields to the unforeseeable future of the maternal body without passing through "the present of coinciding with oneself." This movement evokes the anarchic time of birth I have described in the first part of this chapter as the ethical temporality of gestation and pregnancy. And yet Levinas does not refer to mothers or

children in this passage about latent birth; his reference to "fraternity" in the midst of this passage highlights the unorthodoxy of my own reading of latent birth. While Levinas articulates philosophical concepts that are indispensable for my inquiry into birth, I have sometimes found it necessary to orient these concepts differently, in a way Levinas himself might not have chosen. This is especially the case where issues of gender arise. The masculinity of fraternal politics raises questions for any feminist politics arising from the work of Levinas, and I will address these questions explicitly in chapter 6. For the moment I wish only to emphasize the sense in which the latent birth of the self recalls—for me, if not for Levinas—the passivity of the self's birth to a mother, and its rebirth as one who is *like* a maternal body for the Other. This rebirth of the self is only possible thanks to the anarchic response of another Other: the mother of the mother, the maternal body who—in an immemorial past—bore the one who now bears another stranger "like a maternal body." The latent birth of the self, delayed behind the present and opening toward potentially infinite generations of past and future giving, invites the reader to reflect on infinite generations of responsibility for the mother of the mother, the child of the child, the stranger of the stranger—and also the sister of the brother.

MOSES AND HIS MOTHERS: NUMBERS 11:12

Levinas's account of ethical maternity is both promising and troubling. It suggests a richly evocative language of bearing the Other corporeally without assimilation or synchronization, which is helpful in articulating the complex relations of proximity and alterity between the pregnant woman and the gestating fetus. In particular, Levinas's development of an anarchic, diachronic temporality helps to bring out the sense in which the mother gives time to the child without either losing something she once "had" or gaining something in the style of an Odyssean traveler who merely passes through otherness on its way back to itself. The surprising renewal of the self's own relation to time does not compromise the radical discontinuity between self and Other but rather presupposes it and reconfirms its significance for ethical life. These insights make Levinas's work promising for a feminist interpretation of birth. But even if one accepts that a certain "persecution" is required to sustain the discontinuity between self and Other through substitution and recurrence, the connection between maternity and persecution nevertheless remains troubling in the absence of a concrete illustration to show how maternal substitution actually works, and that it need not work against mothers and other women. In concluding this chapter on maternity, I wish to develop such an illustration by interpreting a biblical text that Levinas cites in his explication of maternal bearing in *Otherwise than Being*. The passage reads as follows:

> In proximity, the absolutely Other, the stranger [*l'Etranger*] whom "I have neither conceived nor given birth to," I have already on my arms, already I

> bear him, according to the Biblical formula, "in my breast as the wet-nurse [*nouriccier*] bears the nursling" (Numbers XI, 12). He has no other place, [is] not autochthonous, without roots, without a fatherland [*apatride*], not an inhabitant, exposed to the cold and to the heat of the seasons. Being reduced to having recourse to me: this is the homelessness [*l'apatride*] or strangeness of the neighbour. It falls upon me, makes me incumbent. (OB 91; AE 145)

This passage implies an ethical imperative to bear the stranger as a child, even if I have no reason and no capacity to bear him. The very homelessness and exposure of the Other speak to me in the imperative, commanding me to respond. But this passage also disrupts any straightforward understanding of what it means to be like a maternal body by referring the reader to Numbers 11:12, where the "wet nurse" who bears the nursling is not a mother or even a woman, but *Moses*. The sex of Moses, and the obfuscation of this sex by Levinas's manner of citation, return us to the questions about virility, femininity, and embodiment raised earlier in this book. How can a male body bear the Other "in [his] breast as the wet-nurse bears the nursling"? But how can he avoid bearing the Other in this manner, if he has been commanded to do so by God?

The story of Moses raises another, less explicit dimension of my inquiry into birth: the religious. The Levinasian vocabulary of infinity, illeity, expiation, and command suggest an opening of the ethical onto the religious. While I will not give a substantial account here of the significance of religion for Levinas, a few words of introduction are in order. Many readers of Levinas have wondered about the viability, even the desirability, of understanding ethics in terms of an infinite responsibility for the Other. Does Levinas not require his reader to sacrifice herself like a martyr or a saint for the sake of the Other? Does infinite responsibility not exceed the scope of the human in ways that might make other, more particular political obligations disappear from view? In an interview from 1987 with Joel Doutreleau and Pierre Zalio, the interviewers pose a question along these lines: "The I as ethical subject is responsible to everyone for everything; his responsibility is infinite. Doesn't that mean that the situation is intolerable for the subject himself, and for the other whom I risk terrorizing by my ethical voluntarism? So isn't there an impotence of ethics in its will to do good?" (Levinas 1998a, 203). Levinas responds:

> I don't know if this situation is intolerable. It is not what you would call agreeable, surely; it is not pleasant, but it is the good. What is very important—and I can maintain this without being a saint myself, and I don't present myself as a saint—is to be able to say that the man who is truly a man, in the European sense of the word—descended from the Greeks and the Bible—is the man who understands holiness as the ultimate value, as an unassailable value. (1998a, 203)

Humanity—or, as Levinas puts it, the "truly" "European" "man"—understands holiness and sainthood as the ultimate value, even if this saintliness does not

become present and actual. The language of true European manhood here obscures the main point that Levinas seems to want to make: namely, that ethics is not a matter of what I *can* do but rather what I *ought* to do. Ethics refers not to my own finite abilities but rather to my capacity to be opened by the presence of an Other who infinitely overflows and disrupts my own representation of him or her. But Levinas's unfortunate comment nevertheless raises a set of critical questions that I will take up later in this section, and again in chapter 6: How—if at all—does the infinite alterity of the Other relate to the particular cultural, racial, and sexual differences that flesh out our ethical and political encounters? Is the reference to true European manhood in the above passage merely an unfortunate and impolite remark, or does it reveal an inability or unwillingness of Levinas's ethics to respond to the *difference* of Others as well as their alterity?[18] Is the goodness of ethical "sainthood" recognizable, relevant, obvious, and unassailable only within a European framework that also happens to privilege men over women, whites over blacks, unity over diversity?

Levinas also invokes the value of sainthood in an interview from 1985, but this time without explicitly connecting it to European culture. He says: "I have never claimed to describe human reality in its immediate appearance, but what human depravation itself cannot obliterate: the human vocation to saintliness; I say that man cannot question the supreme value of saintliness" (Levinas 1999, 180).[19] As human beings—and perhaps not only as men "in the European sense of the word"—we are called to saintliness, as though the very definition of the human were to be the sort of creature who is commanded to exceed the limitation of its own finite abilities. Again, the lack of explicit reference to European manhood here does not mean that women and men are equally included in Levinas's concept of humanity. But I will argue that, even if Levinas emphasizes the masculinity of the self who is called to saintliness, his account of maternal substitution requires a certain feminization of the human, an alteration of virility in response to the feminine Other. This suggestion may risk identifying femininity with saintliness, thus confirming the patriarchal ideal of a woman who thinks nothing of herself and gives selflessly to the Other. Levinas does not exclude men from the ethical imperative to bear Others, but his use of maternity as a figure for ethics in general threatens to appropriate one aspect of maternity—its generosity—without acknowledging women's very particular, historical, and embodied experience as mothers. But these risks, however worrying, also call us to reexamine the categories of femininity and maternity in resistance to patriarchal ideals or political agendas that would identify woman as mothers, saints, or anything else. How might a feminist reader of Levinas respond to his account of ethical maternity without either accepting this account as the truth about motherhood as such or overlooking the feminist potential of his work?

In what follows, I propose a reading of Levinas's reference to the Book of Numbers along the lines of what Edith Wyschogrod describes as a *hagiography*.

For Wyschogrod, the story of a saint's life implicitly commands the reader to become *like* the saint, even as it holds up the unique singularity of the saint as an example that is impossible to follow. Wyschogrod writes: "It is the life as narrated that exhorts the text's addressees to 'make the movements' of the saint's existence after her/him. The success of the life's appeal is in part the result of sheer perlocutionary force: the indicative mood of the narrative's sentences carry imperative weight" (Wyschogrod 1990, 28). Saints are "those who put themselves totally at the disposal of the Other" (xiv); the saint's goodness is excessive, uncalled-for, beyond any reasonable expectation. Often the saint's life directly contradicts the law of the land or exceeds the limits of altruism. The life of a saint is not an instruction manual for ethics; its function is not to say, *Do this*, but rather, *Listen to this story; be altered by it*. Become *like* this Other whom you are not and can never become. To be like someone is to imitate, and so in a certain sense to repeat; but it is to repeat the unrepeatable, which is not accessible and cannot be claimed as my own.[20] To respond well to the imperative spoken in hagiography is to bring forward into the future a past that was never present, even as in birth I give time to the Other without owning or possessing the time that I give. Wyschogrod suggests that hagiography, in distinction from myth, is "lived forward" (29). It does not so much recount a story of origins as command the reader to become like a saint, existing *for the Other* both in words and in the flesh.

I interpret the story of Moses, invoked by Levinas's reference to Numbers 11:12, as a "hagiography" in the sense that Wyschogrod describes. The story of Moses both issues an imperative to become like a maternal body for the Other and also disrupts any simple understanding of the relation between ethics and reproduction. Translated into the vocabulary of Levinas, the saint would be a responsible self who substitutes herself for the Other, bearing her like a maternal body. In *Otherwise than Being*, Levinas does not state directly to the reader: "Be a hostage! Expose yourself! Be persecuted!" His account of the sensible, temporal, and substituting self is written in the indicative, but nevertheless issues an ethical imperative to the reader. This imperative arises in the text of *Otherwise than Being* itself; it is both amplified and complicated by the biblical reference that interrupts the text. Levinas may or may not have intended this citation as an interruption in the sense that I propose; the issue of authorial intention remains undecidable. But given the importance of citation and textual interpretation for the Talmudic tradition, Levinas's reference to Numbers 11:12 implies a religious significance that is belied by the brevity of the citation.

The context in which Levinas cites Numbers 11:12 emphasizes the homelessness of the Other whom I am commanded to bear. The biblical passage also evokes a context of hardship and homelessness in which the Hebrew people are returning from exile and slavery in Egypt, reluctantly following their equally reluctant leader, Moses. The people are weary from traveling; they begin to complain about the lack of good food to eat. God has given them manna for their journey home, and this manna is plentiful and easily gathered,

but the people crave something more interesting and varied to eat. They begin to grow nostalgic for Egypt, where they seemed at least in retrospect to enjoy cucumbers and fish for "free." The difficulty of the journey home has made even slavery seem idyllic, and the people complain to Moses, who turns to God and asks:

> "Why have you treated your servant so badly? Why have I not found favour in your sight, that you lay the burden of all this people on me?
>
> *"Did I conceive all this people? Did I give birth to them,* that you should say to me, '*Carry them in your bosom, as a nurse carries a sucking child*,' to the land that you promised on oath to their ancestors?
>
> "Where am I to get meat to give to all this people? For they come weeping to me and say, 'Give us meat to eat!'
>
> "I am not able to carry all this people alone, for they are too heavy for me.
>
> "If this is the way you are going to treat me, put me to death at once—if I have found favour in your sight—and do not let me see my misery."
>
> <div align="right">(Num. 11:11–11:17, my emphasis)</div>

Like the responsible self in *Otherwise than Being*, Moses is almost overwhelmed by his infinite ethical and material burden, which feels like an affliction or persecution. He did not give birth to these people. Why should he bear the sole responsibility for feeding them and giving them enjoyment? What resources does he have to satisfy their cravings? Moses does not even possess these resources for himself; he is a "stranger in a strange land" (Exod. 2:22), without a fatherland, homeless and exposed. Like Zion in Isaiah 49, who has nothing to offer the strangers who claim to be her children, Moses protests that he does not have the capacity to bear "all this people alone, the burden is too heavy for me" (Num. 11:14). And yet like Zion, Moses will be given the capacity to bear this people by another Other: God. The thirdness of God already commands Moses to welcome and harbor these people, even if the obligation to welcome seems like a persecution and a hostage-taking. While in *Totality and Infinity* the "father" turned out to be both a mother and a daughter, here in *Otherwise than Being* the "maternal body" turns out to be a man: Moses. The manner in which Levinas cites Numbers 11:12 tends to obscure the fact that, in this case at least, the "maternal body" is male. What is the effect of this play on sexual difference, in which a man is called on to be a "male wet nurse" (*nourricier* in French, or *ammon* in Hebrew) for strangers whom he has "neither conceived nor given birth to"?

We could read this text in a number of different ways. On the one hand, we could argue that by referring to Moses as an example of maternity—especially in the absence of any *female* examples of maternity—Levinas appropriates the female capacity to give birth for the male body. This is by no means an uncommon gesture in the history of Western civilization, and much feminist scholarship has been dedicated to an analysis of this sort of appropriation. But I would like to suggest another feminist interpretation of this gesture that might

at the same time shed light on the potential significance of ethical substitution for feminist thought. In the interpretation that follows, I suggest that Moses's responsibility for the people requires him to be *feminized* by this responsibility, in a manner similar to the feminization of the self described in chapter 3 on hospitality. This interpretation of Moses' maternity does not restrict the significance of maternal substitution to Moses himself but rather implies several generations of substitution in which Moses both bears and *is borne* by Others. Moses is not literally a mother, but he was born to a mother. And, as we shall see, he was borne by more than one woman who substituted for him "like a maternal body," even though they had "neither conceived nor given birth to" him. What is the relation between Moses' own bearing and the sense in which he has been borne by Others? What is the relation between *giving birth*—or giving time to the Other, substituting and expiating for her—and *being born* to another maternal body? My response to this question will emphasize the sense in which the illeity of *another* Other, both before and beyond me, is invoked in every responsibility of the self for the Other.

Listen, then, to the story of Moses who substituted for his people "like a maternal body." Moses was born to a Hebrew woman at the time of exile and enslavement in Egypt. Pharaoh ordered the midwives to kill every Hebrew son and spare every daughter, perhaps expecting that this measure would "feminize" the Hebrew people, eventually integrating them into Egyptian life. But the midwives disobeyed Pharaoh's orders and refused to kill the sons, claiming that the Hebrew women were "vigorous" and always gave birth before a midwife could arrive (Exod. 15:19). Like the saints Wyschogrod describes, the midwives risk their own safety for the sake of the Other, claiming never to be in a situation where they could carry out the unjust orders of the state. When Pharaoh orders every Hebrew son to be cast into the Nile, Moses's biological mother responds with her own gesture of resistance. She places her son into the river, but in a basket made of bulrushes. This basket saves Moses from the water until someone comes along to find him. Displacing the law more than breaking it, Moses's mother interprets the law otherwise, creating the conditions whereby her son might have a future. A third displacement of the law is given by another woman who substitutes herself for Moses like a maternal body. Pharaoh's own daughter finds Moses in his basket among the reeds. He is crying, and she takes pity on him even though she immediately recognizes him as "one of the Hebrews' children" (Exod. 2:6). Moses's sister approaches Pharaoh's daughter and offers to find a Hebrew wet nurse for the child; she agrees, and the sister brings Moses's biological mother to be a nurse for her "own" child. The irony of this story multiplies at every turn: the woman whose father ordered the death of all Hebrew boys acts to save one of these boys; she steps in like a substitute mother and hires the boy's own mother to be a substitute for his new substitute mother. Thus, the child's biological mother is displaced not once but twice from her "natural" role, yet this displacement is the very condition for the child's future and for her own future as a mother to him.

Pharaoh's daughter is a stranger, even an enemy to the child; yet she becomes also like a mother and a midwife to him: drawing his body out of the water, giving him the promise of a future, carrying and naming this child to whom she owes nothing but for whom she has risked her own safety. By resisting her father's law for the sake of an Other, Pharaoh's daughter substitutes herself for a child whom she has neither "conceived nor given birth to," bearing him "in [her] breast as the wet-nurse bears the nursling" (Exod. 2:9).[21]

Pharaoh's daughter names the child Moses, as she explains, "[b]ecause I drew him out of the water" (Exod. 2:10). In Hebrew, the name means "to draw out," as in the act of a midwife or a water-bearer; the same name in Egyptian means "to beget a child."[22] Even Moses's name refers to the birth of a child: a birth that for him seems to have happened not once but at least three times, and each time thanks to women who substitute for him in resistance to an unjust law. Moses is a name that speaks the languages both of the homeland from which he was exiled, and of the exile that had become his home. Moses's task and his glory are bound to his name. Like a midwife, he draws his people through water from slavery into the promised land. Like the woman who gave him his name, Moses gives his people a different, more hopeful future. Indeed, the *feminization* of Moses—his reluctance to be a leader, his midwifery, his bearing of strangers to whom he owes no debt—is his glory. It is in being "like" the women who once bore him that Moses leads his people out of slavery, in a way that is both *for* the Other and commanded *by* the Other. Moses's mothers and substitute mothers suggest through their bearing that one becomes a mother by becoming *like* a mother; that one becomes responsible not by drawing on some innate female capacity, but by imitating in advance of any example the gestures of a substitution by which I take the place of an Other who both faces me and exceeds my grasp.

In the passage that I have cited from Numbers 11:11–17, God himself becomes like a fourth substitute mother for Moses. He gives to Moses the resources with which to bear this people who seem too much, even impossible to bear. In so doing, God turns the despair of Moses and his people into a future of promise. He says to Moses: "Gather for me seventy men of the elders of Israel . . . and they shall bear the burden of the people along with you so that you will not bear it all by yourself" (Num. 11:16–17). As if He were the parent of Moses, God takes responsibility for His child's own responsibility, making it possible for the child to bear an impossible burden. But the parenthood of God goes beyond this assistance whereby the responsibility of one is diffused among many. For in Moses's own words to God, a strange alteration takes place. At the end of his protest Moses says to God, "If this is the way you [in Hebrew, *at*, the feminine form of "you"] are going to treat me, put me to death at once" (Num. 11:15).[23] In protesting his burden—in trying to struggle out from under this responsibility that he did not actively undertake, for a people whom he did not conceive or give birth to—Moses addresses God with the *feminine* form of the second person pronoun.

Why does Moses address God in the feminine, and why only in this passage? Perhaps it is because if Moses is to nourish his people like a maternal body, then only a divine *maternal* body can assist him—because even God must become "like" a mother to bear responsibility for feeding His (or Her) people. Rabbinic commentators such as Rashi and Nachmanides have speculated on the significance of this feminine address. Rashi suggests that Moses addressed God in the feminine because "Moses' strength grew weak like that of a woman, because the Holy One, blessed be He, showed him the punishment He was to bring upon them for this [sin of theirs]" (cited in Ramban 1975, 100). But Nachmanides disagrees: "For the pronoun *at* refers to him on high [to God]!" (100). He argues that the word "thou" does not refer back to the "I" who speaks it, but rather goes forth toward the Other whom I address, and so there must be some sense in which God, too, can be addressed in the feminine. Nachmanides suggests that the word *at* in this passage refers not to the feminine weakness of Moses but to the divine "attribute of justice ["attribute" in the Hebrew is feminine, and the meaning of the verse is: "if it be decreed that the attribute of justice encounter me, then *kill me, I pray thee*"]" (101). He adds that "the student versed [in the mystic lore of the Cabala] will understand" (101). On this interpretation, Moses addresses God in the feminine not out of his own weakness, but rather as a way of seeking God in the divine—and *feminine*—attribute of justice.[24] Moses seeks justice for himself since he wants to be spared the misery of having not found favor in God's sight; he also seeks justice for the people who seem at the moment of his despair so little to deserve justice, given their unreasonable complaints and desires. The suggestion seems to be that if Moses is to draw the people forth to a land of promise, like a midwife drawing forth a child, then God must also make himself known in the feminine, as one who is also "like a maternal body" for his people.[25] This is not the only moment in the Bible when God appears as a feminine or maternal figure; as we have already seen in Isaiah 49, God compares himself to a woman who never "forget[s] her nursing child,/ or show[s] no compassion for the child of her womb" (Isa. 49:14). The Hebrew people may be on their way to the fatherland, but if they are to arrive there, they must be sheltered and fed by a God and a leader who bear them "like a maternal body."

In his reading of Numbers 11:15, Nachmanides refers specifically to the divine attribute of justice, citing as the reason for this interpretation the femininity of the word "attribute" (*sefirah*: emanation, potency, attribute). But in the Cabalistic view of God, there are ten divine attributes, some of which are more connected to masculinity, others more to femininity. The ninth *sefirah*, *Yesod* or foundation, is connected to male potency or transcendence and the tenth, *Malkhuth* or kingdom, suggests a female receptacle [Rojtman 1998, 76, 77; see Rojtman 72–88 for a fuller analysis of the feminine (*zot*) and masculine (*zeh*) apsects of the ten *sefirot*]. But there is nothing specifically feminine about the fifth attribute of justice or judgment (*Gevurah*), which is counterposed with the fourth attribute of mercy or grace (*Hesed*). However, as Gershom Scholem

explains, the exile of the Jews is tied to the exile of the *Shekhinah*, or the feminine face of God (Scholem 1965, 107–8); this exile brings about an opposition or division between masculine and feminine aspects of God, as well as a splitting of judgment from mercy to the point at which the former dominates:

> [T]here are states of the world in which the *Shekhinah* is dominated by the powers of stern judgment, some of which have issued from the *sefirah* of judgment, made themselves independent and invaded the *Shekhinah* from without. As the *Zohar* puts it: 'At times the *Shekhinah* tastes the other, bitter side, and then her face is dark.'. . . While in most other contexts she is the merciful mother of Israel, she becomes at this stage the vehicle of the power of punishment and stern judgment. (Scholem 107)

Scholem argues that these oppositions and divisions between masculine and feminine aspects of God are signs of a fallen world, where redemption would mean the return of the Shekhinah from exile, the reconciliation of masculine and feminine aspects, and a renewed balance between judgment and mercy. Given this brief sketch of the Cabalistic framework informing Nachmanides's reading, what can we say about his reference to the attribute of justice or judgment (*Gevurah*) when explicating Moses's feminine address to God?

"Put me to death at once," Moses says to God (Num. 11:15), preferring death to the sight of his own misery. This is the desperate request of an exile and leader of exiles, addressed to a God who seems unlikely to offer mercy or compassion. But even if Moses addresses his appeal to the divine attribute of justice or judgment in this moment, God responds with an ambivalent mixture of judgment and mercy. God tells Moses to gather elders to help share the burden of the people; but God also sends a "gift" of quails that turns into a nightmarish plague for the people (Num. 11:31–33). Piles and piles of birds fall from the sky and are heaped around the camp; suddenly, there is enough meat to feed the entire camp for a month or, as God says, "until it comes out of your nostrils and becomes loathsome to you" (11:20). If the people crave meat, they will have meat—so much that they will choke on it and wish they had never complained! At this point in the exile of the Jews, God shows two different, even opposite sides: compassion and wrath, measured assistance and outrageous punishment. God's response to Moses complicates the picture of maternal responsibility I have sketched thus far. While I do not wish to set up a correspondence between God's response (with or without the layers of Cabalist interpretation) and motherhood as such, I find here an occasion to explore another dimension of motherhood that troubles the saintly image of the woman who substitutes for Others without thinking of the risk this may bring to herself.

Motherhood is not always a patient, generous, compassionate practice of ethical substitution. Maternal generosity can spill over into resentment and anger, even to the point of becoming violent. Women and men who raise children, like anyone else, have moments of impatience, fatigue, distraction, selfishness; these moments do not indicate a failure of particular mothers to reach the ideal of

maternal sainthood, but rather a confirmation of the difficulty of ethical life and the vulnerability of human creatures who are both limited and responsible for Others who push their limits. If we were unfailingly saintly, there would be no need for hagiography or even for an ethics of responsibility; knowing the good, doing the good, and being good would all neatly coincide. Precisely because mothers are not necessarily saints, we need both an ethics of substitution and a narrative practice of listening to stories that challenge us with their perlocutionary force. But we also need something else. Given the exposure of the responsible self to violence and persecution—given the possibility of abusing the generosity of Others or being abused oneself—we need a politics of justice that protects both mothers and children from a reification of the ethical asymmetry between self and Other into a social asymmetry between those whose role it is to bear Others and those who enjoy the luxury of being borne, perhaps without even realizing it. I will address the relationship between maternal ethics and feminist politics in the next and final chapter.

Who is the "real" mother in this story of Moses? Is it his biological mother, or the woman who gives him a metaphorical second birth by drawing him out of the water? Is the real mother Moses himself, commanded to bear an entire people whom he has "neither conceived nor given birth to"? Or does God "Himself"—addressed in the feminine by an Other who seeks His help—bear these children like a mother, even as He commands Moses to do likewise? Each of these figures becomes like a maternal body for the Other who is homeless and destitute, yet each is also displaced from the *identity* of motherhood in some way. If we return to the context in *Otherwise than Being* when Levinas refers to the story of Moses, we find that this tension between the displacement from identity and the command to bear an Other is the ethical tension par excellence. The "homelessness or strangeness of the neighbour . . . falls upon me, makes me incumbent" (OB 91; AE 145). I have no room for the Other who approaches me and no reason to think that I have been the cause of her suffering. There is nothing in my own character or identity that would compel me to take responsibility for the Other. And yet as soon as she approaches me, homeless and destitute, it is incumbent on me to welcome her, to make room for her in the midst of my own exile. This fact of the Other's approach, which speaks to me in the imperative mood, turns me into a unique, embodied, and responsible self. It commands me to *give birth* by substituting for the Other and bearing her like a maternal body, but it also *gives birth to me* in the latent birth of the responsible, maternal self.

The maternity of Moses and of God suggests that one is not born, but rather *becomes* like a mother. Hence, the biological fact of incarnation in a female body does not condemn me to the destiny of childbirth, nor does my incarnation in a male body free me from the responsibility of bearing the Other "like a maternal body." If the literal and metaphorical dimensions of birth fail to remain separate here, perhaps it is because the story of Moses disrupts the possibility of a strictly literal *or* metaphorical interpretation. For

Levinas, the approach of a strange and unknown Other commands me to become like a maternal body for one whom I may or may not have conceived, whether I am male or female, at home or in exile. If we understand maternity in this way, not as a fixed biological or even social identity but as the response to an ethical imperative from the Other, then maternity might become disengaged from a strict biological interpretation without being thereby disincarnated. The understanding of maternity as a substitution for the Other commands me to respond face-to-face and in the flesh; it also releases me from any predetermination of my identity by the chemistry of my flesh. In this sense, maternity becomes more than a social role or fixed biological destiny, either of which might bind the identity of women to childbirth and child-rearing, as Beauvoir feared. By understanding maternity *ethically* as the embodied response to an Other whom I may or may not have "conceived and given birth to," we recognize maternity as a locus of responsibility without expecting women to bear that responsibility alone. But we can only hold to the promise of ethics by keeping Levinas's discourse open to interruptions from the outside, raising questions about the limits of his own ethical interpretations of birth and maternity.

How do these reflections on birth ultimately bear on our understanding of the relation between birth, time, and ethics? And how does the story of Moses in particular guide us toward a more complex understanding of this relation? I have suggested that the narrative of Moses and his (substitute) mothers, while told in the indicative mood, speaks to its readers in the imperative. The narrative says: *Listen, and be altered*. Bear the Other as God bears Moses, as Moses bears the people, and as the women in the story bear Moses. Moses becomes himself not by taking on the identity of a hero for his people, but rather by responding to the Other—and to another Other, God—and by bearing his people as the women in his life have also borne him. In this sense, the figure of Moses does not define the meaning of maternity so much as carry this meaning over: from the God who commanded him, the biological mother who nursed him, the midwife who spared his life, the stranger who adopted him, and the sister who assisted at this adoption. These (mostly anonymous) women have not been showered with the glory of historical celebration, but without them, there would be no history to be told. Together, they embody what Levinas calls the "glory of the infinite":

> Glory is but the Other face of the passivity of the subject. Substituting itself for the other, a responsibility ordered to the first one on the scene, a responsibility for the neighbour, inspired by the other, I, the same, am torn up from my beginning in myself, my equality with myself. The glory of the Infinite is glorified in this responsibility. (OB 144; AE 226)

The women who encounter Moses and risk their safety for his sake are like the saints whom Wyschogrod describes in her account of hagiography; their goodness is excessive and uncalled-for, *even if it is also commanded by the face of*

the Other. The ethical command does not issue forth a universal duty but rather calls *this* singular self to a goodness beyond what is reasonable or even possible. To make of these women an example for all mothers, or to deduce from their response an ethical code of maternal responsibility, would not only be a philosophical mistake—it would approach the injustice of reducing ethical asymmetry to a social or political asymmetry in which mothers in particular are expected to be saintly or self-sacrificing, perhaps so the rest of us can be relieved of the burden of singular responsibility. Precisely because it calls for such inordinate goodness, Levinas's ethics of radical responsibility—his commitment to "the supreme value of saintliness" (Levinas 1999, 180)—requires a politics of justice to address and critique the unshared social burden that is often heaped on certain groups of people: women, workers, black and brown people, anyone whose contribution to collective life goes regularly unnoticed or unreciprocated. This is not exactly the way Levinas would articulate his own political concerns; as we saw earlier, he is quite comfortable using the language of European manhood to support the value of sainthood. And yet, precisely in response to the blundering political content of Levinas's occasional remarks, I wish to argue that his ethics of alterity calls for a politics of diversity, and that the ethics of maternal substitution in particular calls for a feminist politics of reproduction and motherhood, even if this feminist politics also returns to the ethical encounter for its inspiration.

We must not overlook the long history in which women have been coerced, both directly and indirectly, to produce children; yet if we do not imagine different ways of thinking about the relation between women and birth, then we might never find a way of repairing this history in the hope of a different future. Substitution may not be the final word on birth, but reflecting on the ethical significance of substitution allows us to move the discourse about birth from a biological burden toward an ethical gift, without thereby forgetting the flesh. Perhaps every new mother, no matter how young or old, has wondered how she, still the child of another, could suddenly become a mother for someone else. More viscerally than in paternity, the new mother is transubstantiated from child into parent. How will she know what to do, how to be this new self? More than instinct is involved in this new birth or rebirth of the mother; and perhaps something of this "more" can be articulated with the word "like." To become *like* a maternal body even when you are one is to admit a gap between mothering as an ethical practice and the mother as a fixed ontological or biological identity. By recognizing that it is possible to be *like* (but also *unlike*) a mother even while one "is" a mother, we recognize a difference between ethics and being, between being and the otherwise-than-being. Feminists have long sought to disentangle the identity-positions of woman and mother. Perhaps Levinas's concept of ethical substitution, if read with these feminist questions in mind, allows us to make a separation between woman and mother without making this separation absolute.

CHAPTER SIX

Maternal Ethics, Feminist Politics: The Question of Reproductive Choice

The ethical maternity of Moses raises questions for the social and biological identities of motherhood by suggesting that both men and women may be commanded to become "like a maternal body" for the Other. But this is not to say that biological and social identities are therefore irrelevant to the theory or practice of maternal ethics and the politics of reproduction. Indeed, current research in the area of reproductive technology—as well as a political climate in which women's right to abortion and access to birth control are once again being challenged—make the question of maternal identity increasingly important. While anyone, male or female, may become "like" a maternal body, only a woman can become pregnant, and only a woman can be faced with her own unwanted pregnancy. In this sense, physiological differences between the sexes raise the possibility of an ethical situation that only women—and not all women—will encounter. While Moses may be called on to bear his people maternally, only a woman can find herself in a situation in which she already bears a fetus in her body, before having had a chance to accept or refuse this proximity. In light of this difference, Beauvoir's demand for reproductive freedom remains pressing, even if we might want to challenge her account of women's experience of reproduction. How might a feminist politics of reproduction emerge from the ethics of maternal embodiment that I have outlined here without ultimately falling back on either a liberal or existentialist account of the individual as one who is free and unencumbered by Others before "choosing" to become responsible? To put this question rather differently: Given Levinas's emphasis on radical, anarchic, unchosen responsibility for the Other, are there any grounds within a reading of his work to support a claim for women's right to choose not to bear a fetus to term?

At first glance, it may seem difficult if not impossible to reconcile the feminist demand for reproductive choice with the work of Levinas. How would a

woman's right to safe, legal, and accessible abortion stand alongside Levinas's account of the discrete feminine Other in *Totality and Infinity*, or the persecuted maternal body in *Otherwise than Being*? Levinas's own notorious comments about the nobility of women dying in childbirth complicate this matter to the point of raising doubts whether Levinas would have supported my own argument in this chapter. In a 1991 interview with Bracha Lichtenberg-Ettinger, Levinas says: "I think that the heart of the heart, the deepest point of the feminine, is dying in giving life, in bringing life into the world" (Levinas and Lichtenberg-Ettinger 1991, 9). He immediately adds, "I am not emphasizing *dying* but, rather, *future*" (9). But the implication remains that the deepest ethical gesture for the feminine is to give herself up for the sake of an Other, to die in the midst of "giving life." Unless we read very carefully between the lines, as I have sought to do in chapters 4 and 5, it seems that, for Levinas at least, the future belongs to fathers and sons rather than to the women who make this future possible through their own discretion, modesty, disappearance, or death.

While Levinas's ethics fails to sit comfortably with pro-choice feminist politics, I will argue that it sits even less comfortably with the pro-life argument that every woman who conceives is thereby responsible for carrying the pregnancy to term. I resist both the view that a woman's choice to abort necessarily represents an abdication of her ethical responsibility for the Other, and also the view that women's reproductive freedom would be compromised by any serious talk about responsibility for an unborn Other. I suggest the possibility of a certain *ethical* responsibility for the prenatal Other that does not preclude the vital necessity of women's *political* right to safe and accessible abortions. If we accept the argument over abortion in the terms in which it is so often presented—as a battle between the fetus's "right to life" and the woman's "right to choose"—then my desire to speak of a certain responsibility to fetuses would surely fail on feminist grounds. To concede personhood to a fetus—let alone to concede Otherness to it, where the Other is one who commands me to infinite responsibility—would be to lose the battle as feminists, so long as we assume that the battleground is determined by competing rights.[1] Pro-choice arguments that depend on a liberal account of the pregnant woman as an autonomous, rights-bearing individual who "owns" her body—and whose right to choose follows from this ownership—tend toward a philosophical and rhetorical impasse. Faced with popular pro-life representations of the fetus as a prenatal person whose right to life trumps the pregnant woman's right to choose, the pro-choice liberal feminist finds herself forced to argue that the fetus is not a "person" capable of bearing rights, and therefore not a significant moral threat to women's own right to choose. Rather than deeply contesting and displacing the terms of the pro-life argument, liberal feminists find themselves in the awkward position of agreeing with pro-lifers that the person is a rights-bearing individual, but disagreeing about when, where, and in whom these rights should be located.[2]

But what if we shifted the ground of the argument over abortion altogether? What if we grounded women's reproductive freedom not on the assumption of

an autonomous subject who owns her body and therefore has a right to choose, but rather on the ethical sensibility of an always-already embodied self whose very exposure to the Other calls for justice and equality, and *therefore* for women's right to choose?[3] Feminists such as Drucilla Cornell have noted the ethical and philosophical limitations of the standard liberal analysis of abortion and proposed alternate defenses of reproductive choice that do not rely on the assumption of an atomistic, autonomous individual. Cornell articulates the right to abortion on demand in terms of a woman's right to imagine herself as a whole and completed person, where personhood is understood to emerge through one's temporal and ethical relations with Others rather than as the exclusive property of an atomistic self. In Cornell's argument, the denial of access to abortion amounts to a reduction of women in the social imaginary—and indeed in concrete, particular situations—to members of the sex for whom it is a social and biological duty to bear Others. I wish to build on Cornell's defense of abortion by elaborating the ethical and political consequences of my feminist interpretation of Levinas. The aim is to provide an account of embodied selves whose ethical responsibility is excessive and anarchic, but also mediated by the political demand for justice and equality. I argue that women's right to abortion constitutes one among many political demands without which ethical responsibility for an Other might appear as "slavery" (as Levinas puts it in *Otherwise than Being*) or as "the pure and worst violence" (as Derrida puts it in "Violence and Metaphysics" (Derrida 1978, 107)). Without a feminist politics of reproductive choice, a maternal ethics of embodiment for the Other threatens to confirm the traditional view of women and especially mothers as humble, self-sacrificing supports for other people—or even to valorize the persecution, trauma, and displacement of the maternal self. And yet, without an ethical account of pregnant embodiment, the politics of choice would risk reducing the gift of birth to a choice or project undertaken by a fully autonomous subject.[4] Levinas's maternal ethics calls for a feminist politics—and, given the language of maternity in *Otherwise than Being*, it calls in particular for a feminist politics of reproduction. My aim in this chapter is thus twofold: to explore the significance of Levinas's ethics for feminist accounts of reproductive freedom, and to examine the vital importance of these feminist political accounts for the viability of Levinas's own ethics. By moving between the work of Levinas and Cornell in this way, I hope to articulate an ethical approach to the politics of reproduction: an approach that maintains the gap between woman and mother without widening this gap into an unbreachable chasm.

DEFENDING THE IMAGINARY DOMAIN: DRUCILLA CORNELL

Cornell's defense of women's access to abortion contests the standard liberal argument that women own their bodies and therefore have a right to decide what happens to their property. While contesting the language of ownership,

Cornell does not dismiss the importance of autonomy as an ideal toward which one might orient oneself and in relation to which one might defend the political right to freedom from violence or persecution. Precisely because we exist as embodied selves in relation to others—precisely because we *live* our bodies rather than own them—we need to take account of the fragility of bodies and selves in legal terms, defending women's equal access to the project of constructing a flexible but more or less stable sense of personal identity. Cornell calls this a demand for the "equal protection of the minimum conditions of individuation" (Cornell 1995, 3).[5] She writes:

> The image necessary for personhood is that of coherence and self-control. If one were truly in control of one's body then the problem of unwanted pregnancy would solve itself. What is being protected [by the legal right to abortion] is not any actual power to control, but the need to retain some image of coherence in spite of the loss of actual control which threatens a return to a raw, fragmentary experience of the body. (Cornell 1995, 67)

For Cornell, personhood refers not to a disembodied legal entity, but to the project of imagining oneself whole in relation to images of which I am not the origin, but without which I would not emerge as myself. Equal access to this project of personhood needs to be defended by law; however, personhood itself is not just an abstract legal concept, but rather an open-ended, embodied project that each of us must undertake for ourselves. A person is always in the process of *becoming* a person, moving toward an imagined autonomy that is never accomplished in the present but rather projected into the time of the future anterior, a time in which I "will have been" a whole and integrated self. This open-ended identity of the self does not exclude otherness but rather emerges in response to an Other who is meaningfully different from myself. In this sense, Cornell both modifies the liberal definition of personhood (emphasizing wholeness over sovereign independence), and also displaces this autonomous personhood into a past that was never present and a future that never quite arrives.[6]

There are many possible ways of imagining the female body's capacity to become pregnant, gestate a fetus, and give birth to a baby. Depending on the personal and cultural context, this capacity may appear as a blessing, a curse, an enviable power, a sign of weakness, or various other possible images; in any case, the capacity to become pregnant is not fully subject to individual choice and control. Women are exposed to sexual violence; condoms break; people make choices that they later regret. However careful I am, I can find myself pregnant against my will. Cornell argues that, in light of women's unique capacity to conceive, gestate, and give birth, the law needs to guarantee the publicly funded access to abortion on demand as one of the basic conditions for women's equal chance at the project of personhood. This is not to assume that all women will someday find themselves in the position of considering an abortion, or that access to abortion automatically clears the way for the

project of personhood for all women. But given both our capacity to become pregnant and our cultural inheritance of images representing women as mothers, saints, whores, or various combinations of the above, Cornell suggests that universal access to abortion is required to hold open the *imaginary domain* in which the meanings of woman and mother can be reinvented. The denial of such access implicitly reduces women to an isolated part of their bodies; it says, for example, "You *are* this egg, this womb, this bit of ovarian tissue. Once this egg is fertilized, you will be a mother; and if you terminate this pregnancy, you will be a mother murdering her baby." The definition of woman as a collection of body parts—and the interpretation of these body parts as isolated bits of "motherhood"—attacks the conditions for imagining oneself as a whole person. Cornell argues: "To deny a woman the right to abortion is to make her body not "hers" at the same time that it reduces her to her "sex," limitedly defined as maternal function" (Cornell 1995, 52). In resistance to this representation of women as always-already potential mothers, Cornell suggests other possible ways of imagining abortion that do not imply this reduction: for example, as a woman's choice to halt her own pregnancy, as the decision *not* to give birth.[7]

Ironically, in order to exist as a "whole" person rather than a collection of fragments (as a womb or a viable egg), I need the *instability* and *lack* of a wholeness that is endlessly deferred into the future, the ambiguity of a split identity that does not neatly coincide with any given representation. The gap between static representation and fluid imagination is held open by the difference or diachrony between past and future possibilities for personal identity. The insistence on a full and completed identity in the present would destroy the very promise of becoming a person, reducing the imaginary domain to the flat space of presence or representation. For Cornell, the function of law is to hold open the space in which each of us can encounter both the instability of our present identity, and the endlessly deferred project of becoming a whole and completed person. On this view, justice requires a framework of laws, institutions, and objective principles, but it is not *exhausted* by this framework, as if justice could be immediately produced by the right set of universal rules. Rather, justice refers to an open-ended future in which the demand for equality does not compromise the singularity of the "I" and the alterity of the "you." In this sense, justice is oriented toward a future that never quite arrives in the present moment, a time that resists adequate representation; it refers to a future anterior, a time that *will have been* just. As Cornell writes: "Justice is not something to be achieved, it is something to be struggled for" (Cornell 1995, 16). Approached from this perspective, the feminist demand for reproductive justice would be oriented toward the conditions under which a woman may emerge as an "I" who is not already reduced to a "she" by her reproductive capacity. Contrary to the appeal of pro-life rhetoric, the idea that women could be biologically assigned to an ethical responsibility at the moment of conception is not morality—it is injustice. An ethical response to

the Other cannot be legislated or rhetorically coerced from women—it may *only* emerge given a demand for social and political equality, one of the conditions for which is publicly funded access to abortion, such that women need not become mothers by default.

In a different context but a similar spirit, Zoe Sofia argues that the pro-life image of the fetus—as a tiny, fully formed person who only requires further incubation in a maternal body in order to emerge as the autonomous subject that it already "is" in nascent form—implies a collapse of the future into the present. Sophia offers a critique of the political temporality invoked by an anti-abortion pamphlet written by Dr. J. C. Wilke of the National Right to Life Committee. The pamphlet asks a series of rhetorical questions: "Did you 'come from' a human baby? No! You once were a baby. Did you 'come from' a human fetus? No! You once were a fetus. Did you 'come from' a fertilized ovum? No! You were once a fertilized ovum" (cited in Sofia 1984, 56). Sofia comments:

> Dr. Wilke's embryological catechism attempts to persuade us that we did not just "come from" an embryo (the *future conditional*), we "once were" that embryo (*collapsed future*); that embryo was always already what we are now, an adult person. The embryo faces no alternative futures, but one single destiny, which is moreover collapsed back onto all previous states of being, allowing the conceptus to be spoken of as a "tiny person" and the deliberate arrest of its development equated with homicide. Contrasting with this *collapsed future* of anti-abortion rhetoric is the *future conditional* of feminists, who understand conception as an occurrence with a number of possible outcomes, to be determined by the future events or decisions which might influence or terminate its development. (57)

She continues: "The perversity of the collapsed future tense lies in its ability at once to invoke and deny the future. For if the future is already upon us, we have no need to consider the survival needs of future generations: we *are* the future generation" (57). Again, the pro-life attempt to demand responsibility from pregnant women for the sake of future generations leads, at least implicitly, to a collapse of the conditions under which such a responsibility might emerge. Sofia points to a sense of "'not strictly biological' parenthood" (58) as a way of imagining our responsibility for unborn generations whom we will never meet and to whom we have no immediate connection. I am responsible for future generations *like* a maternal body (to borrow Levinas's phrase), whether or not there are biological ties between us. This maternal responsibility is not the same as a moral obligation to carry every pregnancy to term simply because "it happened to me." Rather, I argue that the maternal responsibility that Levinas describes may only arise under conditions when women are granted the political space to imagine themselves otherwise, as mothers or not as mothers, in relation to a conditional future rather than a collapsed one.

LEVINAS BETWEEN ETHICS AND POLITICS

While Cornell's project differs in important ways from that of Levinas, they share a commitment to justice understood as the transformation of present practices in light of a future that will never quite arrive in the present moment.[8] In *Totality and Infinity*, Levinas anticipates Cornell's argument for a justice that exceeds the legal system that it nevertheless requires:

> In reality, justice does not include me in the equilibrium of its universality; justice summons me to go beyond the straight line of justice, and henceforth nothing can mark the end of this march; behind the straight line of the law the land of goodness extends infinite and unexplored, necessitating all the resources of a singular presence. I am therefore necessary for justice, as responsible beyond every limit fixed by an objective law. The I is a privilege and an election. (TaI 245; TeI 274)

The place of the individual self remains ambiguous in this passage, but this ambiguity is crucial. Justice both requires me and excludes me from an "equal" claim to equality. To modify Alyosha's phrase in *The Brothers Karamazov*: We are all equal, but the Others are more equal than I am. I am always more responsible for Others than they are for me, to the point where I am responsible even for the equality that I share with Others. This ambiguity of the ethical self is tied to the temporality of a justice that is endlessly deferred, but nevertheless requires my immediate attention. Justice cannot wait until tomorrow, yet the beginning of injustice is the claim that we have arrived at a state of perfect justice here and now, that the present regime coincides with justice and therefore places itself beyond question. For Levinas, justice is only possible given this pulling apart of present and future time, this tension between the urgent necessity of justice and the impossibility of any final or absolute state of justice. Like Cornell, Levinas distinguishes between justice and any particular legal or political system:

> This means concretely or empirically that justice is not a legality regulating human masses, from which a technique of social equilibrium is drawn, harmonizing antagonistic forces. That would be a justification of the State delivered over to its own necessities. Justice is impossible without the one that renders it finding himself in proximity. (OB 159; AE 248)

The systems and institutions that justice requires do not find their center of gravitation in themselves but rather in the proximity to an Other who draws me into a social world. In other words, justice finds its limit in ethical proximity; the political violence and persecution of ethical life find their limit or justification in a politics of justice and equality.

Given this intertwining of ethical responsibility and political justice, I believe there are resources within Levinas's work for a feminist defense of women's reproductive choice, even if Levinas did not and probably would not

propose such a defense himself. My argument turns on the claim that an ethics of responsibility requires (and does not merely tolerate) a politics of social justice and equality for all, even for myself. In his essay, "Transcendence and Height," Levinas writes: "As I see it, subjective protest [to political injustice] is not received favorably on the pretext that its egoism is sacred, but because the I alone can perceive the 'secret tears' of the Other which are caused by the functioning—albeit reasonable—of the hierarchy" (Levinas 1996, 23). The persistence of the I and its right to self-defense against violation or annihilation is important for Levinas not primarily for its own sake, but for the sake of those Others who might be left without a defender if I should disappear. If the ethical asymmetry of my responsibility for Others is to be rigorously distinguished from the asymmetry of injustice—in which one group of people is made to bear an unequal and nonreciprocal burden based on their sex, race, class, or any other form of identity—then a defense of social and political symmetry or equality is necessary. This insistence on the equality of all persons does not impose limits on the asymmetry of ethics, nor does it moderate my infinite responsibility for Others; rather it holds open the space in which an ethical response might arise. As Levinas says in a 1982 interview:

> I don't at all believe that there are limits to responsibility, that there are limits to responsibility in 'myself.' My self, I repeat, is never absolved from responsibility towards the Other. But I think we should also say that all those who attack us with such venom have no right to do so, and that consequently, along with this feeling of unbounded responsibility, there is certainly a place for defense, for it is not always a question of 'me' but of those close to me, who are also my neighbors. I'd call such a defense a politics, but a politics that's ethically necessary. Alongside ethics, there is a place for politics. (Levinas 1989, 291–92).[9]

While ethics remains *first* philosophy for Levinas, there is nevertheless a place—and a vital one—for a politics that defends against violence: especially against the violation of one's neighbors, but also against the violation of oneself. It is not primarily for my own sake, but for the sake of the *other* Other—the third party, who might otherwise be excluded from the face-to-face ethical encounter—that such an approach to politics becomes necessary.

Because there is more than just one Other in the world, even my infinite responsibility for the Other is not enough. I must also attend in some way to the other Others both near and far, both those with whom I share a home and those whose faces I will never encounter in my lifetime. This attention to the third party requires a certain negotiation of duties, a calculation of resources, a measurement of that which resists all measure. Given the existence of more than one Other in the world, "It is consequently necessary to weigh, to think, to judge, in comparing the incomparable. The interpersonal relation I establish with the Other, I must also establish with other men" (Levinas 1985, 90). Because there is always a multiplicity of Others whom I will never encounter

face-to-face, we need a politics of justice: a rational discourse through which rights and responsibilities can be balanced and negotiated. Without an ethical imperative that displaces the centrality of the I and questions its identity, politics might become little more than a calculation of more or less enlightened self-interest. But without the mutual negotiation of political life, the ethics of radical responsibility could become an obsession with the first Other who gets under my skin, to the point of blotting out the world and leaving me blind to anyone else. For Levinas, political justice is necessary for the sake of these otherwise neglected Others who would be left without a response if the self should collapse, or if it should remain narrowly obsessed with the Other who gets under my skin. The demand for justice introduced by the third party does not emerge as a mere afterthought or addendum to my ethical responsibility for the Other, but rather in the midst of this responsibility. As Levinas writes in *Totality and Infinity*: "The third party looks at me in the eyes of the Other—language is justice. It is not that there first would be the face, and then the being it manifests or expresses would concern himself with justice; the epiphany of the face qua face opens humanity" (TaI 213; TeI 234).

The face of the stranger already invokes the claim to justice, equality, and politics by referring me to the Other *of* the Other, to the third person whose existence concerns me thanks to the Other who commands me, but no less than this Other. We could express this complex relation in the language of pronouns: the I emerges as a responsible self—as a "me" absolved of the egoist *Moi*—in response to a You who commands me and, in the midst of this command, points me to Him or Her, thereby opening the possibility of a We, a political community in which the distinctions between You, I, She, and He would not be dissolved but preserved as anterior to the We that they constitute. To borrow a phrase from Alphonso Lingis, the We invoked by justice raises the possibility of a "Community of those who have nothing in common" (Lingis 1994): a shared political space that is bound not by a common language, essence, blood, or land, but by an ethical responsibility for the Other who faces me and a political commitment to justice for the other Others, whoever they may be.

While the demand for justice emerges in the midst of the face-to-face encounter, ethics is not *the same* as justice. Ethics demands an immediate response to the Other, prior to all reflection and calculation; politics is already mediated by particular social situations that demand a rationalization of available resources. While ethics displaces the self from its apparent "place in the sun" even to the point of persecution, the demand for justice recalls the importance of defending the self against violence and protecting it from a reduction to this or that objective identity. This double defense—preserving the self's right to a certain integrity and wholeness, while at the same time defending it against the imposition of a fixed identity from the outside—echoes Drucilla Cornell's defense of women's right to abortion. To force a woman to bear every fetus she conceives is not to make her responsible for her actions, as some may

claim; rather it is to reduce her to her sex, which in turn is reduced to her bare reproductive capacity. In light of this threat, reproductive justice would involve both a defense of women's individual selfhood against the reduction to a fixed social or biological role as well as a defense of women's access to the resources and support required to make an informed decision about their own pregnancy, wanted or unwanted.

This dual defense of reproductive choice is compatible with Levinas's views on justice, even if Cornell makes the defense on different grounds. For Levinas, the demand for justice involves a certain confirmation of the identity of the I, if not quite for its own sake, then for the sake of holding open the possibility of a just community and a responsible self. "Justice would not be possible without the singularity, the unicity of subjectivity" (TaI 246; TeI 275). The opposite of justice, and the paradigm of injustice, is war. While the absolute Other *interrupts* the identity of the same and puts it in question, war *annihilates* this identity, integrating both same and Other into a single totality, "an objective order from which there is no escape" (TaI 21; TeI 6). War violates persons by "interrupting their continuity, making them play roles in which they no longer recognize themselves, making them betray not only commitments but their own substance, making them carry out actions that will destroy every possibility for action" (TaI 21; TeI 6). Here, again, we hear echoes of Cornell's defense of the right to free and safe abortions; the woman who has no choice but to carry a pregnancy to term is set against her own substance, forced into a role in which she does not recognize herself. Like war, sexism (and racism and other forms of oppression) absorbs the individual into a totality in which neither self nor Other may appear; it establishes "an order from which no one can keep his [or her] distance; nothing henceforth is exterior. War [like sexism] does not manifest exteriority and the other as other; it destroys the identity of the same" (TaI 21; TeI 6).

Even if justice is important for the sake of the third, it nevertheless requires a self—the tenuous and fragile identity of an "I"—in order to emerge as justice. Without the I as a starting point, but not the final end point of justice, equality would entail little more than a reduction of differences to the neutrality and anonymity of the same; politics would be practically indistinguishable from war.[10] A certain sense of uncompleted wholeness (or, as Cornell puts it, deferred "personhood") is required for justice, just as a sense of home and material sufficiency is required for hospitality. When my home or my body are violated by Others, I may find that I no longer have room for generosity, no foothold for justice. For justice to take root, the doors to my home must both open and close; similarly, the identity of the self must be both exposed and defended against violence.[11] For Levinas, this ambiguous identity of the self is important for ethics as well as politics:

> The alterity, the radical heterogeneity of the other, is possible only if the other is other with respect to a term whose essence is to remain at the point of departure, to serve as the *entry* into the relation, to be the same not relatively

but absolutely. *A term can remain absolutely at the point of departure of relationship only as I.* (TaI 36; TeI 25, emphasis in original)

Levinas argues for the *secrecy* of the separated I, for an interiority that remains opaque to the view of objective history and irreducible to the position of the third person. "Only on the basis of this secrecy is the pluralism of society possible" (TaI 58; TeI 51). If the self were fully permeable—if the interior were fully accessible from the outside—then I would not be able to receive an Other in welcome, or respond to the Other as someone truly different and distinct, with his or her own inviolable secrecy. This is not to say that a political defense of the self automatically guarantees or produces ethical responsibility, or even that justice must be secured before any ethical encounter can take place. Rather, it suggests that the immediacy of ethics calls for a political mediation that it also requires in order to hold open this space of immediacy. In addition to demanding infinite responsibility, ethics also demands its own condition—namely, justice.

How is my ethical responsibility for the Other "related" to the claim for justice and equality in which I, too, am somehow included? Ethically, the Other is prior to the self: radically prior, to the point at which my response emerges in anarchy, before I can present myself as an I. And yet, given the political demand for justice—which the Other already issues in the face-to-face encounter by referring me to a third party—a certain synchronization is required, through which even the self may present its claims as if it were on an equal footing with Others. The possibility of making claims for justice and equality on behalf of a group to which I myself belong is important for my argument that feminist reproductive politics are compatible with at least a certain reading of ethical maternity in Levinas. On the one hand, it would seem that for Levinas I am never justified in turning away from any Other, especially not from a vulnerable and defenseless Other, whether or not I would have chosen to engage in an ethical encounter. On the other hand, concrete differences between men's and women's bodies have the effect of exposing women to an Other who "gets under their skin" in a way that has never been possible for men. If the anarchy of ethics is betrayed by the synchronization of a politics that guarantees women's right to reproductive choice and control, then Levinas's account of ethical maternity seems doomed to remain on a (dubious) metaphorical level. But if the synchronization of feminist reproductive politics is compatible with and even necessary for the ethics of maternal bearing, then an exchange between Levinas and feminism becomes important on both a theoretical and a practical level.

To untangle the complex relation between ethics and politics—in which ethics both antecedes the politics of justice and requires it—we must shift focus to *Otherwise than Being*, where Levinas reflects more explicitly on the logic of ambiguity and oscillation that binds ethics and politics together while holding them distinct.[12] In *Otherwise than Being*, justice emerges in a non-dialectical relation with ethical responsibility, an oscillation that echoes the

relation between two dimensions of language: the saying and the said. The said refers to that which we ordinarily understand by language: the form and content of speech or writing. The said presents themes for understanding, but insofar as it presents these themes *to an Other*, the said is also a saying. In this sense, the said cannot be neatly separated from saying, nor can there be a pure saying that does not already congeal into a said and so present itself as a theme or proposition. The distinction between saying and said is articulated on an ethical–temporal level. Anarchically prior to the said, the saying embodies my proximity to the Other; even while I speak about the weather or dairy farming or philosophy, I am still saying this *to someone*, exposing myself to her face, responding to her command. While the proximity of saying is betrayed in the said, such that our encounter may be reduced to a theme or a topic for a book, nevertheless Levinas insists that the saying *must* be said: "[It] must spread out and assemble itself into essence, posit itself, be hypostatized, become an eon in consciousness and knowledge, let itself be seen, undergo the ascendancy of being. *Ethics itself, in its saying which is a responsibility, requires this hold*" (OB 44; AE 75, my emphasis). Ethics requires this hold *for the sake of justice*, and even for the sake of holding open the space in which ethics can take place. And yet, while the saying must be crystallized in the said, the said must also be recalled or "reduced" to the anarchy and proximity of saying though an *unsaying* of the said that Levinas attributes to philosophy. The political task of philosophy consists of "immediately reducing the eon which triumphs in the said and its monstrations and, despite the reduction, retaining an echo of the reduced said in the form of ambiguity, of diachronic expression. For the saying is both an affirmation and a retraction of the said" (OB 44; AE 74). Like the relation between saying and said, ethics both affirms the need for synchronization and compromise in politics and already retracts this compromise, recalling us to a proximity that exceeds all calculation but also provides its justification. In this sense, ethics requires politics, but, as Levinas immediately adds, politics is only justified—that is, oriented toward justice—by remaining open to ethical critique. How does this justification of politics emerge?

Despite the radical decentering of consciousness in responsibility—and in some sense, thanks to this decentering—justice brings about "the latent birth of cognition and essence, of the said, the latent birth of a question, in responsibility" (OB 157; AE 244). The political question, which marks "the limit of responsibility," is this:

> What do I have to do with justice? A question of consciousness. Justice is necessary, that is, comparison, coexistence, contemporaneousness, assembling, order, thematization, the visibility of faces, and thus intentionality and the intellect, the intelligibility of a system, and thence also a copresence on an equal footing as before a court of justice. (OB 157; AE 245)

That which the proximity of the Other made impossible—namely, the understanding of an Other in terms of an intelligible theme that grants me certain

reasonable rights and duties—this very impossibility returns, with the advent of the third party, as the necessity of justice. Justice requires me to compare the incomparable, to calculate my resources and balance my commitments. But this act of comparison and calculation is only *just* (rather than callous and dehumanizing) insofar as it remembers its ethical proximity to the Other and attends to the third party, the "neighbor of the other" who concerns me differently but no less urgently than the Other (OB 157; AE 245). A philosophical discourse based on reason is justified not by its purity, neutrality, or truth, but rather by its invocation of reasons and justifications for the sake of a third party. I cannot immediately "face" every Other, yet no one is more (or less) deserving of my attention than the first one who happens to come along. In order to attend to those whom I will never encounter face-to-face—and in order to exist in a community of more than two, a social order—I must balance and negotiate my relations with other Others. "The relationship with the third party is an incessant correction of the asymmetry of proximity in which the face is looked at" (OB 158; AE 246). This correction compels me to look beyond the Other who obsesses me, even in the midst of this obsession; while my relation to the third is mediated by the Other, it is not for this reason secondary. Recalling his argument in *Totality and Infinity*, Levinas writes:

> In no way is justice a degradation of obsession, a degeneration of the for-the-other, a diminution, a limitation of anarchic responsibility, a neutralization of the glory of the Infinite, a degeneration that would be produced in the measure that for empirical reasons the initial duo would become a trio. But *the contemporaneousness of the multiple is tied about the diachrony of two*: justice remains justice only in a society where there is no distinction between those close and those far off, but in which there also remains the impossibility of passing by the closest. The equality of all is borne by my inequality, the surplus of my duties over my rights. (OB 159; AE 248)

Ethics, diachrony, and the proximity of the Other remain anarchically prior to the synchronization of justice that betrays them for the sake of the third.[13] My responsibility is not thereby diminished, but rather extended (albeit in a different way) to Others whom I will never meet face-to-face.

This demand for justice raises the possibility that I, too, am justified in seeking equality, that despite my ethical asymmetry with the Other (and indeed, in the midst of this asymmetry), I myself might emerge as socially and politically symmetrical with the Others. Insofar as I am included in the community of thirds, I may also make a claim for justice and fair treatment. My political orientation toward the third party is "the original locus of justice, a terrain common to me and the others *where I am counted among them*, that is, where subjectivity is a citizen with all the duties and rights measured and measurable which the equilibriated ego involves" (OB 160; AE 250, my emphasis). There is justice for me, too, insofar as I am included in the "community of those who have nothing in common." This justice is possible given

the ambiguity of the self, which remains *for the Other* in the midst of demanding justice for itself and the third. As Levinas puts it:

> [J]ustice can be established only if I, always evaded from the concept of the ego, always desituated and divested of being, always in non-reciprocable relationship with the other, always for the other, *can become an other like the others*. Is not the Infinite which enigmatically commands me, commanding and not commanding, from the other, also the turning of the I into 'like the others,' for which it is important to concern oneself and take care? *My lot is important but it is still out of my responsibility that my salvation has meaning,* despite the danger in which it puts this responsibility. (OB 160–61; AE 250–51, my emphasis)

It is as if I were the other of the Other and therefore must also attend to myself *for her sake*. Without this attention to the self—which remains in proximity to the Other, even in the midst of its self-concern—there would be no responsible self and no one to demand justice for the third. In the midst of my infinite responsibility for the Other, and indeed thanks to this Other who also points me to the community of thirds, "there is also justice for me" (OB 159; AE 247). Levinas calls this relation among equals *fraternity*; I am a brother among brothers, and this equality does not exempt me from also becoming "my brother's keeper."[14] Perhaps at this point, we may return to Beauvoir's final words in *The Second Sex*, making a claim—on our own behalf but, more important, on behalf of all other women—for a small but important modification of the passage. Beauvoir concludes her book with a demand for social and political symmetry, such that "by and through their natural differentiation men and women unequivocally affirm their [sisterhood and] brotherhood" (Beauvoir 1952, 689).

If we return now to consider the questions of identity and representation raised by Cornell, we find that a twofold political and ethical critique of pro-life discourse becomes possible. It is politically important to defend the singularity of individual women against a reduction in advance to the status of a third person in their own lives, to a "she" whose future is already determined by her capacity to reproduce. Without this defense, the possibility of justice is foreclosed in advance; women would simply be destined to bear an unequal share of the burden of reproducing the species. But with this foreclosure of justice, the possibility of ethical responsibility would also threaten to collapse. For without an "I" who resists this reduction to "she" or "he," there is no one to respond to the face of the Other, or to defend the claims of the third party. In this sense, an ethics of maternal bearing such as Levinas describes in *Otherwise than Being* requires a political recognition of mothers as singular and irreplaceable selves: not as a walking womb or a source of egg cells, but as an I who remains itself in the midst of its being-for-Others. Likewise, the politics of reproduction that Cornell defends requires an acknowledgment of the possibility that even a fetus might make an ethical claim on me. The

possibility of such a claim does not in itself determine the range of "good" or "just" responses; rather, it calls on me to respond in the best way possible under the circumstances.

There are many different ways of being a mother, and many different ways of *not* being one. To understand responsibility as becoming "like a maternal body" is not necessarily to reduce these meanings to a single identity; ideally, it is to recognize that mothers of all descriptions have already been practicing an ethics of substitution for centuries, but in ways that have been often, if not always, overlooked. To be like a maternal body for the Other is to become something that has never existed but is always coming-into-existence: A self without an ego, but still itself. A body not reduced to matter, but giving itself materially. A subject who does not possess itself, but is given by and for Others. These claims do not (and must not) construct a version of motherhood based on a moral superiority that is unattainable by mothers or anyone else. Rather, they seek inspiration in what mothers already do, sometimes even despite themselves, for the articulation of an ethics that remains in the flesh and for the Other. To understand ethics as the process of becoming like a maternal body for the Other is to propose, in resistance to the traditional image of the mother as a biologically driven martyr, a vision of maternity as the gift of time and incarnation, a gift that carries over the imperative to give to an Other. The ethical situation of birth need not, and most emphatically *should not*, be translated into a command to carry every pregnancy to term.[15] The logic at work in the political agenda that seeks to make women "accountable" for their sexual choices by denying access to abortion or birth control already reduces both mother and child to things that are made rather than Others who are born. To say to a woman, *You conceived this child; therefore you must give birth to it*, is akin to saying, *You caused this thing; therefore you are responsible for it*. But a child is not a thing that is made, nor is birth a matter of causation but rather of responsibility despite causation. For Levinas, I am responsible for the Other whom I have *not* caused, whether or not I have "conceived or given birth to" her. While this does not mean that Levinas has issued a call for women's reproductive rights, it certainly does not exclude the possibility of doing so.

ETHICS, POLITICS, AND THE PROSPECT OF "UNBORN MOTHERS"

I have argued that an exchange between Levinas's ethical maternity and a feminist politics of reproduction is both possible and productive. This exchange opens up theoretical possibilities for thinking of maternity as a gift of time and embodiment that is neither freely granted in the sense of being chosen in advance by an autonomous subject, nor legitimately coerced from a woman in the absence of decent reproductive choices. But what, if any, practical possibilities arise from the exchange between Levinas and feminism? I will respond to this question by looking at recent developments in reproductive technology

that have raised ethical and political questions concerning the relation between women and fetuses. The contingency of birth, which I have emphasized throughout this book as a starting-point for embodied ethical responsibility, is no longer a "fact of life" for many people, given the proliferation of fertility clinics offering reproductive services such as In-Vitro Fertilization (IVF), Intra-Cytoplasmic Sperm Injection (ICSI), Gamete Intra-Fallopian Transfer (GIFT), and Zygote Intra-Fallopian Transfer (ZIFT). While it is still not possible to choose one's own parents (except perhaps in Sartre's sense of existential choice), it has become possible for parents to choose which embryo to implant, and even to choose the sex of that embryo under certain circumstances. Prospective parents in countries such as the United States, the UK, and Australia may select potential embryos on the basis of sex in order to screen out genetically inherited diseases, and possibly even as a means of achieving "family balance" (though this possibility remains highly controversial). The more control people have over the circumstances of conception, the less meaningful the distinction between production and reproduction becomes, to the point of potentially altering the ethical and ontological significance of birth that I have described in this book.

In what follows, I explore the ethical and political aspects of a recent media account of New Reproductive Technologies (NRT), considering in particular the way women and fetuses are represented such that neither emerges as a potential *person* in Cornell's sense of the word, or as an ethically responsible self in Levinas's sense. In a recent story from the *Guardian Weekly* (widely disseminated on the Internet and in print media), we are warned of the "Prospect of babies from unborn mothers" (Sample 2003, 1). A team of researchers led by Dr. Tal Biron-Shental have been attempting to grow viable eggs from the ovarian tissue of aborted fetuses for use in fertility treatments such as IVF. Success has been limited; by stimulating the tissue with hormones, researchers are able to develop primary and secondary egg follicles about halfway to the point of maturity. In response to questions about the ethics of this research, Dr. Biron-Shental says: "We use sperm that's donated. Ethically, it's almost the same. There's just the question of whether your mother was an aborted foetus or your father was someone who donated his sperm" (2). However, there is an important difference here; while the father is a person who donates his sperm, the mother is not (in any ordinary sense) a person who donates an egg. Rather, the "mother" here is a bit of ovarian tissue harvested from an aborted fetus and cultivated under certain conditions to produce an egg. In this sense, an "unborn mother" would be a body part without a body, an egg donor but not a person, a "mother" but not a woman. Under what cultural and political circumstances does it make sense to identify this personless, disembodied egg source as a mother? This question demands a closer look at the media representation of women, mothers, and fetuses in relation to New Reproductive Technologies. I begin my analysis with the discourse on "unborn mothers" as reported in the *Guardian*, gradually widening the scope to reflect on reproductive politics and

abortion. My critique of pro-life rhetoric draws on Cornell's defense of women's right to personhood, as well as Levinas's account of ethical responsibility and political justice.

The *Guardian* article surveys the reaction to so-called unborn mothers from various groups including researchers, ethicists, and pro-life groups; no feminist response is mentioned. Two main issues arise in this brief discussion of reproductive ethics. First is the issue of consent. Clearly an aborted fetus cannot agree or refuse to donate its ovarian tissue; the material is simply harvested from the organism, presumably with the legal consent of the woman who had the abortion (though this detail is not noted in the article). Roger Gosden, an American "fertility expert," suggests that "it would be less controversial to take ovarian tissue from a woman, for which consent could be given" (Sample 2003, 2). Less controversial, to be sure—but also more expensive, less efficient, and more unpredictable to persuade mature women to donate ovarian tissue when there is already "a worldwide shortage of donated eggs" (1). The appeal of growing eggs from aborted fetal tissue would be the possibility of treating them as raw material rather than as an autonomous subject who is able to consent or refuse or—worst of all—change her mind about the level and nature of her participation in the procedure. The cultivation of eggs from fetal material would circumvent the need to negotiate with egg donors as *persons*; if women were not providing enough eggs to keep up with the demand of the reproductive marketplace, then one could simply develop new sources, putting otherwise wasted biomaterial to good use. In this sense, the use of aborted fetuses as raw material for reproductive technologies would circumvent the need to deal with women *or* fetuses as persons who can give or withhold consent.

Apart from this concern over fetal consent, the second dominant response to this new research has been a concern for the identity of any child produced by so-called unborn mothers. A spokesperson for the Human Fertilisation and Embryology Authority (HFEA) in England suggests, "It would be hard for any child to come to terms with being created using aborted foetal material" (Sample 2003, 2). A representative from Life, the UK's largest pro-life organization, makes a similar point. She says: "Children manufactured as a result of these donor eggs will probably often be the result of donor sperm. This means they will have no sense of their own identity and may have enormous psychological problems" (2–3). These responses are notable for the close association they assume between personal identity and biological genesis. Here again the question of personhood arises, though in a more complicated way; the article asks us to imagine mothers simultaneously as persons and nonpersons in a way that mirrors the representation of women in pro-life discourse. To show how this is the case, I will follow through some of the unarticulated assumptions in the comments I have just quoted.

To make sense of the threat that "unborn mothers" pose to the identity of their offspring, we need to believe that the contribution of an egg to

the fertilization process gives something more than just genetic information. Already in this biological contribution, there must be a social or psychological significance that is substantial enough to influence the child's future identity. *Just* an egg, grown from a bit of aborted female tissue, is apparently not enough to make this important psychological contribution; as a child, I need to know that my mother really existed as a person. And yet the psychological dimension is not considered here to be entirely separate from the biological. If it were, then it would hardly matter that the fetus was produced from an egg grown from aborted tissue so long as its identity was supported in other ways by other people who care for it once it is born. If we are to accept that the child of an "unborn mother" would suffer from identity problems, then we must believe that social and psychological consequences follow from the biological contribution of an egg to fertilization. In other words, we need to imagine the mother as *more* than just a bit of tissue from which eggs are produced, as someone who shapes the identity of a child in substantial ways, and moreover does so *already* through her donation of an egg. The mother must be a person: not necessarily for her own sake, but for the sake of developing the child's identity.

But this is only half the story. For in order to make sense of the phrase "unborn mother" we need to imagine the mother quite differently: as nothing more than a source of egg cells. The phrase "unborn mother" relies for its coherence on a reduction of motherhood to a strictly biological function in which the social practice of mothering and the subjective life of the mother have become irrelevant. Valerie Hartouni makes a similar point about the media representation of mothers in her book, *Cultural Conceptions*. In response to a headline that reads, "Brain-dead Mother Has Her Baby" (from the *San Francisco Chronicle*, July 1986), Hartouni writes:

> The coherence of this statement rests, in part, on a very particular understanding of "motherhood," an understanding in which motherhood is equated with pregnancy and thereby reduced to a physiological function, a biologically rooted, passive—indeed, in this case, literally mindless—state of being. (Hartouni 1997, 29)

In the cultural context in which headlines like this make sense (however surprising or disturbing they may be), it is difficult to imagine a biological female who is not already a potential mother or a mother who is not biologically female. As Hartouni observes, "The only sense in which it could be said that *she* [this brain-dead woman] is a *mother* who *has* a baby is if her *sheness* is reduced to motherhood [which in turn] is reduced to all biological tissue and process" (31). If we juxtapose these two representations of motherhood, we find ourselves in an awkward place. The woman is reduced to a mother, and the mother reduced to a biological condition for the production of a child; at the same time, social and psychological consequences for the child's identity are drawn from the biological status of the woman as mother. The discourse

surrounding "unborn mothers" remains caught between a reduction of motherhood to the merely biological, and an expansion of the biological to include a social and psychological significance. In order for the *Guardian* article to make sense, we need to imagine the mother as *just* an egg source and *more* than just an egg source at the same time.

This equivocation mirrors the logic of mainstream pro-life discourse. As many feminists have argued, pro-life rhetorical strategies tend to represent the fetus as already a "baby"—and the pregnant woman as already a "mother"—from the moment of conception. The woman's termination of a pregnancy is thus interpreted, apparently with perfect coherence, as a mother murdering her baby. But the incoherence of this position—and its immediate attribution of social, psychological, and moral consequences to a biological moment—is obscured by the powerful impact of photographic images depicting the fetus as a tiny, independent person. As Barbara Katz Rothman observes: "The fetus in utero has become a metaphor for "man" in space, floating free, attached only by the umbilical cord to the spaceship. But where is the mother in that metaphor? She has become empty space" (Katz Rothman 1986, 114). When the image of the fetus as a separate, autonomous person moves into the foreground, the image of the pregnant woman as a separate, autonomous person moves into the background, or—more often than not—*becomes* the background, the uterine environment, the container for new "life." The represented fetus appears as a completed whole; but this appearance of fetal wholeness entails the fragmentation of the maternal body, which appears on the ultrasound screen only as the blank spaces where the fetus is not—as the parts of the picture that need not be illuminated, or could only be illuminated at the expense of obscuring the fetal image. In photographs of fetal development, the woman's body tends to appear in bits and pieces, in the form of an amniotic sac enclosing the fetus or as a bit of umbilical cord trailing off the edge of the picture. More often than not, her body dissolves into a magisterial expanse of stars—thanks to the powerful imagery of Lennart Nilsson's book, *A Child Is Born* (first published in 1965). In the context of these images, the fetus emerges as both a solitary, autonomous, already distinct person and at the same time as an extremely vulnerable, threatened Other who requires the services of doctors, lawyers, and political advocates to maintain its well-being even against the wishes of its uterine environment.[16] This double-sided representation of the fetus as both an independent, rights-bearing person and a vulnerable, defenseless Other implies a similarly double-sided representation of the woman as both a depersonalized uterine environment or life-support system and a uniquely responsible moral agent who is obliged and can be justly forced to support the life of the fetus.

In this context, the pregnant woman is understood as being not only "morally" responsible for the fetus but *biologically* responsible; indeed, her moral obligations are thought to derive from her biological condition, just as in the *Guardian* article a social and psychological effect on the child's identity

is thought to derive from her biological contribution of an egg. The much-vaunted "future of the species" depends on women carrying through this biological responsibility from beginning to end. But this representation—where the fetus is doubly coded as an autonomous individual and a threatened hostage and the pregnant woman's responsibility for the fetus is rooted in biological grounds—*demands* responsibility from the pregnant woman, and at the same time *denies* her the reproductive choices required to make this responsibility meaningful. An ethical relation between woman and fetus is only possible when the popular representation of the fetus is questioned and the claim for responsibility is not issued to women in general as an automatic consequence of their reproductive capacity, but rather to *me*, as a singular I who has a chance to respond, but also to turn away from this particular fetus.

But if this is the case, then a unique and unshared responsibility for the fetus could never apply to women as a whole, and certainly not as the social, psychological, or ethical effect of our biological constitution. As Levinas suggests, only a singular, separated I bears responsibility for the Other; as Cornell argues, only a political commitment to the equality of women and men can hold open the space in which this responsibility is possible. But when the dominant cultural identity of women is perceived as being biologically and socially bound to motherhood, it becomes difficult to imagine oneself as a woman *and* as a singular "I." In a world in which the phrase "unborn mothers" makes sense to us, and where psychological implications are already drawn from the biological contribution of an egg, women are represented as "she" before they exist in the mode of an "I" or "you." The political context to which the *Guardian* article implicitly refers—a context in which abortion is put to good use by providing a supply of viable eggs for fertilization—already reduces both women and fetuses to third-person representations. Rather than invoking responsibility, it attacks the conditions under which both individual personhood and the gift of birth might emerge.

The prospect of babies from "unborn mothers" is chilling to ethicists and pro-life groups alike because it raises the possibility of a mother who never existed as a *person*, but only as a bit of aborted fetal tissue. And yet, as I have argued, the representation of women, mothers, and fetuses in the article already forecloses the project of becoming a person in Cornell's sense of the word. Like the fertility experts and pro-life activists mentioned in the *Guardian* article, I also find the prospect of "unborn mothers" unsettling, though for different reasons. The most urgent ethical issues raised by this procedure are not whether it poses problems for the psychological identity of children, or even whether a contract can be signed to give consent. Indeed, this analysis of the question merely obscures and even exacerbates the issues at stake here. For me, the most pressing ethical problem inherent in this research is that one woman's choice to terminate a pregnancy (the political guarantee of which inserts a gap between womanhood and motherhood) is then used to symbolically deny this gap, and to circumvent the need to recognize mothers and other women as persons in

their own right. While the production of "unborn mothers" is undertaken for the sake of women who might not otherwise conceive, it nevertheless also reduces the aborted female fetus to mere raw material for the reproduction of the same, a "standing reserve" for species maintenance and survival.[17]

The motivation for growing eggs from the tissue of aborted fetuses is to produce donor eggs for IVF, with the apparent benefit of avoiding complicated negotiations with individual adult egg donors. But perhaps if we imagined the identity of motherhood differently, not only as a biological condition with automatic social and psychological consequences but as the gift of one's time, care, and responsibility, then we might not perceive the reality that some women do not conceive and give birth to children as a *problem*. The absence of viable eggs is only a shortage, and the shortage is only a problem if women are thought to have natural rights and/or obligations to produce offspring. Considered in this light, the procedure of growing eggs from the ovarian tissue of aborted fetuses has the potential to collapse the meaningful distinction between woman and mother that is otherwise maintained by access to a decent range of reproductive choices. It thus reinforces the reduction of women to mothers—and of mothers to their reproductive organs—that Cornell and other feminists have contested.

ALTERED MATERNITIES

Whether I would have chosen it or not, I am born. Birth gives me both the possibility of autonomous self-control and the command to bear Others responsibly. Like Ivan in *The Brothers Karamazov*, I may not assent to the world into which I was born, a world in which the innocent suffer needlessly and without explanation. But, like Alyosha in the same book, I nevertheless affirm that I, more than anyone else, am responsible for this suffering, even if I have done nothing to cause or assent to it. To be responsible is not to be the "cause" of something or someone; it is to substitute myself for the Other whom I have not caused, but whose vulnerable face *and body* speak to me in the imperative. Ethics means taking one more step toward the Other than she has taken (or is likely to take) toward me. I am responsible not because the Other has done something to earn my response, as if I were merely settling the score or repaying a debt, but rather in response to a gift that exceeds measure and disrupts the logic of reciprocity—infinitely.

In this book, I have sought to bring Levinas's account of ethical responsibility to the concrete situation of giving birth and being born; I have also sought to "rectify" his approach to maternal and paternal responsibility by questioning his claims from the perspective of a feminist politics of reproductive justice. The ethical and political significance of birth contests the image of the human being as either a self-made individual or a biologically determined member of the species. It illustrates the ambiguity between freedom and facticity that, for Beauvoir, makes a constant reinterpretation of the "facts" of life

both possible and necessary. Birth initiates me into a world with Others, as Arendt suggests; my relation to these Others, however, is not from the start a symmetry between citizens in a *polis*, or a permanent inequality between members of a patriarchal household. I have argued along with Levinas that the radical asymmetry of ethics anarchically disrupts the arrangements of an established *polis* and calls these arrangements to justify themselves. At the same time, by reading Levinas alongside the work of Irigaray, Kristeva, Cornell, and others, I have argued against the tendency in Levinas's own texts to represent the relation to a feminine Other as the pre-ethical condition for ethics. The woman's ethical gift of birth commands me to become like a feminine Other for the stranger who seeks hospitality, and like a maternal body for the stranger who asks to be borne. This is not to suggest that women in particular ought to bear the privilege or burden of the Other alone. Rather, it demands a reinterpretation of gender and sexual difference along ethical lines, such that both men and women are called on to become (in Gertrude Stein's words) "other than young and grown."

Throughout this book, I have found inspiration for this reinterpretation in the biblical texts that Levinas cites in the course of explicating maternal and paternal responsibility. But I will close with a rather different image of maternity from Pedro Almodovar's film, *All About My Mother*. The film tells the story of a baby who belongs to no one, but for whom many different people substitute themselves "like a maternal body," despite their best interests or intentions. In the opening scenes, Manuela's only son Esteban is killed in a car accident; she finds herself unable to accept this loss or continue with a solitary life that seems drained of all meaning or direction. After a complicated series of events, Manuela adopts the newborn son of her estranged husband, whose name is also Esteban, but who has been living for many years as Lola, a transvestite prostitute. The biological mother of Lola's child is a young nun, Rosa, who dies in childbirth due to AIDS-related complications, having named her child Esteban. This third Esteban does not so much replace Manuela's lost son as carry over his name, which is itself carried over from the name of the "woman" who is his "father." Like Pharoah's daughter in the story of Moses, Manuela becomes like a maternal body for the child of a stranger; she responds generously without expectation of return. And yet in the midst of this response, Manuela's own relation to time and existence is renewed. Once unable to mourn the loss of her son, she now has hope for a future that is not only her own time but also the time of an Other, the future of a child whose body has neutralized the disease that killed both of his biological parents. Almodovar dedicates his film to "all the actresses who have played actresses, to all women who act, to men who act and become women, to all the people who want to be mothers. To my mother." For Almodovar, maternity is not a biological fact or even a social role, but rather an embodied performance: a performance which males, females, and she-males alike give in response to the stranger in need. The film's narrative weaves a complex web of biological and

nonbiological family relations that affirm that a new beginning is possible, that mortality is not the last nor even the definitive word on human existence. To borrow Arendt's phrase, the film's narrative acts like "an ever-present reminder that [women and] men, although they must die, are not born in order to die but in order to begin" (Arendt 1958, 246).

Almodovar's film illustrates for me the enormous range of concrete possibilities for bearing the Other whom I have "neither conceived nor given birth to . . . in my breast as the wet-nurse bears the nursling" (Numbers 11:12; OB 91, AE 145). One need not be a saint in any conventional sense to substitute for the Other "like a maternal body"; indeed, it is more likely that one must question the conventional sense of sainthood in order to understand substitution as both an ethical response and a political practice. Birth suggests an interpretation of existence that does not turn on possession or self-possession, but on the fortunate *dispossession* of being given to Others. While I may die alone, I am never born alone; already, I am bound to at least one Other before I can grasp hold of myself. The unchosen contingency and passivity of birth discloses a limit of human existence that orients me, perhaps even despite myself, toward Others without whom I could not be who I am. This passivity does not indicate a lack or absence of activity; rather, it refers to the affective exposure of oneself to the Other, a profound sense of not controlling one's existence from the ground up. To be born is to be received into the world as someone utterly new, but it is nevertheless to be received *by an Other*. Dependence on this welcome does not compromise my uniqueness, but rather makes it possible as an embodied, ethically charged singularity in a shared world. Perhaps I only begin to appreciate this possibility when I respond to the demand of another Other, bearing even the stranger like a maternal body.

Notes

INTRODUCTION

1. See Rank's book, *The Trauma of Birth* (1952).

2. In his essay, "Ethics as First Philosophy," Levinas writes: "My being-in-the-world or my 'place in the sun,' my being at home, have these not also been the usurpation of spaces belonging to the other man whom I have already oppressed or starved, or driven out into a third world; are they not acts of repulsing, excluding, exiling, stripping, killing? Pascal's 'my place in the sun' marks the beginning of the image of the usurpation of the whole earth" (Levinas 1989, 81–82). Levinas also cites this phrase from Pascal as an epigraph to *Otherwise than Being* (1998).

3. I make the case for this comparison at greater length in chapter 5.

4. I address the time of paternity, and the feminist response to this particular formulation of parenthood, in chapter 4.

5. Throughout, I will indicate page numbers for *Totality and Infinity* and *Otherwise than Being* in the English and French. I abbreviate *Totality and Infinity* (1969) as TaI; *Totalité et Infini* (1961) as TeI; *Otherwise than Being* (1998b) as OB; and *Autrement qu'être ou au-delà de l'essence* (1978b) as AE. For the most part, I have used Lingis's English translations, but from time to time I have indicated alternative translations that I find important for the philosophical significance of the text.

6. I will refer to the child with the masculine pronoun only where it seems necessary to distinguish grammatically between mother and child. Nevertheless, it is important to bear in mind that, for Levinas, the child is imagined first and foremost as a *son*. I will discuss the ethical problems with this image in chapter 4.

7. I develop this claim in chapters 3, 4, and 5, but I also argue that, despite the problems that Levinas raises with respect to the feminine Other and the maternal body—and sometimes because of these problems—Levinas has much to offer a feminist philosophy of birth.

8. Indeed, if anything, he tends to exclude women from the ethical encounter, if only implicitly. I address this problem in chapter 3 on hospitality and the feminine Other.

9. The recent volume, *Feminist Interpretations of Emmanuel Levinas*, demonstrates a range of feminist responses (Chanter 2001a). In particular, see Tina Chanter's Introduction (1–27) for a concise overview of the relation between Levinas and feminism.

10. See in particular chapter 4, where I read *Totality and Infinity* alongside Isaiah 49, and chapter 5, where I read *Otherwise than Being* alongside Numbers 11:12. Both verses are cited by Levinas himself, but both contest the apparent significance of his own text.

11. This phrase, "like a maternal body," does not appear in the current English translation of *Otherwise than Being*; there it is translated, "Psyche is the maternal body" (OB 67). However, it appears as the phrase, "Psychisme, comme un corps maternal," in *Autrement qu'être* (AE 109).

12. I will discuss different versions of both myths as they appear in the work of Beauvoir (chapter 1) and Arendt (chapter 2). For a good feminist analysis of the biological myth, see Emily Martin's book, *The Woman in the Body* (1987), or Kelly Oliver's "Animal Body Mother" in *Family Values* (1997, 11–61). For examples of the myth that women need to be liberated from motherhood as such, see Shulamith Firestone's book, *The Dialectic of Sex* (1971), and Jeffner Allen's essay, "Motherhood: The Annihilation of Women" (in Pearsall 1993, 102–11).

CHAPTER ONE

1. For example, see Iris Marion Young's critique in "Throwing Like a Girl": "By largely ignoring the situatedness of the woman's actual bodily movement and orientation to its surroundings and its world, Beauvoir tends to create the impression that it is woman's anatomy and physiology as such that at least in part determine her unfree status" (Young 1990b, 143). See also Mary O'Brien's critique in *The Politics of Reproduction* (1981, 65–92). Compare these critiques, however, with Julie K. Ward's reevaluation in "Beauvoir's Two Senses of Body" (in Simons 1995, 234–38).

2. Beauvoir draws attention to what she interprets as the temptation to avoid "the strain involved in undertaking an authentic existence. When man makes of woman the *Other*, he may, then, expect her to manifest deep-seated tendencies toward complicity. Thus, woman may fail to lay claim to the status of subject because she lacks definite resources, because she feels the necessary bond that ties her to man regardless of reciprocity, and because she is often well pleased with her role as the *Other*" (Beauvoir 1952, xxi). Of note here is the way that material and psychological aspects of oppression (lacking "definite resources" and feeling "well pleased" with her role) may implicate and reinforce one another.

3. In "The Data of Biology," Beauvoir points to the importance of biological "facts" that are nevertheless not definitive for women's situation: "Thus we must view the facts of biology in the light of an ontological, economic, social, and psychological context. The enslavement of the female to the species and the limitations of her various powers are extremely important facts; the body of woman is one of the essential elements in her situation in the world. But that body is not enough to define her as woman; there is no true living reality except as manifested by the conscious individual through activities and in the bosom of a society" (Beauvoir 1952, 33). And again: "Certainly these facts cannot be denied—but in themselves they have no significance" (31).

4. Iris Marion Young elaborates these contradictions with respect to women's bodily movements in her classic essay, "Throwing Like a Girl" (see Young 1990b, 141–57).

5. Of course, given current developments in reproductive technology, increasingly I *can* make myself pregnant, and I *can* choose the child who grows inside me. At what point does reproduction become another form of production, and with what consequences for women's experience of birth? I will address this question, albeit obliquely, in chapter 6.

6. Later, Beauvoir reiterates the distinction between the temporality of feminine and masculine procreativity. She writes: "Man's design is not to repeat himself in time: it is to take control of the instant and mold the future. It is male activity that in creating values has made of existence itself a value; this activity has prevailed over the confused forces of life; it has subdued Nature and Woman" (Beauvoir 1952, 61).

7. As Kristeva puts it in a different context: "For man and for woman the loss of the mother is a biological and psychic necessity, the first step on the way to becoming autonomous. *Matricide is our vital necessity*, the sine-qua-non of our individuation, provided that it takes place under optimal circumstances and can be eroticised" (Kristeva 1989, 27–28, my emphasis). The implication is that either the mother must be psychologically destroyed or her suffocating power will destroy me. I discuss Kristeva's ambivalent response to maternity in chapter 5.

8. Beauvoir elaborates this point at length. She writes of the male child: "He would be inevitable, like a pure Idea, like the One, the All, the absolute Spirit; and he finds himself shut up in a body of limited powers, in a time and place he never chose, where he was not called for, useless, cumbersome, absurd. The contingency of all flesh is his own to suffer in his abandonment, in his unjustifiable needlessness. She [the mother] also dooms him to death. This quivering jelly which is elaborated in the womb (the womb, secret and sealed like a tomb) evokes too clearly the soft viscosity of carrion for him not to turn shuddering away. Wherever life is in the making—germination, fermentation—it arouses disgust because it is only made in being destroyed; the slimy embryo begins the cycle that is completed in the putrefaction of death. Because he is horrified by needlessness and death, man feels horror at having been engendered; he would fain deny his animal ties; through the fact of his birth murderous Nature has a hold on him" (Beauvoir 1952, 135).

9. For a sense of the more orthodox existential perspective in *The Ethics of Ambiguity*, see, for example, chapter 1 ["Every man is originally free, in the sense that he spontaneously casts himself into the world" (Beauvoir 1964, 25) and chapter 2 ("Man's unhappiness, says Descartes, is due to his having first been a child" (35)].

10. Iris Marion Young also emphasizes the ambiguity of pregnancy in her essay "Pregnant Embodiment" (1990b): "The pregnant subject . . . is decentered, split, or doubled in several ways. She experiences her body as herself and not herself. Its inner movements belong to another being, yet they are not other, because her body boundaries shift and because her bodily self-location is focused on her trunk in addition to her head . . . Pregnant existence entails, finally, a unique temporality of process and growth in which the woman can experience herself as split between past and future" (160). Young argues that pregnancy is not inherently alienating, but can be experienced as such in a patriarchal society like the one Beauvoir describes. The difference between

this account and the analysis in "Throwing Like a Girl" mirrors the difference between my first and second readings of Beauvoir.

11. As I will argue in chapter 5, the maternal body is just such a figure for Levinas. The difference between Beauvoir's account of enslavement to the species and Levinas' account of responsibility for the Other turns in large part on their different accounts of the *temporality* of giving birth.

CHAPTER TWO

1. While I do not develop the narrative aspect of natality in this chapter, Adriana Cavarero has done so at length in her impressive book, *Relating Narratives: Storytelling and Selfhood* (2000).

2. Implicit here is a critique of Heidegger. For a developed analysis of Arendt's critique of Heidegger, see, for example, *The Thracian Maid and the Professional Philosopher: Arendt and Heidegger* (Taminiaux 1998).

3. Arendt reiterates this almost exactly in *The Life of the Mind*: "Not Man but men inhabit this planet. Plurality is the law of the earth" (Arendt 1978, I:19). She adds: "To be alive means to live in a world that preceded one's own arrival and will survive one's own departure" (I:20).

4. Arendt contrasts this with the *vita contemplativa*, or "theoretical life" that seeks to disengage from the world for the sake of immortality. On the *vita contemplativa*, see Arendt 1958, 14–21 and 289–94.

5. This recalls Beauvoir's account of housework as endless repetition or "marking time: [the housewife] makes nothing, simply perpetuates the present" (Beauvoir 1952, 425).

6. "*Labor* has the same etymological root as *labare* ("to stumble under a burden"); *ponos* and *Arbeit* have the same etymological roots as "poverty" (*penia* in Greek and *Armut* in German). . . . The German *Arbeit* and *arm* are both derived from the Germanic *arbma-*, meaning lonely and neglected, abandoned" (Arendt 1958, 48).

7. "Man, in so far as he is *homo faber*, instrumentalizes, and his instrumentalization also implies a degradation of all things into means, their loss of intrinsic and independent value" (Arendt 1958, 156). See pp. 153–59 for Arendt's critique of utilitarian logic.

8. There is a religious dimension that should not go without mention, although it will not be developed at any great length here. Ecclesiastes finds release from the vanity of mortal life not merely through death, but by seeking the judgment of God. The chapter concludes: "Fear God, and keep his commandments; for this is the whole duty of men. For God will bring every deed into judgement, with every secret thing, whether good or evil" (Eccl. 12:13–14). Arendt refers to birth as the "miracle that saves the world" (Arendt 1958, 247), and even quotes the "glad tidings" of the Gospels: "A child has been born unto us" (cited in Arendt 1958, 247). The complexity of this religious dimension—and the status of Arendt's relation to Christianity and Judaism—is beyond the scope of this inquiry. But I will at least touch on the religious significance of forgiveness, expiation, and absolution for Levinas in chapter 5.

9. What Arendt calls the *political* time of promise and forgiveness, I would call an *ethical* time, following Levinas's sense of ethics as responsibility for the Other.

Seyla Benhabib argues that, for Arendt, ethics refers to a private, individual quest for "the good life," while politics invokes a public sphere shared with other citizens who together seek freedom and justice (Benhabib 1992, 110). Arendt tends to confirm this traditional opposition by associating politics with the capacity for "enlarged thought," or putting oneself in the place of another for the sake of a common, public world, whereas the private person remains concerned with a classically ethical sense of *arête*, excellence. For Arendt, ethics implies a private search for harmony and unity, while politics requires engagement with a plurality of others (see Benhabib 1992, 139ff). But the notion of a *feminist ethics* would confound this distinction since feminist concerns already operate on a political level, and since we bring these political concerns to the private sphere as well as the public. I will discuss the relation between ethics and politics at length in chapter 6.

10. "To be sure, this equality of the political realm has very little in common with our concept of equality: it means to live among and to have to deal only with one's peers, and it presupposed the existence of "unequals" who, as a matter of fact, were always the majority of the population in a city-state. Equality, therefore, far from being concerned with justice, as in modern times, was the very essence of freedom: to be free meant to be free from the inequality present in rulership and to move in a sphere where neither rule nor being ruled existed" (Arendt 1958, 32–33). While Arendt does not necessarily endorse the ancient separation between equality and justice, her preference for the ancient *polis* rather than "modern times" suggests that she did not necessarily condemn it.

11. For a view that supports Arendt's position but identifies itself as feminist, see for example, Jean Bethke Elshtain, *Public Man, Private Woman: Women in Social and Political Thought* (1993).

12. hooks writes: "Throughout our history, African-Americans have recognized the subversive value of homeplace, of having access to private space where we do not directly encounter white racist aggression. Whatever the shape and direction of black liberation struggle (civil rights reform or black power movement), domestic space has been a crucial site for organizing, for forming political solidarity. Homeplace has been a site for resistance" (hooks 1990, 47).

13. Adrienne Rich wrote of *The Human Condition* that it displayed "the tragedy of a female mind nourished on male ideologies" (Rich 1979, 212). Mary O'Brien calls Arendt a "female male supremacist" for her devaluation of privacy and reproduction (cited in Honig 1995, 19). But, more recently, some feminists have found inspiration for feminist politics in Arendt's work. See, for example, Bonnie Honig's essay, "Toward an Agonistic Feminism: Hannah Arendt and the Politics of Identity" (Honig 1995).

14. For example, Elizabeth Young-Bruehl observes that Arendt was "suspicious of women who 'gave orders,' sceptical about whether women should be political leaders and steadfastly opposed to the social dimensions of Women's Liberation" (cited in Honig 1995, 19).

15. "Nothing, to be sure, is more private than the bodily functions of the life process, its fertility not excluded" (Arendt 1958, 111). "The *animal laborans* does not flee the world but is ejected from it in so far as he is imprisoned in the privacy of his own body, caught in the fulfilment of needs in which nobody can share and which nobody can fully communicate" (118–19).

16. For a discussion of Arendt's critique of modern "society," see Hanna Pitkin's essay, "Conformism, Housekeeping, and the Attack of the Blob: The Origins of Hannah Arendt's Concept of the Social" (in Honig 1995). While I find many aspects of Arendt's critique of society compelling, I disagree with her account of the social as an extension of labor and privacy to the public sphere, precisely because I contest her interpretations of labor, privacy, and the public sphere.

17. I develop an account of the home as an *ethos* of hospitality in the following chapter.

CHAPTER THREE

1. I will explore the ethical asymmetry between mother and child in chapter 5.

2. Here and elsewhere in *Given Time*, Derrida draws on Heidegger's vocabulary of giving (*Es gibt*, literally "it gives" but equivalent to the English phrase "there is") from *On Time and Being* (Heidegger 1972). While I will not follow through the connections here, it is helpful to keep in mind this reference throughout Derrida's *Given Time* to Heidegger's specifically *ontological* gift of time.

3. See Jean-Luc Nancy's book, *The Birth to Presence* (1993), for an account of birth as a continual presencing that never "arrives" as present or representable, but is always coming, always yet to-come (or futural, referring to the French *l'a-venir*). Nancy writes: "Presence is what is born, and does not cease being born. Of it and to it there is birth, and only birth. This is the presence of whoever, for whomever comes: who succeeds the 'subject' of the West, who succeeds the West—this coming of another that the West always demands, always forecloses" (2). Here, once again, the debt to Heidegger's language in *On Time and Being* is apparent.

4. In a similar spirit, Marion writes: "[T]he gifts that give the most and most decisively give *nothing*—no thing, no object; not because they deceive expectation but because what they give belongs neither to reality nor to objectness and can thus surpass all expectation, indeed fulfil a desire" (Marion 2002, 106). But Marion also calls into question the apparently metaphysical presumptions involved in Derrida's account of the "conditions" of the gift (see Marion 2002, 80–81).

5. In addition to the letter of Madame de Maintenon (Derrida 1992, 1–5), see Derrida's brief discussion of Baudelaire's notes on the "generosity" of prostitutes (71–72).

6. See, however, *Glas* (1986) and "Circonfession" (in Derrida and Bennington 1993).

7. Thank you to Andres van Toledo and Victoria Wynne-Jones for conversations on Cixous and Levinas that have informed my reading in this chapter.

8. On general and restricted economies, see *The Accursed Share* (Bataille 1988, 9–41 and 63–77).

9. Indeed, Cixous acknowledges the existence of "feminine" men whose writing has influenced her own work: Joyce, Kleist, Shakespeare (Cixous 1975, 98–99).

10. In chapter 5, I will explore the significance of this phrase "other in the same" for Levinas's account of the maternal body.

11. This reference to an anti-Ulysses resonates nicely with the work of Levinas, for whom the self "no longer has the structure of the subject which from every

adventure returns to its island, like Ulysses" (TaI 271; TeI 304). Levinas (1998c) contrasts the circular movement of Ulysses with the wandering of Abraham: "To the myth of Ulysses returning to Ithaca, we wish to oppose the story of Abraham who leaves his fatherland forever for a yet unknown land" (177).

12. "To fly/steal is woman's gesture, to steal into language to make it fly" (Cixous 1975, 96).

13. "The body naked and indigent is the very reverting, irreducible to thought, of representation into life, of the subjectivity that represents into life which is sustained by these representations and *lives of them*; its indigence—its needs—affirm "exteriority" as non-constituted, prior to all affirmation" (TaI 127; TeI 133).

14. This distinction between birth and causality bears an affinity with Arendt's account of birth as a "free gift from nowhere" (Arendt 1958, 2–3) and also with her emphasis on natality as the emergence into a shared, human, and plural world. However, Levinas's ethics of radical responsibility for the Other goes beyond the sort of symmetrical interaction that Arendt identifies with politics.

15. Thus, what Levinas calls "labor" is much closer to what Arendt would call "work."

16. See in particular the chapter of *Family Values* entitled, "No Body Father" (Oliver 1997, 119–94), in which Oliver contrasts this virile tendency with the vision of fatherhood in Levinas and Ricouer.

17. Oliver writes: "The virile subject maintains the fantasy that it is the only one, the only subject. All others are merely objects or alter egos controlled or constructed by the virile subject himself" (Oliver 1997, 132).

18. Levinas's critique of virility is not restricted to *Totality and Infinity*, but in this chapter I will concentrate on the way the critique unfolds in this particular text. For a subtle reading of virility in *Time and the Other*, see Ewa Ziarek's essay, "Kristeva and Levinas: Mourning, Ethics and the Feminine" (1993). Ziarek cites the following passage from *Time and the Other*, placing emphasis on the final sentence: "My mastery, my virility, my heroism as a subject can be neither virility nor heroism in relation to death. There is in the suffering at the heart of which we have grasped the nearness of death . . . this reversal of the subject's activity into passivity. . . . To die is to return to this state of irresponsibility, to be the infantile shaking of sobbing" (Levinas 1987, 41; cited in Ziarek 1993, 69). Ziarek comments: "What this amazing passage implies is that the event of death is in fact a repetition of an immemorial past: it returns the virile masculine subject to the state of utter passivity, which is figured in terms of a sobbing infant dependent on the maternal body. Beyond the anguish of death, the infant's convulsions of sobbing passionately evoke and erase the absent figure of the mother. Consequently, the figure of death is inscribed in a double temporality: an opening of an absolutely surprising future and a forgetting of an anarchic past, a forgetting of birth. The infantile cry, however, is not a simple evocation of the lost mother but betrays a profound ambiguity about maternal alterity: it is already denied and yet unable to be forgotten" (Ziarek 1993, 69–70). In chapter 5, I will address the loss of the mother and the temporality of melancholia invoked in Ziarek's reading of Levinas and Kristeva.

19. In chapter 5, I will address the "latent birth" of the responsible self in *Otherwise than Being*; this latent birth arises unexpectedly in the midst of a temporal and ethical "recurrence" of the persecuted, maternal body.

20. I will discuss the ethical and political significance of the future anterior at greater length in chapter 6.

21. In this sense, the feminine economy is anarchic: both *prior to* and *disruptive of* the masculine or virile economy. I will discuss the ethical temporality of anarchy with respect to the maternal body in chapter 5.

22. See Derrida's reading of Levinas on the presence/absence of the writer in his essay, "At this very moment in this work here I am" (1991).

23. In chapter 4, I will address the relation between infinity and discontinuity at greater length through my reading of paternity in *Totality and Infinity*.

24. In chapter 5, I will consider the imperative, which Levinas articulates in *Otherwise than Being*, to bear the Other "like a maternal body" (OB 67; AE 109).

CHAPTER FOUR

1. I use the masculine pronoun here because it is the only pronoun Levinas considers. Later, I will have occasion to ask whether the child could also be a "she," or a daughter.

2. Levinas revisits this notion of the self as an Other in *Otherwise than Being*, where he cites both Rimbaud ("I is an other" (cited in OB 118; AE 187, translation slightly altered)) and Paul Celan ("Ich bin du, wenn/ ich ich bin" (cited in OB 99; AE 156). In *Otherwise than Being*, the non-identity of the I receives a more radical articulation than it does in the context of paternity.

3. See also Gibbs's close reading of Levinas on forgiveness in *Why Ethics?* (2000, 345–53).

4. I will return to consider the rebirth or "latent birth" of the self in chapter 5, on the maternal body in Levinas and Kristeva.

5. In chapter 5, I will consider the more radical temporality of maternal bearing, which marks a past *of* the present rather than *in* the present.

6. Arendt echoes this sentiment in advance (see Arendt 1958, 242).

7. A few passages suggest that the feminine Other does already open an infinite future; but these tend to be undermined by a preoccupation with the son. For example: "*Eros* does not only extend the thoughts of a subject beyond objects and faces; it goes toward a future which *is not yet* and which I will not merely grasp, but I *will be*—it no longer has the structure of the subject which from every adventure returns to its island, like Ulysses. . . . Its future does not fall back upon the past it ought to renew; it remains an absolute future by virtue of this subjectivity which consists not in bearing representations or powers but in transcending absolutely in fecundity" (TaI 271; TeI 303–4). Thus, eros opens an absolute future, but it does so only by virtue of its capacity to become fecund.

8. In chapter 5, I will discuss the significance of rebirth and expiation for Levinas in *Otherwise than Being*. For a development of the intergenerational connections between mothers and daughters, see Adriana Cavarero's (1995) account of the "maternal continuum" in *In Spite of Plato* (60, 68, 82). Even though Cavarero uses the word "continuum" while I emphasize the *dis*continuity of the generations, I think we are talking about a similar series of relationships extending endlessly forward and back in (or as) time.

9. Of course, Zion is not only a woman; "she" is also an allegory for Israel, understood as the promised land of the Jews. In my reading, I bracket these allegorical meanings; see Derrida's treatment of the intersection between religious, political, and ethical issues in Levinas's work, and in particular his relation to Zionism (Derrida 1999, esp. 58–123).

10. Thank you to Robert Gibbs for this translation, and for our conversations about this passage.

11. There is still a great deal of ambiguity here about the "motherhood" or "fatherhood" of God, and I return to this question of God as a parent in chapter 5, where we see a much clearer maternity of God. But in the present text, it seems unclear to me whether God is *like* a nursing mother who does not forget, or (as a *father* who does not forget) is different from a forgetful nursing mother. The latter position might be supported by Isaiah's invocation of his own birth, which seems to give God the father a more decisive role in the birth of a child, making the mother but a vessel for creation. Chapter 49 begins with Isaiah's words: "The Lord called me before I was born / while I was in my mother's womb he named me" (Isa. 49:1–3). Later in the verse Isaiah echoes this claim once again: the Lord "formed me [and here the Hebrew word for creation or "giving form" is used] in the womb to be his servant" (Isa. 49:5), as if the child were created "in" the mother by God the Father. Either reading of this text is possible, but I hope to make a stronger claim for the interpretation of God as a maternal figure in chapter 5.

CHAPTER FIVE

1. See, however, Kelly Oliver's analysis of the father's bodily contribution to reproduction and the "fantasy of a disembodied father" in *Reading Kristeva: Unraveling the Double-bind* (1993, 88–90).

2. For an account of this "myth of woman," see the section of *The Second Sex* entitled "Myths: Dreams, Fears, Idols" (Beauvoir 1952, 129–85, especially 132 ff).

3. The French reads: "Passivité antérieure à toute receptivité. Transcendante. *Antériorité antérieure à toute anteriorité représentable*: immémoriale" (AE 195).

4. There is a distinction between the pregnant body and what Levinas calls "the maternal body," neither of which coincides exactly with the mother as a person who raises children to whom she may or may not have given birth. In the second section of this chapter, I will indicate an ambiguity within Levinas's account of the maternal body between pregnancy and gestation; ultimately, I think ethical maternity refers both to the passivity of bearing an Other and to the passivity of being borne by an Other. But, in this section, I am concerned to highlight the distinct senses of passivity in both situations.

5. Jennifer Purvis explores the feminist potential of the placenta as a figure for thinking through the relation between woman and Other in her essay, "Irigaray's (Marxist) Placental Economy: Corporeal Paradigms and the Destabilization of Domination" (2004).

6. See the work of Barbara Duden (1991), Alice Adams (1994) and Emily Martin (1987) for different accounts of how this disappearance of the mother happens in the age of intrusive, visually based reproductive technologies. I will address this disappearance at greater length in chapter 6.

7. *God, Death and Time* is a lecture course delivered from November 1975 to May 1976, in the two years following publication of *Otherwise than Being* in 1974. The full passage reads: "I would open a parenthesis about the comprehension of the time presented here. It concerns the duration of time as a relation with the infinite, with the uncontainable, with the Different. It concerns duration as a relationship with the Different which for all that, is nonindifferent; a relationship in which diachrony is like the *in* of the other-*in*-the-same—without the Other ever entering into the Same. A deference of the immemorial to the unforeseeable. Time is at once this Other-within-the-Same and that Other who cannot be together with the Same; it cannot be synchronous. Time would thus be a disquieting of the Same by the Other, without the Same ever being able to comprehend or encompass the Other" (Levinas 2000, 19).

8. Recall my interpretation of paternity in chapter 4, where forgiveness "conserves the past pardoned in the purified present" (TaI 283; TeI 315–16).

9. In this context, Levinas quotes the Song of Songs: "I opened; he had disappeared" (Song 5:6).

10. Indeed, Levinas compares the sensible, but infinite responsibility of the maternal body to an "incessant alienation of the ego (isolated as inwardness) by the guest entrusted to it. Hospitality, the one-for-the-other in the ego, delivers it more passively than any passivity from links in a causal chain" (OB 79; AE 126).

11. I will address this image of the mother as "virgin queen" later in this section in my reading of Kristeva's essay, "Stabat Mater."

12. The said, by contrast, refers to any theme, message, meaning, or narrative that can be told, expressed in nouns and verbs, intended in a speech act or in a written text. Most of what we commonly understand as language falls under the rubric of the said, which posits a correlation between terms, establishing "this *as* that." To understand signification solely in terms of the said would be to forget the dimension of language in which I do not merely express a content but express myself *to the Other*. For a concise account of the difference between saying and said, see Adriaan Peperzak's essay, "From Intentionality to Responsibility: On Levinas' Philosophy of Language" in *The Question of the Other*.

13. For Kristeva's discussion of the distinction between semiotic and symbolic aspects of language, see *Revolution in Poetic Language* (Kristeva 1984, 19–107).

14. For example, Kristeva criticizes Beauvoir, who "too hastily saw a feminine defeat [in the nativity of Piero della Francesca] because the mother kneeled before her barely born son" (Kristeva 1987, 246). Kristeva suggests that Francesca's nativity introduces a "wholly human mother" whose sensitivity and humility "comes closer to 'lived' feminine experience" (246). We have already encountered a similar critique from Cixous: "One trend of current feminist thought tends to denounce a trap in maternity that would consist of making the mother-woman an agent who is more or less the accomplice of reproduction: capitalist, familialist, phallocentrist reproduction. An accusation and a caution that should not be turned into prohibition, into a new form of repression" (Cixous 1975, 89).

15. Is a "standardized household" so important that it justifies maternal anonymity and self-sacrifice? I have argued that this is not the case in my reading of Arendt on the household of the paterfamilias; see chapter 2.

16. In his essay, "Mourning and Melancholia," Freud remarks that with the melancholic patient, "one cannot see clearly what has been lost, and it is all the more reasonable to suppose that the patient cannot consciously perceive what he has lost either. This, indeed, might be so even if the patient is aware of the loss which has given rise to his melancholia, but only in the sense that he knows *whom* he has lost but not *what* he has lost in him" (Freud 1984, 254).

17. In his essay, "Female Sexuality," Freud writes: "Our insight into this early, pre-Oedipus phase in girls comes to us as a surprise, like the discovery, in another field, of the Minoan-Mycenaean civilization behind the civilization of Greece" (Freud 1991, 372).

18. For a similar set of questions, see Sonia Sikka's essay, "The Delightful Other: Portraits of the Feminine in Kierkegaard, Nietzsche, and Levinas" (2001, 96–118). Sikka suggests that "it could even be that an ethics emphasizing alterity and asymmetry, an ethics that deliberately refrains from imagining the Other as similar to oneself, might contribute to a failure to recognize and respect that Other, precisely in his or her very difference to oneself" (110). This is an important concern, and I will attempt to address it, if somewhat obliquely, in chapter 6 by elaborating Levinas's distinction between ethics and politics.

19. And once again, in the same interview: "Responsibility for the other, the 'disinterested' for-the-other of saintliness. I'm not saying men are saints, or moving toward saintliness. I'm only saying that the vocation of saintliness is recognized by all human beings as a value, and that this recognition defines the human. The human has pierced through imperturbable being; even if no social organization, nor any institution can, in the name of purely ontological necessities, ensure, or even produce saintliness. There have been saints" (Levinas 1999, 171).

20. A fruitful discussion might arise through a comparison of this imitation of the inimitable, and Irigaray's notion of a mimesis that repeats patriarchal discourse with a difference, thereby displacing its privilege and authority. See, for example, Drucilla Cornell's remarks on the "hope of mimesis" in *Beyond Accommodation* (1999, 147–52).

21. A fourth intervention by a woman occurs later, when Moses's wife Zipporah circumcises his son in order to save Moses from God (see Exod. 4:24–26). See also Derrida's reading of this in "Circumfession" (1993).

22. See *The New Oxford Annotated Bible*: "The name Moses, from an Egyptian word meaning 'to beget a child' and perhaps once joined with the name of an Egyptian deity (compare the name *Thut-mose*), is here explained by a Hebrew verb meaning 'to draw out'" (68, note 10).

23. Many thanks to Robert Gibbs for the Hebrew translation as well as the references to Rashi and Nachmanides.

24. For Levinas, justice refers beyond ethics, to the political dimension opened up by a third person. I will elaborate this distinction between ethics and politics in chapter 6.

25. Some other passages in which God appears "like a maternal body" occur at Isaiah 42:14 ("I will cry out like a woman in labour, I will gasp and pant"); Isaiah 66:13 ("As a mother comforts her child, so will I comfort you"); Deuteronomy 32:18 ("You were unmindful of the Rock that begot you,/ and you forgot the God who gave you birth").

CHAPTER SIX

1. See Cynthia Daniels' essay, "Fathers, Mothers and Fetal Harm" (1999) for an argument that negotiates between the importance of maternal autonomy, care, and responsibility.

2. Mary Poovey makes a similar point in her essay, "The Abortion Question and the Death of Man" (1992, 239–56). Poovey suggests that both pro-choice and pro-life arguments tend to share a common understanding of personhood in terms of privacy, self-ownership, and personal autonomy. Even the so-called defense of equality—which argues that women's reproductive capacity subjects us to systematic oppression in a legal system that assumes a masculine, nonpregnant subject—ultimately rests on the assumption that both women and men should be enabled to act as private, autonomous subjects, regardless of their biological capacities or constraints. Poovey argues that we need to rethink identity in terms of a shifting, historically contextualized sense of the person, rather than an essential core of personhood to which rights and duties would be attached.

3. For an argument made in a similar spirit, see Rosalyn Diprose's work on surrogacy. In *The Bodies of Women* (1994) and *Corporeal Generosity* (2002), Diprose contests the view of the self as a primarily autonomous individual who later enters into contractual relations with Others; through a reading of Merleau-Ponty, Levinas, and others, she develops an alternative account of the embodied self constituted in and through its relationships.

4. Adrienne Rich plays on this risk when she writes: "Ideally, of course, women would choose not only whether, when, and where to bear children, and the circumstances of labour, but also between biological and artificial reproduction. Ideally, the process of creating another life would be freely and intelligently undertaken, much as a woman might prepare herself physically and mentally for a trip across country by jeep, or an archaeological "dig"; or might choose to do something else altogether. But I do not think we can project any such idea onto the future—and hope to realize it—without examining the shadow-images we carry out of the magical thinking of Eve's curse and the social victimization of women-as-mothers. To do so is to deny aspects of ourselves which will rise up sooner or later to claim recognition" (Rich 1986, 175).

5. Cornell has more recently taken some distance from this particular phrase ("minimum conditions of individuation"), preferring instead to emphasize the right to "bodily integrity" (192). See her interview with Jodi Dean, "Exploring the Imaginary Domain" (*Philosophy and Social Criticism* 24:2/3 (1998) 173–98).

6. Cornell draws on Lacan's mirror stage to explain the importance of this imagined wholeness and its displacement into the future anterior. (See Cornell 1995, 38–43 and Lacan 2000, 330–35.) The mirror stage refers to the infant's encounter with an ideal image of itself in relation to which its personal identity is constituted. Between the ages of six and eighteen months—at a time when the infant has only a fragmentary experience of its body as a jumble of uncoordinated bits and pieces—it becomes fascinated with its own image in the mirror. The baby in the mirror looks like a whole and completed person, an organized and coherent self that the infant is not *presently*, but in relation to which it begins to emerge as an "I." This ideal image exists in a past that was never present (in the sense that it antecedes my own identity and

helps to shape it), but it also exists in a future that will never arrive (in the sense that I will never perfectly coincide with the image of this whole and completed person in the mirror). It's important to note here that, for Lacan, and by extension for Cornell, the images I encounter in the mirror stage are not just a duplication or reflection of myself, nor are they produced by me alone. Rather, the mirror is a social interface in which preexisting cultural images are inscribed on the self and the self writes itself into culture. For this reason, it is important for any account of personhood to interrogate the dominant cultural images in relation to which our identity is constituted and reconstituted. I will return to this point in the final section of this chapter when I examine the rhetoric surrounding so-called unborn mothers.

7. See also Adriana Cavarero's argument in support of access to abortion in her book, *In Spite of Plato* (1995, 74–90, esp. 74–79). In an argument that recalls Cornell's insistence on women's unconditional access to abortion, Cavarero argues for the nonnegotiable sovereignty of women's choice *not* to give birth by terminating an unwanted pregnancy.

8. For a sense of Cornell's critique of Levinas, see *The Philosophy of the Limit* (1992): "In Levinas, we must constantly remind ourselves of our inevitable failure to fulfil our responsibility. We must constantly seek to do more for the Other. We can never do enough. We do not have much fun in 'the ethical relation.' In Irigaray, more specifically, Levinas' emphasis on the inevitable lack of fulfilment of the individual allows the source of dissatisfaction of women to be ignored. No woman finds enjoyment in her reduction to either the good wife or the bad mistress" (88).

9. Levinas confirms this in *Otherwise than Being*: "[I]n no way is justice a degradation of obsession, a degeneration of the for-the-other, a diminution, a limitation of anarchic responsibility" (OB 159; AE 248).

10. Indeed, this is often how Levinas writes of politics. For example: "The art of foreseeing war and of winning it by every means—politics—is henceforth enjoined as the very exercise of reason. Politics is opposed to morality, as philosophy to naiveté" (TaI 21; TeI 5). However, in this passage and elsewhere where he may seem to dismiss politics tout court, Levinas is referring to a sense of politics already divorced from ethical critique and the demand for justice. For a more extended argument to this effect, see, for example, chapter 3 of *Levinas and the Political* (Caygill 2002, 94–127).

11. Elaine Scarry's work on the violence of torture and war makes this point stunningly clear. See *The Body in Pain* (1985, esp. 1–60).

12. In *Totality and Infinity*, the distinction between justice and ethics is not yet rigorously developed. As Levinas explains in a 1986 interview: "In *Totality and Infinity* I used the word "justice" for ethics, for the relationship between two people. I spoke of "justice," although now "justice" is for me something which is a calculation, which is knowledge, and which supposes politics; it is inseparable from the political. It is something which I distinguish from ethics, which is primary. However, in *Totality and Infinity*, the word "ethical" and the word "just" are the same word, the same question, the same language" (Levinas in Bernasconi and Wood 1998, 171).

13. Levinas emphasizes this point: "Philosophy is called upon to conceive ambivalence, to conceive it in several times. Even if it is called to thought by justice, it still synchronizes in the said the diachrony of the difference between the one and the other, and remains the servant of the saying that signifies the difference between the one and

the other as the one for the other, as non-indifference to the other. Philosophy is the wisdom of love at the service of love" (OB 162; AE 252–53).

14. Levinas writes: "The other is from the first the brother of all the other men" (OB 158; AE 246); on fraternity, see also TaI 278–81; TeI 310–13. For an insightful feminist critique of Levinas on fraternity, see Stella Sandford's argument in *The Metaphysics of Love* (2000, 71–75).

15. Beauvoir comments that, while birth may entail a moral obligation to the child who is born, "There is nothing natural in this obligation: nature can never dictate a moral choice; this [choice] implies an engagement, a promise to be carried out" (Beauvoir 1952, 493). However, "no one can impose the engagement upon [a woman]" (493), and sometimes the best way to carry out one's "moral obligation" is not to give birth at all.

16. In his 1970 book, *The Biocrats*, Gerald Leach claims: "Quite simply, the womb has become the most perilous environment in which humans have to live" (cited in Witt 1998, 137). Doris Witt explores the political consequences of imagining women's bodies this way in her essay, "What (N)ever Happened to Aunt Jemima: Eating Disorders, Fetal Rights, and Black Female Appetite in Contemporary American Culture" (Witt 1998).

17. See Robyn Ferrell's essay, "Desire and Horror: Conceiving of the Future" (2004) for a Heideggerian critique of this and other related research into reproductive technology.

Bibliography

Adams, Alice. 1994. *Reproducing the Womb*. Ithaca: Cornell UP.

Allen, Jeffner, and Iris Marion Young. 1989. *The Thinking Muse: Feminism and Modern French Philosophy*. Bloomington: Indiana UP.

Arendt, Hannah. 1958. *The Human Condition*. Chicago: U of Chicago P.

———. 1961. *Between Past and Future: Six Exercises in Political Thought*. Cleveland and New York: World Publishing Co.

———. 1965. *On Revolution*. New York: Viking Press.

———. 1978. *The Life of the Mind*. New York: HarcourtBrace.

Atwood, Margaret. 1977. "Giving Birth." Pp. 239–54 in *Dancing Girls*. Toronto: McClelland and Stewart.

Bataille, Georges. 1988. *The Accursed Share: An Essay on General Economy*. Trans. Robert Hurley. New York: Zone Books.

Beauvoir, Simone de. 1952. *The Second Sex*. Trans. H. M. Parshley. New York: Bantam Books.

———. 1964. *The Ethics of Ambiguity*. Trans. Bernard Frechtman. New York: Citadel Press.

Benhabib, Seyla. 1992. *Situating the Self: Gender, Community and Postmodernism in Contemporary Ethics*. New York: Routledge.

Benjamin, Jessica. 1988. *The Bonds of Love: Psychoanalysis, Feminism, and the Problem of Domination*. New York: Pantheon Books.

Bernasconi, Robert, and David Wood, Eds. 1998. *The Provocation of Levinas: Re-thinking the Other*. Routledge: London.

Bernasconi, Robert, and Simon Critchley, Eds. 1991. *Re-Reading Levinas*. Bloomington: Indiana UP.

Boulous Walker, Michelle. 1998. *Philosophy and the Maternal Body*. London: Routledge.

Cavarero, Adriana. 1995. *In Spite of Plato: A Feminist Rewriting of Ancient Philosophy*. Trans. Serena Anderlini-D'Onofrio and Aine O'Healy. Cambridge, UK: Polity Press.

———. 2000. *Relating Narratives: Storytelling and Selfhood.* Trans. and Intro. Paul Kottman. London and New York: Routledge.

Chanter, Tina. 1994. *Ethics of Eros: Irigaray's Rewriting of the Philosophers.* New York: Routledge.

———. 2001a. *Feminist Interpretations of Emmanuel Levinas.* University Park: Pennsylvania State UP.

———. 2001b. *Time, Death and the Feminine: Levinas with Heidegger.* Stanford: Stanford UP.

Cohen, Richard A., Ed. 1986. *Face to Face with Levinas.* Albany: SUNY.

Cornell, Drucilla. 1992. *The Philosophy of the Limit.* New York and London: Routledge.

———. 1995. *The Imaginary Domain: Abortion, Pornography and Sexual Harassment.* New York and London: Routledge.

———. 1999. *Beyond Accommodation: Ethical Feminism, Deconstruction and the Law.* Lanham, MD: Rowman and Littlefield.

Critchley, Simon. 1992. *The Ethics of Deconstruction: Derrida and Levinas.* Oxford and Cambridge, MA: Blackwell.

Critchley, Simon, and Robert Bernasconi, Eds. 2002. *The Cambridge companion to Levinas.* Cambridge: Cambridge University Press.

Daniels, Cynthia. 1999. "Fathers, Mothers and Fetal Harm" Pp. 83–98 in *Fetal Subjects, Feminist Positions.* Lynn Morgan and Meredith Michaels. Philadelphia: U of Pennsylvania P.

Diprose, Rosalyn. 1994. *The Bodies of Women: Ethics, Embodiment and Sexual Difference.* London and New York: Routledge.

———. 2002. *Corporeal Generosity: On Giving with Nietzsche, Merleau-Ponty, and Levinas.* Albany: SUNY.

Derrida, Jacques. 1978. "Violence and Metaphysics." Pp. 79–153 in *Writing and Difference.* Trans. Alan Bass. Chicago: U of Chicago P.

———. 1991. "At this very moment in this work here I am." Trans. R. Berezdivin. In *Re-Reading Levinas.* Ed. Robert Bernasconi and Simon Critchley. Bloomington: Indiana UP.

———. 1993. "Circumfession." In *Jacques Derrida.* Jacques Derrida and Geoffrey Bennington. Trans. Geoffrey Bennington. Chicago: U of Chicago P.

———. 1994. *Given Time: I. Counterfeit Money.* Trans. Peggy Kamuf. Chicago: U of Chicago P.

———. 1995. *The Gift of Death.* Trans. David Wills. Chicago and London: U of Chicago P.

———. 1999. *Adieu to Emmanuel Levinas.* Trans. Pascale-Anne Brault and Michael Naas. Stanford: Stanford UP.

———. 2000. *Of Hospitality.* With Anne Dufourmantelle. Trans. Rachel Bowlby. Stanford: Stanford UP.

———. 2001. "To Forgive: The Unforgivable and the Imprescriptible." Pp. 21–51 in *Questioning God.* Eds. John D. Caputo, Mark Dooley, and Michael J. Scanlon. Bloomington: Indiana UP.

———. 2002. "Hostipitality." In *Acts of Religion*. Ed. Gil Anidjar. New York: Routledge.

Duden, Barbara. 1991. *The Woman Beneath the Skin: A Doctor's Patients in Eighteenth-Century Germany*. Trans. Thomas Dunlop. Cambridge, MA: Harvard UP.

Elshtain, Jean Bethke. 1993. *Public Man, Private Woman: Women in Social and Political Thought*. Princeton: Princeton University Press.

Fausto-Sterling, Anne. 1999. *Sexing the Body: Gender Politics and the Construction of Sexuality*. New York: Basic Books.

Ferrell, Robyn. 2004. "Desire and Horror: Conceiving of the Future." *borderlands* 3:1. http://www.borderlandsejournal.adelaide.edu.au/index.html.

Firestone, Shulamith. 1971. *The Dialectic of Sex: The Case for Feminist Revolution*. London: Cape.

Freud, Sigmund. 1965. "Femininity." Pp. 139–47 in *New Introductory Lectures on Psychoanalysis*. Trans. James Strachey. New York: Norton.

———. 1984. *On Metapsychology*. Trans. James Strachey. The Penguin Freud Library, Vol. 11. London: Penguin Books.

———. 1991. "Female Sexuality." Pp. 367–92 in *Studies on Hysteria*. Josef Breuer and Sigmund Freud. Trans. James Strachey. The Penguin Freud Library, Vol. 3. London: Penguin Books.

Gatens, Moira. 1995. *Imaginary Bodies: Ethics, Power, and Corporeality*. New York: Routledge.

———. 2003. "Beauvoir and Biology: A Second Look." Pp. 266–85 in *The Cambridge Companion to Simone de Beauvoir*. Ed. Claudia Card. Cambridge: Cambridge UP.

Gibbs, Robert. 1992. *Correlations in Rosenzweig and Levinas*. Princeton: Princeton UP.

———. 1999. "The Discontinuity of the Generations: Grandparents and Children." Paper presented at the Brock University Conference on Love and the Family. St. Catherines, ON, Canada.

———. 2000. *Why Ethics?* Princeton: Princeton UP.

———. 2001. "Returning/Forgiving: Ethics and Theology." Pp. 73–91 in *Questioning God*. Eds. John D. Caputo, Mark Dooley, and Michael J. Scanlon. Bloomington: Indiana UP.

Grosz, Elizabeth. 1989. *Sexual Subversions: Three French Feminists*. Sydney: Allen & Unwin.

———. 1994. *Volatile Bodies: Toward a Corporeal Feminism*. Bloomington: Indiana UP.

Hartouni, Valerie. 1997. *Cultural Conceptions: On Reproductive Technologies and the Remaking of Life*. Minneapolis and London: U of Minnesota P.

Heidegger, Martin. 1962. *Being and Time*. Trans. John Macquarrie and Edward Robinson. San Francisco: Harper and Row.

———. 1972. *On Time and Being*. Trans. Joan Stambaugh. New York: Harper & Row.

Held, Virginia. 1989. "Birth and Death." *Ethics* 99 (Jan.): 362–88.

Hendricks, Christina, and Kelly Oliver, Eds. 1999. *Language and Liberation: Feminism, Philosophy and Language*. Albany: SUNY.

Honig, B. 1995. *Feminist Interpretations of Hannah Arendt*. University Park: Pennsylvania State UP.

hooks, bell. 1990. *Yearning: Race, Gender and Cultural Politics*. Boston: South End Press.

———. 1992. *Black Looks: Race and Representation*. Boston: South End Press.

Irigaray, Luce. 1984. *An Ethics of Sexual Difference*. Trans. Carolyn Burke and Gillian C. Gill. Ithaca: Cornell UP.

———. 1985a. *Speculum of the Other Woman*. Trans. Gillian C. Gill. Ithaca: Cornell UP,

———. 1985b. *This Sex Which Is Not One*. Trans. Catherine Porter. Ithaca: Cornell UP.

———. 1986. "The Fecundity of the Caress: A Reading of Levinas, *Totality and Infinity* section IV, B, 'The Phenomenology of Eros.'" Pp. 231–56 in *Face to Face with Levinas*. Ed. Richard A. Cohen. Albany: SUNY.

———. 1991. "Questions to Emmanuel Levinas." Pp. 178–89 in *The Irigaray Reader*. Ed. Margaret Whitford. Oxford: Blackwell.

Katz Rothman, Barbara. 1986. *The Tentative Pregnancy: Prenatal Diagnosis and the Future of Motherhood*. New York: Viking.

Keller, Evelyn Fox. 2000. "Making Gender Visible in the Pursuit of Nature's Secrets," in Kolmar, Wendy, and Frances Bartkowski. *Feminist Theory: A Reader*. Mountain View, CA: Mayfield.

Klassen, Pamela E. 2001. *Blessed Events: Religion and Home Birth in America*. Princeton and Oxford: Princeton UP.

Kristeva, Julia. 1980a. "Motherhood according to Giovanni Bellini." Pp. 237–70 in *Desire in Language*. Ed. Leon S. Roudiez. Trans. Thomas Gora, Alice Jardine, and Leon S. Roudiez. New York: Columbia UP.

———. 1980b. *Powers of Horror*. Trans. Leon Roudiez. New York: Columbia UP.

———. 1984. *Revolution in Poetic Language*. Trans. Margaret Waller. New York: Columbia UP.

———. 1986. *The Kristeva Reader*. Ed. Toril Moi. New York: Columbia UP.

———. 1987. "Stabat Mater." Pp. 234–63 in *Tales of Love*. Trans. Leon S. Roudiez. New York: Columbia UP.

———. 1989. *Black Sun: Depression and Melancholia*. Trans. Leon S. Roudiez. New York: Columbia UP.

———. 2001. *Hannah Arendt*. Trans. Ross Guberman. New York: Columbia UP.

Lacan, Jacques. 2000. "The Mirror Stage as Formative of the Function of the I as Revealed in Psychoanalytic Experience." Pp. 330–35 in *The Continental Philosophy Reader*. Eds. Richard Kearney and Mara Rainwater. London and New York, Routledge.

Levinas, Emmanuel. 1961. *Totalite et Infini: Essai sur l'exteriorité*. La Haye: Martinus Nijhoff.

———. 1969. *Totality and Infinity: An Essay on Exteriority*. Trans Alphonso Lingis. Pittsburgh: Duquesne UP.

———. 1978a. *Existence and Existents*. Trans. Alphonso Lingis. The Hague: Martinus Nijhoff.

———. 1978b. *Autrement qu'être ou au-delà de l'essence*. La Haye: Martinus Nijhoff,

———. 1985. *Ethics and Infinity: Conversations with Phillipe Nemo*. Trans. Richard A. Cohen. Pittsburgh: Duquesne UP.

———. 1987. *Time and the Other*. Trans. Richard A. Cohen. Pittsburgh: Duquesne UP.

———. 1989. *The Levinas Reader*. Ed. Seán Hand. Trans. Seán Hand and Michael Temple. Oxford: Blackwell.

———. 1991. "Judaism and the Feminine." In *Difficult Freedom: Essays in Judaism*. Trans. Sean Hand. Baltimore: Johns Hopkins UP.

———. 1994. "And God Created Woman." In *Nine Talmudic Readings*. Trans. and Intro. Annette Arnowicz. Bloomington: Indiana UP.

———. 1996. *Emmanuel Levinas: Basic Philosophical Writings*. Ed. Adriaan T. Peperzak, Simon Critchley, and Robert Bernasconi. Bloomington and Indianapolis: Indiana UP.

———. 1998a. *Entre Nous: Thinking-of-the-Other*. Trans. Michael B. Smith and Barbara Harshav. New York: Columbia UP.

———. 1998b. *Otherwise than Being or Beyond Essence*. Trans. Alphonso Lingis. Pittsburgh: Duquesne UP.

———. 1998c. "The Trace of the Other" in *Continental Philosophy: An Anthology*. Eds. William McNeill and Karen S. Feldman. Oxford: Blackwell.

———. 1999. *Alterity and Transcendence*. Trans. Michael B. Smith. New York: Columbia UP.

———. 2000. *God, Death and Time*. Trans. Bettina Bergo. Stanford: Stanford UP.

Lingis, Alphonso. 1994. *The Community of Those Who Have Nothing in Common*. Bloomington and Indianapolis: Indiana UP.

Marion, Jean-Luc. 2002. *Being Given: Toward a Phenomenology of Givenness*. Trans. Jeffrey L. Kosky. Stanford: Stanford UP.

Martin, Emily. 1987. *The Woman in the Body: A Cultural Analysis of Reproduction*. Boston: Beacon Press.

Mauss, Marcel. 1990. *The Gift: The Form and Reason for Exchange in Archaic Societies*. Trans. W. D. Halls. Foreword by Mary Douglas. New York: Norton.

Nancy, Jean-Luc. 1993. *The Birth to Presence*. Tran. Brian Holmes and others. Stanford: Stanford UP.

Nietzsche, Friedrich. 1954. *Thus Spoke Zarathustra*. In *The Portable Nietzsche*. Ed. And Trans. Walter Kaufmann. New York: Penguin.

O'Brien, Mary. 1981. *Politics of Reproduction*. Boston: Routledge and Kegan Paul.

Oliver, Kelly. 1993. *Reading Kristeva: Unraveling the Double-bind*. Bloomington and Indianapolis: Indiana UP.

———. 1997. *Family Values: Subjects between Nature and Culture*. New York: Routledge.

———. 1998. *Subjectivity Without Subjects: From Abject Fathers to Desiring Mothers*. Lanham, MD: Rowman and Littlefield.

Pearsall, Marilyn, Ed. 1993. *Women and Values: Readings in Recent Feminist Philosophy*. Belmont, CA: Wadsworth.

Peperzak, Adriaan T., Ed. 1989. "From Intentionality to Responsibility: On Levinas's Philosophy of Language." In *The Question of the Other: Essays in Continental Philosophy*. Arleen B. Dallery and Charles E. Scott. Albany: SUNY Press.

———. 1995. *Ethics as First Philosophy: The Significance of Emmanuel Levinas for Philosophy, Literature and Religion*. New York: Routledge.

Perpich, Diane. 1998. "A Singular Justice: Ethics and Politics between Levinas and Derrida." *Philosophy Today* 42 (suppl.): 59–70.

Petchesky, Rosalind Pollack. 1995. "The Body as Property: A Feminist Re-Vision." In *Concieving the New World Order: The Global Politics of Reproduction*. Ed. Faye D. Ginsburg and Rayna Rapp. Berkeley: U of California P.

Plato. 1961. *The Collected Dialogues of Plato*. Ed. Edith Hamilton and Huntington Cairns. Princeton: Princeton UP.

Pollock, Della. 1999. *Telling Bodies Performing Birth: Everyday Narratives of Childbirth*. New York: Columbia UP.

Poovey, Mary. 1992. "The Abortion Question and the Death of Man." Pp. 239–56 in *Feminists Theorize the Political*. Eds. Judith Butler and Joan W. Scott. New York and London: Routledge.

Purvis, Jennifer. 2004. "Irigaray's (Marxist) Placental Economy: Corporeal Paradigms and the Destabilization of Domination." In *Witnessing Bodies* (IAPL 2004 Virtual Materialities volume). Ed. Peter Gratton. Continuum: Textures Series.

Ramban (Nachmanides). 1975. *Commentary on the Torah: Numbers*. Trans. Rabbi Dr. Charles B. Chavel. New York: Shilo Publishing.

Rank, Otto. 1952. *The Trauma of Birth*. New York: Brunner.

Rich, Adrienne. 1979. *On Lies, Secrets and Silence: Selected Prose 1966–1978*. New York and London. Norton.

———. 1986. *Of Woman Born: Motherhood as Experience and Institution*. Tenth Anniversary Edition. New York and London: Norton.

Rojtman, Betty. 1998. *Black Fire on White Fire: An Essay on Jewish Hermeneutics, from Midrash to Kabbalah*. Trans. Steven Rendall. Berkeley: University of California P.

Sample, Ian. 2003. "Prospect of Babies from Unborn Mothers." *Guardian Weekly*. Tuesday, July 1. Accessed on 4/11/2003 from http://www.guardian.co.uk/medicine/story/0,11381,988615,00.html.

Sandford, Stella. 2000. *The Metaphysics of Love*. New Brunswick, NJ: Athlone Press.

Sartre, Jean-Paul. 1956. *Being and Nothingness*. Trans. Hazel E. Barnes. New York: Philosophical Library.

Scarry, Elaine. 1985. *The Body in Pain: The Making and Unmaking of the World*. New York and Oxford: Oxford UP.

Scholem, Gershom G. 1965. *On the Kabbalah and its Symbolism*. Trans. Ralph Manheim. New York: Schocken Books.

Schues, Christina. 1997. "The Birth of Difference." *Human Studies* 20: 243–52.

Sikka, Sonia. 2001. "The Delightful Other: Portraits of the Feminine in Kierkegaard, Nietzsche, and Levinas." Pp. 96–118 in *Feminist Interpretations of Emmanuel Levinas*. Ed. Tina Chanter. University Park: Pennsylvania State UP.

Simmons, William Paul. 1999. "The Third: Levinas' theoretical move from an-archical ethics to the realm of justice and politics." *Philosophy and Social Criticism* 25 (6): 83–104.

Simons, Margaret A. (Ed.) 1995. *Feminist Interpretations of Simone de Beauvoir*. University Park: Penn State UP.

Sofia, Zoe. 1984. "Exterminating Fetuses: Abortion, Disarmament and the Sexo-Semiotics of Extraterrestrialism." *Diacritics* 14:2 (Summer): 47–59.

Stein, Gertrude. 1962. *The Making of Americans: A Novel*. New York: Harcourt, Brace and World.

Taminiaux, Jacques. 1998. *The Thracian Maid and the Professoinal Philosopher: Arendt and Heidegger*. Trans. and Ed. Michael Gendre. Albany: SUNY.

The New Oxford Annotated Bible. 1973. Revised Standard Version. Ed. Herbert G. May and Bruce M. Metzger. New York: Oxford UP.

Witt, Doris. 1998. "What (N)ever Happened to Aunt Jemima: Eating Disorders, Fetal Rights, and Black Female Appetite in Contemporary America Culture." In *Contemporary Feminist Theory*. Eds. Mary F. Rogers. Boston: McGraw-Hill.

Wyschogrod, Edith. 1990. *Saints and Postmodernism: Revisioning Moral Philosophy*. Chicago: U of Chicago P.

Yaeger, Patricia. 1992. "The Poetics of Birth." In *Discourses of Sexuality: From Aristotle to AIDS*. Ed. Domna C. Stanton. Ann Arbor: U of Michigan P.

Young, Iris Marion. 1990a. *Justice and the Politics of Difference*. Princeton: Priceton UP.

———. 1990b. *Throwing Like a Girl and Other Essays*. Bloomington: Indiana UP.

Zakin, Emily. 1999. "Beyond the Father's Law: The Daughter's Gift of Death." *Philosophy Today* 43 (4): 323–35.

Ziarek, Ewa Plonowska. 1993. "Kristeva and Levinas: Mourning, Ethics and the Feminine" in *Ethics, Politics and Difference in Julia Kristeva's Writing*. Ed. Kelly Oliver. New York: Routledge.

———. 1999. "At the Limits of Discourse: Heterogeneity, Alterity and the Maternal Body in Kristeva's Thought" in *Language and Liberation: Feminism, Philosophy and Language*. Eds. Christina Hendricks and Kelly Oliver. Albany: SUNY.

Index

abortion, 12, 141–146, 176
 See also reproductive choice
Almadovar, Pedro, 162–163
anarchy, 4, 98–104, 152
Arendt, Hannah, 12, 29–47, 66, 77, 162, 163
 action, 30–32, 36–41
 animal laborans, 33, 34, 169
 bios and *zoe*, 34
 birth and death, 31, 34, 35, 37
 birth as initiative and initiation, 30–31, 40
 embodiment, 32–33, 42–43
 and feminism, 30, 40–42, 43–44, 169
 forgiveness, 4, 38–39
 homo faber, 34–35, 168
 The Human Condition, 30–44
 labor, 32–34, 42–43, 168
 The Life of the Mind, 31
 narrative, 29–30, 34, 36
 natality, 12, 30–32, 37–41, 77, 171
 plurality, 30–32, 38, 4767
 polis, 40, 42–44, 45–47
 politics, 31–32, 33, 37–44
 promise, 38
 public/private, 33, 41–44
 repetition, 33–34
 reproduction, 33–34
 "second birth," 39–40, 43
 society, 45, 170
 time, 37–39
 violence, 34–35
 vita activa, 32–36
 work, 34–36
Atwood, Margaret, 49
Audry, Collette, 27–28
Augustine, 1
autonomy, 9–10, 19, 26, 32, 73, 95, 127, 143, 144

Baudelaire, 69
Beauvoir, Simone de, 11, 15–28, 88, 95, 96, 139, 141, 154, 161, 174, 177
 biology and culture, 16–18, 25, 166, 177
 birth as project, 19–24
 critique of maternity, 16–18, 19–22, 108
 embodiment, 17–18, 27
 The Ethics of Ambiguity, 18, 24–28
 existentialist ethics, 19, 167
 immanence, 21–2, 24–25
 "myth of woman," 22, 88, 96
 oppression, 24–26
 repetition, 25
 The Second Sex, 18–24, 95, 154
 species, 16, 26
 time, 20–21, 24, 26–27, 167
 transcendence, 20–21, 24–25
 woman as Other, 19, 166
Benhabib, Seyla, 41
bible
 Ecclesiastes, 37
 Exodus, 97
 Isaiah, 77, 89–94, 112

188 THE GIFT OF THE OTHER

Numbers, 7, 97, 130, 132–139, 163
 See also God, Moses
biology, 11,
 and culture, 16–18, 25, 42–43, 45, 157–160
birth
 and causation, 11, 171
 and forgetting, 1, 56
 gestation, 99–102
 as gift, 49–50, 143
 not a project, 19–24, 79, 176
 pregnancy, 99–102, 141, 173
 as promise and forgiveness, 4–5
 and rebirth, 39–40, 80, 86, 97, 127, 128
 and responsibility, 161–162, 163
 and time, 3–5, 10–11, 20–21, 26–27, 29, 36–39, 97–108 (*See also* anarchy, future, past, time)
 See also natality, reproduction, maternity, paternity, child
body, 17–18, 27, 32–33, 42–43, 143, 144–145. *See also* maternal body

Cabala, 136–137
Cavarero, Adriana, 30, 44–47, 172, 177
child, 77–84, 85–86, 97–102, 104, 106–107
choice, 19, 20, 22–3, 141–143
Cixous, Helene, 12, 53–56, 63, 69, 87
 libidinal economies, 53–54
 Other-in-the-same, 55–56
 Cornell, Drucilla, 12, 143–146, 148–150, 154, 160, 177

daughter, 83–84
Derrida, Jacques, 12, 50–53, 63, 68–69,
Diprose, Rosalyn, 176
Dostoevsky, Fyodor, 147, 161

equality, 147–148, 160, 176
ethics, 64–67, 177
 and politics, 9, 12, 146–154, 168–169
 See also responsibility

feminine, 53–54, 57–58, 60–73
feminism
 and Arendt, 30, 40–42, 43–44
 and Cixous, 53–56, 174
 and Kristeva, 96
 and Levinas, 5–10, 75–76, 84–89, 96, 129, 133–134, 141–143
 liberal feminism, 142–143
 and new reproductive technologies, 155–161
 and pro-choice politics, 141–146
feminization, 12, 57, 72–73, 90, 134, 135
fetus, 8, 142, 146, 156–161
forgiveness, 4–5, 39, 81–83, 97, 107, 128
Freud, Sigmund, 19, 175
future
 in Arendt, 37, 38
 in Beauvoir, 24, 26–27
 future anterior, 70, 76, 103, 144–145
 future conditional, 146
 in Irigaray, 86
 in Levinas, 66, 78–81, 92, 99, 100, 101, 103, 105, 106, 147

Gatens, Moira, 18
Gibbs, Robert, 78
gift, 1–5, 49–58, 170
 betrayal of, 9, 63–64, 73
 of birth, 49–50, 143
 and desire, 51–52
 in Derrida, 50–53
 and ethics, 65–68
 and exchange, 50–56, 83–84, 87, 92, 98
 of the feminine, 53–56, 63–64, 72–72
 of the impossible, 50–53
 of the Other, 2–3, 105
 political conditions for, 8–10
 and sacrifice, 64, 111–112
 of time, 3–5, 7, 39, 51–52, 66, 83, 98–104
 twofold significance, 3
God, 90–93, 130, 132–133, 135–139, 173, 175
Grosz, Elizabeth, 96

hagiography, 131–132, 138, 139–140
Hartouni, Valerie, 158
hooks, bell, 93

INDEX

immanence, 24–5, 26, 84, 86
Irigaray, Luce, 12, 41, 84–89

justice
 in Cornell, 145–146
 in Levinas, 147–154, 177
 and reproductive choice, 8–10, 141–146

Kristeva, Julia, 12, 95–97
 Black Sun, 109, 119–125
 and feminism, 96
 on forgiveness, 97
 on maternal body, 108–109, 114–125
 matricide, 109, 167
 pain, 96
 "Stabat Mater," 115–119

Lacan, Jacques, 176–177
Levinas, Emmanuel
 anarchy, 4, 98–104, 152
 "And God created Woman," 7
 anterior posteriority, 62–63, 82
 creation ex nihilo, 59
 desire, 81
 diachrony, 96–97, 102–104
 dwelling, 60–64, 92–94
 enjoyment, 58–60
 expiation, 113, 126, 128
 face, 64–66
 fecundity, 84–85, 87
 feminine Other, 57–58, 60–73, 85, 88, 172
 and feminism, 5–10, 75–76, 84–89, 129, 133–134, 141–143
 forgiveness, 81–83, 97, 107, 128
 fraternity, 129, 154, 177
 future, 66, 78, 92, 99, 100, 101, 105, 106, 142, 147
 God, Death and Time, 101, 174
 Gyges, 62–63
 hospitality, 5–6, 56–58, 65–69
 infinity, 65, 72, 79–81, 106, 107, 111, 139
 inspiration, 104–105, 106
 "Judaism and the Feminine," 7
 justice, 147–154, 177

labor, 60
language, 67–72
"latent birth," 109, 125, 128, 152
"like a maternal body," 96, 105–106, 126, 135, 136, 138, 140, 146, 155, 163, 166
maternal body, 6, 7, 89, 95–114, 125–129
Otherwise than Being, 6, 7, 94, 95–114, 125–129, 139, 151–154
passivity, 65, 98, 104, 127
past, 81–83, 92, 98, 100, 101–104, 105, 106, 128
paternity, 4, 75–86, 89–90, 97–98, 107
persecution, 108–109, 110–114
politics, 9, 12, 147–154, 177
promise, 79–81
psychism, 104–106
representation, 58, 61–63, 100, 103
responsibility, 5–10, 64–67, 105, 108, 110, 112–114, 146
sainthood, 130–131, 140, 174, 175
saying and said, 113, 152, 177–178
sensibility, 109–111
silence, 69–70
substitution, 110–114
time, 88 (*See also* anarchy, diachrony, future, past)
the third, 9, 148–150, 153–154
Time and the Other, 7
Totality and Infinity, 6, 7, 57–74, 75–84, 91, 94, 97–98, 107, 149, 150–151, 153
transcendence, 76, 81, 84, 90
trans substantiation, 78–79
virility, 67
voluptuosity, 84–87
writing, 69–72
Lichtenberg-Ettinger, Bracha, 142
Lingis, Alphonso, 57, 149
Locke, John, 10

Marion, Jean-Luc, 56–57
maternal body, 95–140
 in Kristeva, 108–109, 114–125,
 in Levinas, 6, 95–114, 125–129, 173

and time, 97–108
See also maternity
maternity, 8–9, 89, 94, 139
 in Beauvoir, 16–18, 19–22, 108
 of God, 135–137, 173
 media representations of, 158–160
 of Moses, 129–140
 myths of, 9–10
 redefining, 156, 161–163
 and violence, 137–138
 See also maternal body
Moses, 97, 129–140, 175

Nachmanides, 136
natality, 12, 30–32, 77
 See also birth, labour, reproduction
Nilsson, Lennart, 159

oikos, 42–44
 and *ethos*, 56, 58–73, 92–94
Oliver, Kelly, 60–1, 83–84, 101

passivity, 65, 78, 98, 104, 127
past, 10–11
 in Arendt, 29, 37, 39,
 in Levinas, 81–83, 92, 98, 100,
 101–104, 105, 106, 128
paternity, 75–94
 asymmetrical, 78–79, 90
 and desire, 80–81
 as forgiveness, 81–83
 future, 79–81
 and infinity, 79–80
 in Levinas, 4, 75–86, 89–90, 94, 97–98, 100, 104
 past, 81–83
 as promise, 79–81
 trans-substantiation, 78–79
Plato
 Republic, 62
 Symposium, 15, 20, 50
politics, 8–10, 12, 177
 in Arendt, 31–32, 37–44
 in Levinas, 147–154
promise, 4–5, 38, 79–81

race, 8, 41, 93, 131, 169
Rank, Otto, 3

Rashi, 136
repetition, 25, 33–34, 83
reproduction, 15–16
 and production, 15–16, 21–24, 27–28, 33–35, 77–78, 156
 See also birth, labour, natality
reproductive choice, 8–10, 141–146, 149–150
 See also abortion
reproductive technology, 155–163
responsibility, 5–6, 64–67, 159–160
Rothman, Barbara Katz, 159

Sandford, Stella, 96
Sartre, Jean-Paul, 22–3
Scholem, Gershom, 136–137
sexual difference, 30, 45–46
Sofia, Zoe, 146
son, 76–83
Stein, Gertrude, 1–2, 10, 162

time
 and birth, 3–5, 10–11, 20–21, 26–27, 29, 36–39
 and ethics, 66
 diachrony, 96–97, 102–104
 future anterior, 70, 76, 103, 144–145
 as gift, 3–5, 7, 66, 98–104
 and maternity, 20–21, 55, 97–108
 and oppression, 24–26
 of promise and forgiveness, 36–39, 79–84
 and representation, 61–63
 See also anarchy, future, past
transcendence, 20–21, 24–25, 26, 76, 84, 90

"unborn mothers," 155–163
Ulysses, 54, 63, 87, 129, 170–171, 172

virility, critique of, 60–61, 67, 76, 92, 127, 171
writing, 55–56, 69–72
Wyschogrod, Edith, 131–132, 134, 139–140

Ziarek, Ewa, 117, 171

www.ingramcontent.com/pod-product-compliance
Lightning Source LLC
Chambersburg PA
CBHW020737230426
43665CB00009B/473